American Art from
The Currier Gallery of Art

American Art from
The Currier Gallery of Art

WITH AN INTRODUCTION BY
Nancy B. Tieken

AND COMMENTARIES BY
Karen Blanchfield, John H. Dryfhout,
William N. Hosley, and Carol Troyen

THE AMERICAN FEDERATION OF ARTS

#32347378

This catalogue has been published in conjunction with *American Art from The Currier Gallery of Art*, a traveling exhibition organized by The American Federation of Arts and The Currier Gallery of Art. It is supported in part by a grant from the National Endowment for the Arts. Additional support has been provided by the National Patrons of the AFA.

The American Federation of Arts, founded in 1909 to broaden the public's knowledge and appreciation of the visual arts, organizes traveling exhibitions of fine arts and media arts and provides museum members nationwide with specialized services that help reduce operating costs.

Library of Congress Cataloging-in-Publication Data

Currier Gallery of Art.
American Art from The Currier Gallery of Art / with an introduction by
Nancy B. Tieken and commentaries by Karen Blanchfield . . .
[et al.].
p. cm.
Catalog of a traveling exhibition first held at the Orlando Museum of Art,
Orlando, Fla., Dec. 3, 1995–Jan. 28, 1996, and five others; organized by the
American Federation of Arts and The Currier Gallery of Art
Includes bibliographical references and index.
ISBN 0-917418-99-9
1. Art, American—Exhibitions. 2. Art—New Hampshire—
Manchester—Exhibitions. 3. Currier Gallery of Art—Exhibitions.
I. Tieken, Nancy. II. Blanchfield, Karen. III. American Federation of Arts.
IV. Orlando Museum of Art. V. Title.
N6505.c86 1995
709' .73'07473—dc20

95-15993
CIP

Publication Coordinator: Michaelyn Mitchell
Design and Typography: Katy Homans and Deborah Zeidenberg
Manuscript Editor: Stephanie Salomon

Printed in Hong Kong by South China Printing Co. (1988) Ltd.

Cover: detail from Jasper Frances Cropsey,
An Indian Summer Morning in the White Mountains, 1857 (cat. no. 12)

Contents

Foreword

New England is richly endowed with museums large and small that preserve and present the cultural achievements of the past. The Currier Gallery of Art is one of those important institutions. That its collections of American and European fine and decorative arts have attracted both regional and national attention has been a point of great pride to the people of New Hampshire.

The Currier's collection of American art focuses on New England from colonial times through the twentieth century, with special emphasis on work unique to New Hampshire, such as furniture made by the Dunlap family and paintings by artists working in the White Mountains. The extraordinary bequest of the Zimmerman House in 1988 crowned the decorative arts holdings. Designed and furnished by Frank Lloyd Wright in the 1950s, the Zimmerman House is the only Wright building in New England that is open to the public.

Although individual objects have been lent frequently to other museums, this exhibition marks the first time that a large selection of masterworks from the permanent collection of the Currier has toured the nation. Organized with the American Federation of Arts to tour during the renovation of the Currier's landmark building, *American Art from The Currier Gallery of Art* focuses on painting, sculpture, silver, pewter, glass, and furniture from the eighteenth to the early twentieth century, just prior to America's embrace of modernism. It is a distinct pleasure for all of us at the Currier to share these important and much-loved works with new audiences.

The occasion of the national tour prompts me to reflect on the history of the Currier and, in particular, on the early days when this remarkable collection was established under the imaginative leadership of the Currier's first director, Maud Briggs Knowlton. The Currier opened its doors in 1929; in 1932, Mrs. Knowlton (as she is still remembered) purchased the core collection of Americana from a pioneering New Hampshire collector, Mrs. DeWitt Clinton Howe Palmer (Katherine B. Howe Palmer). That perspicacious acquisition and subsequent purchases through 1939 formed the nucleus of a collection that fulfilled the trustees' wish to "strive for a collection of the best examples of early-American furniture, particularly those pieces which are characteristic of New England."

Mrs. Palmer scoured New England in search of furniture, primitive portraits, hooked rugs, pewter, and household articles at a time when early American art was not in great favor, and she accumulated thousands of pieces. She knew other first-generation collectors, such as Henry

Francis du Pont and Katherine Prentiss Murphy, but documentation of her approach to collecting and the totality of her original collection is scant. It is hoped that the publication of this catalogue will attract the attention not only of scholars, but of those who once knew her or presently own works with the provenance of "the ubiquitous Mrs. Palmer" (as she has sometimes been referred to in New Hampshire), and that this will ultimately lead to a greater knowledge of her contributions.

Mrs. Knowlton emphasized the importance of the American collection by displaying it in a large main-floor gallery. Paintings by such acknowledged American masters as Copley, Hassam, Henri, and Sargent enriched the collection during her tenure. She also established many of the museum programs that exist to this day—art classes, films, lectures, children's events and school-group visits, concerts, and the library—effectively shaping the Currier into a vital community resource. The history of the Currier published in 1990 describes in further detail the many accomplishments of this early woman museum director.

Subsequent directors have carried forward the vision formulated by those first trustees and given substance by Mrs. Knowlton. Their collecting activities are sketched in the Introduction.

Trustee and collector Henry Melville Fuller continues this remarkable tradition of connoisseurship. Fuller has already given the museum a number of important landscapes and lively genre paintings from his collection. Each bears the stamp of his own selective taste: his eye is drawn to intimate, sometimes humorous works that provide a cheerful counterpart to the museum's textbook examples from the same era. Fuller has promised one day to entrust the museum with his entire painting collection, as well as his collection of paperweights. Thus a bright future for the continued growth of the Currier's American collections is ensured.

Marilyn Friedman Hoffman
Director, The Currier Gallery of Art

Acknowledgments

Since 1909 the American Federation of Arts has been organizing and circulating art exhibitions and producing publications of the highest quality for museums across the nation. The Currier Gallery of Art is grateful for the opportunity to collaborate on both this exhibition and its catalogue with the AFA's experienced staff. We extend our special thanks to director Serena Rattazzi; former curator of exhibitions Andrew Spahr, now a member of the Currier staff; curator of exhibitions Donna Gustafson; and head of publications Michaelyn Mitchell. We also wish to acknowledge Melanie Franklin, Alexandra Mairs, Maria Gabriela Mizes, Rachel Granholm, Evie Klein, Jennifer Rittner, Jillian Slonim, and Robert Workman.

We were fortunate indeed to have been able to enlist several of the most widely respected curators in their fields to write the catalogue entries: paintings expert Carol Troyen, associate curator of American paintings at the Museum of Fine Arts, Boston; decorative arts experts William N. Hosley and Karen Blanchfield, curator and assistant curator of American decorative arts, respectively, at the Wadsworth Atheneum; and sculpture expert John H. Dryfhout, superintendent at the Saint-Gaudens National Historic Site. Together with Nancy B. Tieken, adjunct curator of modern and contemporary art at the Denver Art Museum and former director of education at the Currier, who wrote the Introduction, these authors have created a book that places the objects in their social and cultural context and also sets the collection in its historical context at the Currier.

The vision and hard work of an excellent team saw this project to fruition. I extend my warm appreciation to our capable staff, especially team leader and deputy director Susan L. Leidy, for her stewardship. Other key contributors were curator Andrew Spahr; former Currier curator Michael K. Komanecky; registrar Ellie Vuilleumier, who also served as acting head of the curatorial department for nine months; education director Ellen B. Cutler; curatorial assistant Darlene LaCroix; preparator Jae Hoon Kim; and former preparator Tim Johnson. Cathy M. Carver and Bill Finney photographed the objects; and Mark Zurolo, with the assistance of intern Amy Shaw, helped coordinate the preparation of the manuscript.

Several experts generously contributed their time and lent their knowledge to the project. Charles E. Buckley and William W. Upton advised on selection and valuation of objects. Roland A. Sallada, with the assistance of Sandwich Glass Museum curator Kirk J. Nelson, donated countless hours to the selection of the glass.

The production of the catalogue was supported by a grant from the National Endowment for the Arts, reflecting again the important role this federal agency plays in the cultural activity of our state and our nation. Conservation of the works on tour was made possible in part by David G. Carter and the National Endowment for the Arts. We are very grateful to the AFA for their support throughout the project.

Marilyn Friedman Hoffman
Director, The Currier Gallery of Art

Dedicated to the two great New England ladies who launched the Currier's collection of American fine and decorative arts, Maud Briggs Knowlton and Katherine B. Howe Palmer, and to trustee Henry Melville Fuller who is perpetuating their legacy.

Since its opening in 1929, the Currier Gallery of Art has built a remarkable collection of American painting, sculpture, and decorative arts. These works provide a rich and informative record of artistic traditions in the United States from the colonial period through the early twentieth century, and we are pleased to make a representative selection available to a national audience for the first time.

It has been a pleasure to work with the staff of the Currier Gallery. In particular, our appreciation goes to Marilyn Friedman Hoffman, director; Michael K. Komanecky, former curator; and Susan L. Leidy, deputy director, who together curated the exhibition. We also wish to recognize Andrew Spahr, curator, whose first involvement with this project was as curator of exhibitions at the American Federation of Arts.

The publication reflects the efforts of many individuals. Our gratitude goes to the authors: Karen Blanchfield, assistant curator of American decorative arts at the Wadsworth Atheneum; John H. Dryfhout, superintendent at Saint-Gaudens National Historic Site; William N. Hosley, curator of American decorative arts at the Wadsworth Atheneum; Nancy B. Tieken, adjunct curator of modern and contemporary art at the Denver Art Museum; and Carol Troyen, associate curator of American paintings at the Museum of Fine Arts, Boston. Thanks are also due Katy Homans and Deborah Zeidenberg, for their handsome catalogue design, and Stephanie Salomon, for her skillful editing of the manuscript.

At the AFA, I wish to acknowledge the efforts of Melanie Franklin, exhibitions assistant; Donna Gustafson, curator of exhibitions; Alexandra Mairs, exhibitions/publications assistant; Michaelyn Mitchell, head of publications; and Maria Gabriela Mizes, registrar. I would also like to thank Rachel Granholm, head of education; Evie Klein, exhibitions scheduler; Jennifer Rittner, assistant curator of education; Jillian Slonim, director of public information; and Robert Workman, former director of exhibitions.

We are pleased to recognize the participation of the presenting museums: the Orlando Museum of Art, Florida; the Society of the Four Arts, Palm Beach, Florida; and the Dixon Gallery and Gardens, Memphis, Tennessee.

Finally, the catalogue received generous funding from the National Endowment for the Arts. Additional support came from the National Patrons of the AFA, whose contributions helped to make this project possible.

Serena Rattazzi
Director, The American Federation of Arts

Introduction

NANCY B. TIEKEN

The Currier Gallery of Art in Manchester, New Hampshire, has not always been a household word to people outside northern New England. As director of education from 1988 to 1991, I soon realized that an important part of my job was to introduce new audiences to the museum, and the results were rewarding. Visitors were delighted to find that the Currier is, in fact, a museum of masterpieces of European and American art—Renaissance, baroque, colonial to contemporary. They were often surprised to learn that Moody Currier, the founder and primary benefactor, was not related to the Currier of Currier and Ives. And they were generous in sharing their enthusiasm with others near and far, dispelling the Currier's reputation as New England's best-kept secret.

Since this is the first traveling exhibition drawn from the Currier's important collection of American art, I have yet again the opportunity to introduce new audiences to Moody and Hannah Currier and to the museum they willed into existence—knowing they would never see the results of their farsighted intention to establish a "benevolent and public institution."

At the dawn of the twentieth century, Manchester, New Hampshire, boasted the largest single textile-producing complex in the world. By 1810, the citizens of the town of Derryfield, New Hampshire, had seen the promise of the industrial revolution and the potential of the Merrimack River to drive the wheels of production, and they dared to change their town's name to Manchester, in hopes of emulating one of England's greatest manufacturing cities. Soon afterward, a group of wealthy investors calling themselves the Boston Associates determined to make Manchester a prosperous utopian industrial society. They bought up the land bordering the river and, in 1831, incorporated the Amoskeag Manufacturing Company, borrowing the Indian word that had described the area as a fertile fishing ground.

In the ensuing years, the company oversaw the expansion of Manchester on a grand scale. The mill complex grew rapidly, as the production of machinery and other goods augmented the textile industry. A wide boulevard and city parks were built. Banks, department stores, and other businesses were created to fill the needs of the expanding population. One of the ambitious men who was drawn to this city of opportunity was Moody Currier (fig. 1)—a nineteenth-century Renaissance man. Born on a New Hampshire farm in 1806, he was educated at Hopkinton Academy and Dartmouth College. He came to Manchester from Concord, New Hampshire, where he had been a school principal, a magazine editor, and a law student. Arriving in

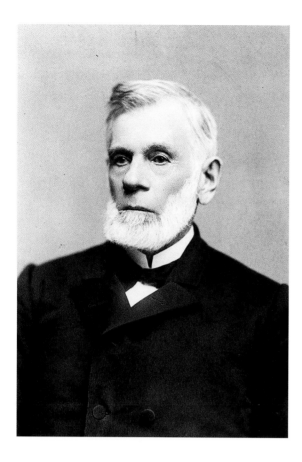

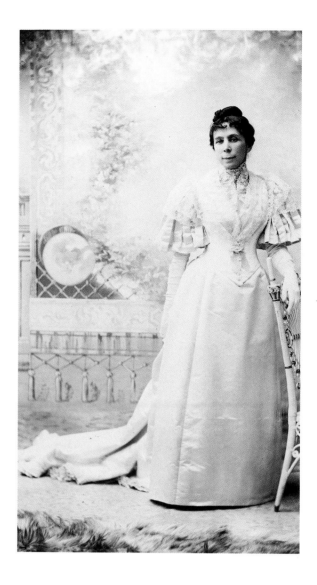

Fig. 1
Stephen Piper (d. 1903), *Moody Currier*, n.d. Albumen print.
The Currier Gallery of Art Library

Fig. 2
Photographer unknown, *Hannah Slade Currier*, 1885. Collodion print.
The Currier Gallery of Art Library

Manchester in 1841, he opened a law office and, in his spare time, purchased an interest in a Manchester newspaper and served as its part-time editor. In 1848, Currier became one of the founders of the Amoskeag Bank and the institution's first cashier, and his lucrative business interests continued to proliferate until his retirement at the age of eighty-six. Currier also had a political career at both the city and state levels, which was capped by his election as governor of New Hampshire in 1884.

In addition, Currier was a man of letters—a philosopher, astronomer, theologian, and poet. His high regard for culture and history, and his devotion to his city and state, must have influenced his decision to provide Manchester with the one institution he believed it was lacking—an art museum—even though Currier himself did not collect art. Before his death in 1898, he laid plans to realize his vision of a museum for the people of New Hampshire on the grounds of his Manchester home. His intentions were honored by his third wife, Hannah Slade Currier (fig. 2), who died in 1915, leaving instructions and funds for the establishment of the Currier Gallery of Art and its collections.

According to the provisions of Hannah Currier's will, the Hillsborough County Probate Court appointed a board of trustees in 1917 and charged them with the task Currier had set them. It was not an easy assignment. Proposals by two eminent architects—one for an elaborate medieval Italianate villa and chapel resembling the recently completed Isabella Stewart Gardner Museum in Boston, the other for a baronial eighteenth-century-style mansion— were rejected. Not until 1926 was the commission awarded, to Tilton and Githens, a firm from New York that submitted plans for a beaux-arts rendition of an Italian Renaissance palazzo with an airy, columned, glass-roofed court flanked by two stories of graciously proportioned galleries.

Even before the architect had been chosen, the ten Currier trustees made two invaluable appointments to their board: Penelope W. Snow, Hannah Currier's niece, and Maud Briggs Knowlton, a well-known Manchester artist and art educator. In May 1929, Knowlton was selected to become the museum's first director. The Currier opened to the public in October of that year, twenty days before the stock market crashed. Fortunately, thanks to ample financial

resources and prudent management, not even this calamitous event could derail Moody Currier's legacy.

The history of the Currier's collection is, in large part, the story of the seven directors who shaped it and of the four curators with whom they have worked. Their initiatives have extended far beyond the field of American art, and their vision has enlarged the museum's educational mission and its role in the community.

Maud Briggs Knowlton (director, 1929–46) faced a formidable challenge. With the exception of the Currier family portraits, a friend's bequest of unremarkable landscape and genre paintings, and Penelope Snow's gift of several panels of French wallpaper by the nineteenth-century French artist Felix Sauvenet, there was neither art to fill the galleries nor an acquisition policy to guide the development of the collections. Wisely, Knowlton arranged a series of notable loan exhibitions from private and commercial sources, including a presentation of Rodin's work in 1931, until she and the trustees determined how best to proceed.

It is essential that collections be brought together with the greatest care, and whatever is to form a part of a permanent collection should be of outstanding merit (Maud Briggs Knowlton, Annual Report, 1932). . . One good canvas is worth a whole gallery of undistinguished paintings (Maud Briggs Knowlton, Annual Report, 1933).

Knowlton's first purchase was *Crest of the Wave*, a bronze fountain sculpture by the American sculptor Harriet Frishmuth, a pupil of Rodin's. It was one of the featured works in the inaugural show of contemporary painting and sculpture assembled by the Grand Central Galleries in New York. A lithe bronze water nymph poised on a rock, the work is permanently installed at the Currier's south entrance.

In a few bold moves, Knowlton also set the tone for the museum's American decorative arts holdings. In 1932, she purchased important eighteenth-century works from the collection of Mrs. DeWitt Clinton Howe Palmer. In 1935, she launched the American painting collection with the acquisition of John Singleton Copley's superb 1769 portrait of John Greene (cat. no. 1). In 1936, she bought the last portrait John Singer Sargent ever painted, an elegant likeness of the melancholy Marchioness Curzon of Kedleston (cat. no. 29). The next year she purchased Childe Hassam's luminous oil *The Goldfish Window* (cat. no. 28), which delights Currier visitors today as much as it did fifty years ago.

The Currier bequest was prudently invested throughout the 1930s, and in addition to American pieces, Knowlton also bought significant European objects, including a rare fifteenth-century Franco-Flemish tapestry. Even during the war years, she kept the galleries filled with people and objects, and her legacy of careful collection-building endures.

Gordon M. Smith, the Currier's second director (1946–55), an art historian educated at Williams College and at Princeton and Harvard, recognized that the Currier had the potential to become a "great" small museum. His conviction, stated in 1952, became the museum's credo:

The idea we have had most often is that a small museum should make no attempt to collect important paintings . . . [It] should realize that it is the little sister of big institutions, and as such should be grateful for "cast-offs." The Currier Gallery of Art has formed an acquisition policy which is quite different from the above . . . Our long-range objective is a necessarily small, but very choice, collection of top-quality paintings, each making a distinct contribution toward an appreciation and understanding of the major movements and periods of art (Gordon M. Smith, "Little Gallery on Big Scale," Art News, vol. 50, no. 9, [January 1952], p. 22ff).

To accomplish his mission, Smith purchased some remarkable European paintings, including seminal works by John Constable, Claude Monet, and Jacob van Ruisdael. His attention to the American holdings was equally ambitious. In 1947, he acquired an early Albert Bierstadt landscape of a New Hampshire scene (cat. no. 15). To the American decorative arts collection he added two fine eighteenth-century pieces: a chest-on-chest (cat. no. 38) and a silver cream pot made by Paul Revere I (cat. no. 55). In 1948, Smith put Manchester on the American art-world map by inviting Charles Sheeler, the eminent Precisionist painter, and his family to New Hampshire for their summer vacation. He commissioned a starkly majestic painting of the city's mills, later titled *Amoskeag Canal*.

Charles E. Buckley (director, 1955–64), educated at the Art Institute of Chicago and Harvard University, arrived from the Wadsworth Atheneum in Hartford and brought a rare mixture of discrimination and courage to his collecting and exhibiting missions. With the museum's first curator, Melvin E. Watts, Buckley renewed the Currier's commitment to the early American decorative arts collection, with a particular emphasis on pieces originating in New Hampshire. The exuberant curly-maple chest-on-chest-on-frame (cat. no. 40) and desk attributed to the Dunlap family and a stately clock with works made by Levi Hutchins (cat. no. 43) are but three of his outstanding acquisitions. To make the collection visible to a broader public, Buckley oversaw two ground-

breaking exhibitions, accompanied by thoroughly researched and illustrated catalogues: *New Hampshire Silver, 1775–1825* and *The Decorative Arts of New Hampshire, 1725–1825*.

Buckley also encouraged the formation of the Friends of the Currier Gallery of Art in 1958, whose contributions greatly augmented Currier acquisition funds for the purchase of American art; to date, Friends' funds have added more than one hundred objects to the collection.

Buckley left the Currier in 1964 to continue his distinguished career at the Saint Louis Art Museum, but returned to New Hampshire upon his retirement in 1975 and maintains an active informal association with the Currier and its decorative arts collections.

William Hutton (director, 1965–68), from the Toledo Museum of Art in Ohio, recognized the necessity of maintaining, as well as enlarging, the museum's furniture collection, and arranged a program for its physical evaluation and ongoing conservation. He also pursued an interest in researching and collecting nineteenth-century American painters who worked in Italy, a group he termed the "Travelers in Arcadia." To fill the gap in the museum's collection in this area, he purchased the Elihu Vedder painting *Bordighera* (cat. no. 17), a charming example of Vedder's passion for the Italian landscape and this small town in northern Italy.

The directorship of David Brooke (1968–77), a Harvard-educated Englishman from the Art Gallery of Ontario, coincided with a revitalization of the visual and performing arts in Manchester. Brooke took a leadership role in the community and masterminded a diverse program of acquisitions and exhibitions. In addition to acquiring important collections of glass and pewter, he was responsible for purchasing a captivating folk-art portrait that has become a pilgrimage piece for Currier visitors, *Emily Moulton* by Samuel Miller (cat. no. 10).

The exhibitions and catalogues from Brooke's tenure were equally noteworthy and remain essential references for scholars in the field. Melvin Watts organized *Pewter in America, 1650–1900*, followed by *British Pewter, 1600–1850*. Charles S. Parsons organized *The Dunlaps and Their Furniture*, documenting for the first time the outstanding contributions of this hitherto obscure "provincial" workshop.

Brooke also persuaded trustee Henry Melville Fuller to exhibit sixty works from his collection of nineteenth-century American paintings, marking the beginning of Fuller's ongoing contributions to the museum. In addition to establishing a fund for the purchase of nineteenth-century American art, which enabled the museum to buy Randolph Rogers's life-size marble statue *Nydia, the Blind Girl of Pompeii* (too massive to travel) and Thomas Eakins's portrait of Florence Einstein (cat. no. 24), Fuller has given paintings by Asher B. Durand (see cat. no. 14) and Frederic Edwin Church (see cat. no. 11). Equally important, Fuller was among the first collectors to seek out unusual, lesser-known artists such as Lily Martin Spencer (see cat. no. 13) and William Holbrook Beard (see cat. no. 16), whose charming genre scenes add special character to the collection.

Robert M. Doty (director, 1977–87), who was educated at Harvard University and served as curator at the Whitney Museum of American Art and director of the Akron Art Museum, combined an interest in contemporary art and photography with a passion for folk art. In addition to organizing several exhibitions and symposia on New England folk life and Shaker furniture, he and curator Marilyn F. Hoffman presented the exhibition *Heirlooms, Historical Art, and Decorative Arts from New Hampshire Collections*. Most of the folk art in the Currier's collection was acquired by the museum during Doty's tenure.

The Doty years also reinforced the Currier's dedication to American decorative arts. The capstone of curator Melvin Watts's career was a 1979 exhibition and catalogue titled *Eagles, Urns, and Columns: Decorative Arts of the Federal Period*. His successor for five years, Philip Zimmerman, is a highly regarded specialist in the field who is now senior curator at the Winterthur Museum in Delaware.

The Currier's present director, Marilyn F. Hoffman, who assumed her position in 1988, and former curator Michael Komanecky continued to augment the American art holdings with the purchase of fine objects, such as the intricately inlaid Herter Brothers cabinet (cat. no. 48), and the acquisition of an entire house and furnishings by Frank Lloyd Wright from the estate of Isadore and Lucille Zimmerman. It is rare to find a museum of any size that can include a completely furnished and landscaped Wright house in its inventory of American art.

Hoffman's contributions to the future of the Currier extend beyond the collections to the institution itself. She and the present board of trustees were well aware that the 1929 building and a 1982 addition, consisting of two pavilions designed by Hugh Hardy, were not adequately climate-controlled. The icy winters and humid summers of New Hampshire presented an increasing threat to maintaining the collections and made it difficult to borrow objects from individuals and institutions accustomed to state-of-the-art conservation standards.

Despite the recent economic downturn in New England, Hoffman and the trustees have overseen a successful capital

campaign designed to ensure the future of the collections and the exhibition program. Turning the necessity of closing the galleries during renovation into an opportunity, she and her curatorial team have selected the finest examples of work by artists and artisans from the seventeenth through the early twentieth century to create *American Art from The Currier Gallery of Art* and this handsome catalogue, which provides a long-overdue guide to the collection. By bringing the museum's treasures to new audiences, we are assured that the Currier Gallery of Art will become more widely known as one of New England's finest museums.

THE CATALOGUE

Painting
and Sculpture

I | JOHN SINGLETON COPLEY (1738–1815)

John Greene, ca. 1769

Oil on canvas; 49⅛ x 39½ in.
Currier Funds, 1935.4

In commissioning John Singleton Copley to paint his portrait, the thirty-eight-year-old Boston merchant John Greene (1731–1781) sought the services of the most talented and successful painter in the city. During the years preceding this portrait, Copley had painted such notable residents of Boston as Nicholas Boylston, John Hancock, and Joseph Warren; his work was in such demand that he was able to command fourteen guineas for a three-quarter-length portrait such as this one.

Yet among Copley's sitters, John Greene was not an especially wealthy man—his income has been estimated at less than five hundred pounds a year. Copley characterizes him as a man of affairs, showing him in a setting he used for many of the other businessmen he painted in the late 1760s. As he had done with the fabulously wealthy Hancock in 1765, Copley posed Greene at a cloth-covered table, with a ledger and a pewter inkstand before him, his quill pen in his hand. But here the ledgers are small, and the trappings of success are modest. Greene sits in a simple Queen Anne chair, not an elaborately carved Chippendale; he wears neither a wig (the most expensive part of an eighteenth-century gentleman's costume, and thus an emblem of wealth) nor powder in his hair. His suit, a blue frock coat with matching waistcoat and breeches, trimmed with gold braid, is handsome and fashionable, yet a far cry from the opulent brocades and velvets worn in the portraits of Nicholas Boylston, Nathaniel Sparhawk, and other extremely wealthy merchants of Greene's day.

Despite his relatively modest means, Greene was active as a philanthropist. He was for many years a vestryman at Trinity Church in Boston and served as an administrator of the Greene Foundation, a fund for the support of assistant ministers of that church. He was also an active member of the Charitable Society, a Boston social club dedicated to good works. Copley suggests Greene's noble character by recording him with bright eyes and a genial expression; his posture—he sits erect and leans forward slightly in his chair—connotes a man of action and decision.

Copley also painted Greene's wife, Catherine, in 1769 (fig. 3). As was often the case in this era, the portraits were most likely conceived as a pair, yet husband and wife are not related by either setting or gesture. John Greene is seated in the kind of imaginary interior Copley used for many male portraits, a space whose importance—and by association, the importance of the sitter—is suggested by the massive column and the swag of drapery behind the table. In contrast, Catherine Greene stands before a fictional landscape, one hand at her face (to draw attention to her unbound hair, adorned with pearls and draped languorously across her shoulder), the other holding the silk wrap that forms the outer layer of her loosely draped gown. Copley here follows eighteenth-century custom in associating the male with the world of business and the female with the world of nature; his perceptive characterization of John Greene and his sensuous rendering of Catherine elevate the portraits above the conventional.

Reference:

Jules David Prown, *John Singleton Copley,* 2 vols. (Cambridge, Mass.: Harvard University Press, 1966), vol. 1, pp. 71–72.

C. T.

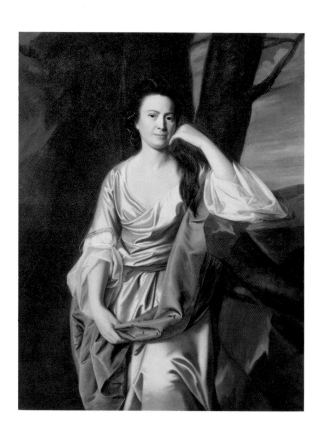

Fig. 3
John Singleton Copley. *Mrs. John Greene,* 1769.
Oil on canvas, 49½ x 39¾ in. The Cleveland Museum of Art,
Gift of the John Huntington Art and Polytechnic Trust, 15.527

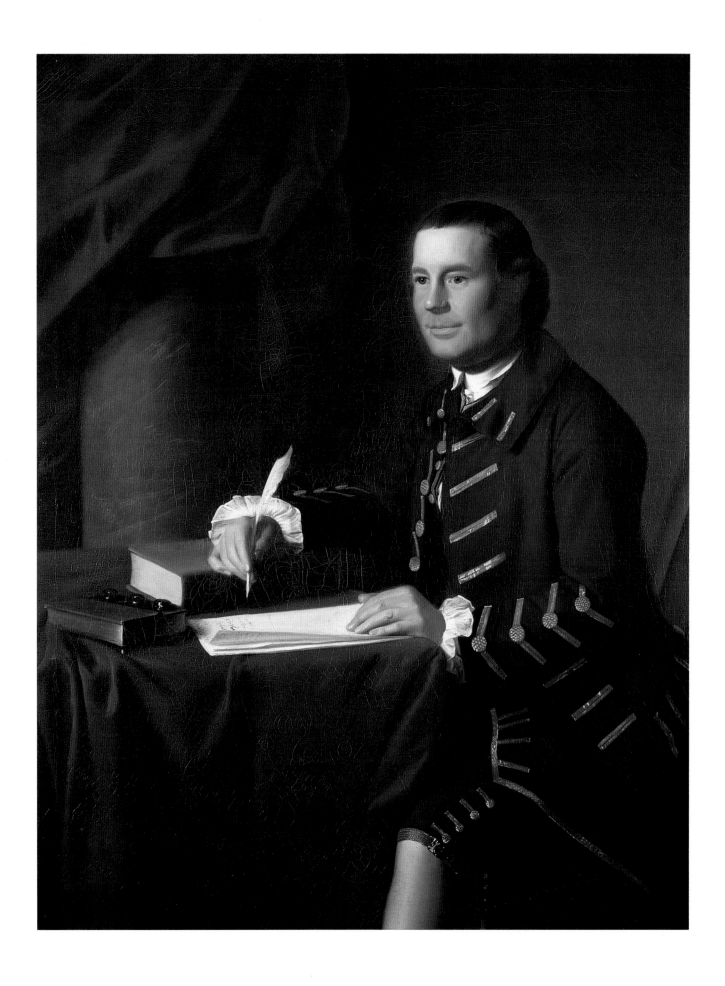

2 | GILBERT STUART
(1755–1828)

Dr. Walter Landor, ca. 1785

Oil on canvas; 28¼ x 23¼ in.
Currier Funds, 1934.3

Gilbert Stuart's development as a newly arrived portrait painter in England was nothing less than extraordinary. The work he produced in Newport, Rhode Island, in the early 1770s on his own and under the tutelage of Scottish painter Cosmo Alexander was flat, linear, and somber in tonality—awkward, if sometimes charming. But shortly after arriving in London in 1775, he found a place in the studio of the benevolent expatriate Benjamin West, who nurtured Stuart's natural talent for painting faces and who introduced him to the artistic and social luminaries of late eighteenth-century London. Stuart quickly mastered the painterly, atmospheric manner of the fashionable British portraitists of his day. His sophisticated style and engaging manner won him important commissions, and after the triumph of *The Skater* (1782; National Gallery of Art, Washington, D.C.) at the Royal Academy exhibition of 1782, he was able to compete successfully for portrait business in a market that included such masters as Sir Joshua Reynolds and George Romney. In 1787, he left London for Dublin, where he spent five years, returning to the United States (one step ahead of his creditors, for he spent money even faster than he earned it) in 1792 to become the painter of presidents.

The painting *Dr. Walter Landor* was probably executed in the mid-1780s, at the height of Stuart's London career. Landor (1732–1805), an Oxford-trained physician, was in his fifties when he sat for Stuart. He was a prominent landowner in both Staffordshire and Warwickshire and had a large family: five children by his first wife, Mary Wright, who died in 1769, and seven more by his second wife, Elizabeth Savage, whom he married in 1774. The oldest son of the second marriage was the noted British poet and critic Walter Savage Landor.

As was typical of Stuart's portraiture, his image of Landor reveals little of the sitter's personal history. There is no allusion to his profession, his property, or his progeny: rather, the focus is almost entirely on his face. Landor is shown at half-length, against a freely painted pinkish sky. His expression is serious but not forbidding, characterized by firmly set lips but also by alert blue-gray eyes and a ruddy complexion. He wears a rich, deep blue jacket generously ornamented with gold buttons and braid, a butter-colored vest, and frothy jabot—a costume conceived both as a complement to the sitter's pleasing coloring and a demonstration of the painter's skill. Fabric and especially flesh are painted with thin translucent tones so that, despite the conventional pose and generalized setting, the image seems luminous and animated. Later in life, Stuart would describe his method to the young painter William Dunlap: "Good flesh coloring [partakes] of all colors, not mixed, so as to be combined in one tint, but shining through each other, like the blood through the natural skin." This portrait is an idealized likeness of a man of distinction; in Stuart's facile hands, Walter Landor also becomes a living, breathing presence.

Reference:

William Dunlap, *A History of the Rise and Progress of the Arts of Design in the United States,* 1918 ed., 3 vols. (Boston: C. E. Goodspeed & Co., 1834), vol. 1, pp. 192–263.

C. T.

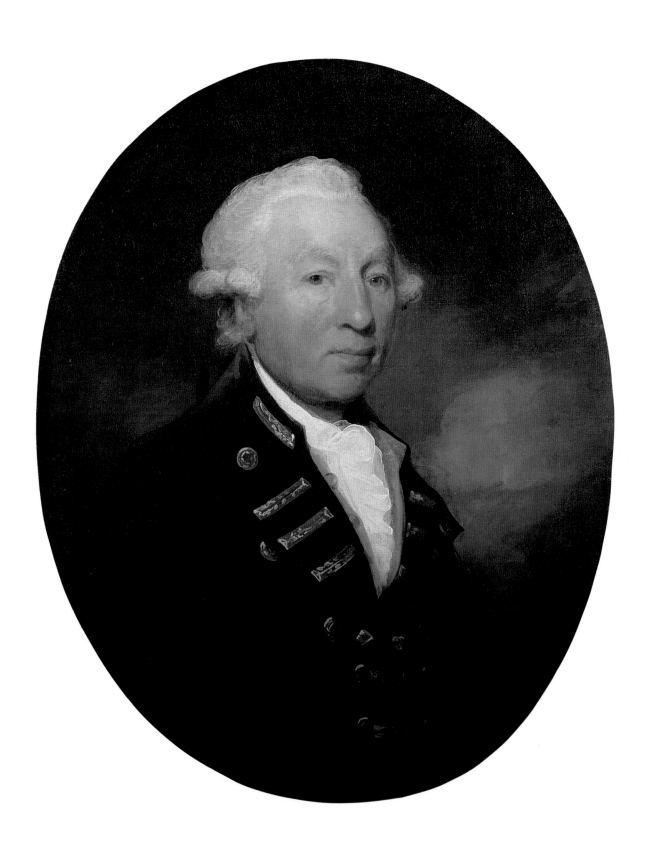

ARTIST UNKNOWN

Charlotte Weeping over the Tomb of Werter, ca. 1807–25

Watercolor and ink on paper; 11 x 13⅜ in.
Inscribed in lower margin: "Charlotte Weeping over the Tomb of Werter"; inscribed on reverse: "Cordelia Hale"
Museum purchase: gift of the friends, 1985.23

When Johann Wolfgang von Goethe's *The Sorrows of Young Werther* was first published in Leipzig in 1774, it created a sensation throughout Europe, inspiring numerous paintings and drawings, musical compositions, a vogue for "Werther costume," and, tragically, the suicides of countless young men who modeled themselves after the unfortunate hero. Werther, a young poet, falls passionately in love with Charlotte, a married woman, whose sense of honor prevents her from returning his affections. At the end of the novella he shoots himself, leaving Charlotte to mourn over his grave.

By the early nineteenth century, Goethe's story had become popular in America too, advancing the burgeoning romantic movement. It found a special audience among refined young women, whose education in "female academies" included instruction in watercolor and needlework, and who illustrated many scenes from the Goethe novella in those mediums. The Currier watercolor is one of four nearly identical illustrations of this melancholy scene from the novella. One, in the collection of the Abby Aldrich Rockefeller Folk Art Center at Colonial Williamsburg, is slightly larger than the Currier's and shows more foliage at left, as well as an elaborate scalloped aureole surrounding the solicitous angel. A second example is owned by the Corning Museum of Glass in Corning, New York; a third version, formerly in the famed Edith Halpert folk art collection, has not been located. All of them may have been inspired by an engraving that appeared as the frontispiece of a popular edition of the story, translated by a "Dr. Pratt" and published in New York in 1807. Like the print, these watercolors all feature Charlotte, hand to heart, kneeling on Werther's grave, with a Gothic church—a frequent attribute of mourning pictures—in the background. The landscape forming the left third of the watercolor is not included in the illustration, however; neither is the angel hovering over the grieving Charlotte. It may be that these features derive from another, as yet unidentified, print.

Although the other versions have not been associated with any named artist, the Currier's watercolor has been attributed to the Connecticut painter Eunice Pinney (1770–1849), probably because she painted two of the earliest, and best known, illustrations from *Werther: Lolotte and Werther* (fig. 4) and *Charlotte's Visit to the Vicar* (private collection). The tiny, feathery strokes characteristic of her style are not apparent in this watercolor, however, which makes artful use of a variety of brush strokes—long, sweeping arabesques in Charlotte's dress and hair, little hatching strokes in the stream by her feet, and—most enchantingly—a mottled effect (possibly produced by applying the watercolor with a sponge) to describe the foliage surrounding the Gothic church. The result is a rich variety of textures and linear patterns that make this one of the most charming and technically inventive watercolors in the Currier's collection.

Reference:

Beatrix T. Rumford, ed., *American Folk Paintings: Paintings and Drawings Other Than Portraits from the Abby Aldrich Rockefeller Folk Art Center* (Boston: Little, Brown and Company, 1988), pp. 217–18.

C. T.

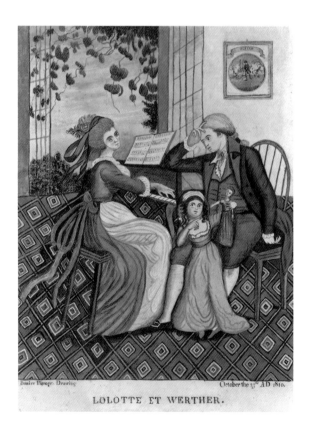

Fig. 4
Eunice Pinney. *Lolotte and Werther,* dated 1810.
Watercolor, 14⅞ x 11½ in. National Gallery of Art, Washington, D.C.
Gift of Edgar William and Bernice Chrysler Garbisch, 1967

AMMI PHILLIPS
(1788–1865)

Abraham Sleight, ca. 1823–25

Oil on canvas; 29¾ x 23¾ in.
Gift of Robert L. Williston in loving memory of his wife,
Marian J. Williston, descendent of the sitter, 1982.27.1

Ruth Roe Sleight, ca. 1823–25

Oil on canvas; 29¾ x 23¾ in.
Gift of Robert L. Williston in loving memory of his wife,
Marian J. Williston, descendent of the sitter, 1982.27.2

Ammi Phillips painted Ruth Roe Sleight (1758–1833) and her husband, Abraham (1755–1842), when they were in their sixties. Prosperous farmers and devout members of the Dutch Reformed Church, the Sleights were descendents of immigrants from Holland. Their forebears were among the first settlers of Dutchess County, New York, and their own ancestral histories were linked with those of the region. Abraham served three enlistments with the Dutchess County militia during the Revolutionary War and subsequently became an important landholder in the county. He married Ruth Roe in 1782; she bore eight children. They were a part of the local gentry of the town of Fishkill, and like many of their neighbors they were willing to pay Ammi Phillips's not inconsiderable charge of twenty dollars per pair to be commemorated in a style that was the height of fashion among rural New Yorkers.

Phillips was a Connecticut-born portrait painter who traveled extensively throughout western Connecticut and Massachusetts and along the Hudson River in New York State during his more than fifty-year career. The paintings of the Sleights exemplify Phillips's realistic manner of the 1820s—a period in which his ability to model facial features came closest to academic standards, and in which he began to subordinate the more decorative aspects of his portraits, such as showy accessories and colorful costumes, to a careful rendering of hands and face. Phillips's sitters often appear quite somber; to the modern eye, his realism can seem harsh and unflattering. In his portrait of Mrs. Sleight, Phillips even included a cyst or wen on the subject's mouth. The Sleights are shown at waist length (a format that by about 1820 had come to be preferred to the old-fashioned three-quarter-length view) and facing one another, but with their heads turned slightly to address the viewer. They are seated in matching fancy painted side chairs, with faux graining and gilt striping on the stiles, a furniture style that was newly fashionable in provincial areas during the 1820s. As is typical of Phillips's portraits during this period, the Sleights are posed against muted backgrounds and dressed in sober-colored costumes that are nonetheless rendered with careful attention to detail: Abraham's stock is crisply painted, and Ruth's lace cap is delicately translucent. Each holds a prop intended as a clue to a character trait: Abraham's fingers mark his place in the "Scott's Bible Gen Jos Vol I," as though the viewer interrupted his study of Scripture. Ruth holds a pair of knitting needles and a ball of wool, tokens of domestic industry meant to suggest that she was never idle.

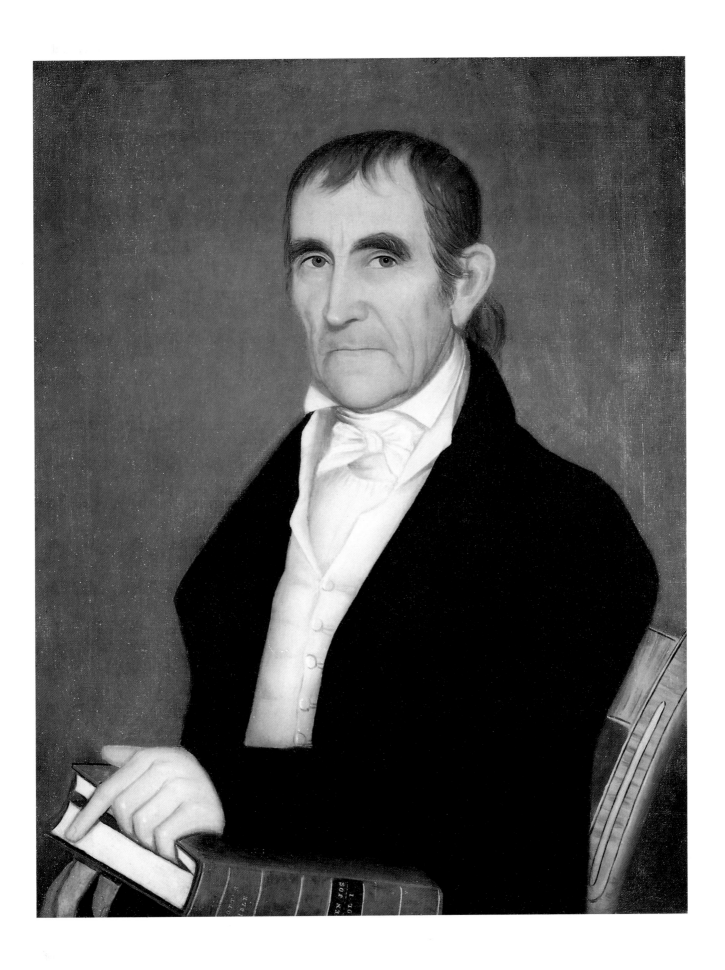

27

During his sojourn in the Fishkill area, Phillips painted a number of other Sleight relations: Abraham's brother John, also of Fishkill; John's wife, Aeltie; and their daughter Sarah Ann, who married into the prosperous De Witt family, many of whose members Phillips also painted. (A number of these paintings are owned by the Senate House State Historical Site, Kingston, New York.) Like the portraits of the Sleights, these pictures are unadorned but are at the same time carefully conceived images that convey the social status of these country squires: sitting in new Hitchcock or other fancy chairs, in stylish costumes, with appropriate books and needlework, their virtue is proclaimed to be unimpeachable, their social position secure.

Just as in the 1760s Copley dominated portrait painting in New England and forged an image of the nobility sitting in high-style Chippendale chairs and wearing fine silks and velvets, fingering exotic blossoms or consulting ponderous ledgers, in the 1820s Phillips became the painter to the well-to-do of Dutchess County. His portraits of the Sleights form part of the documentation for understanding a provincial dynasty and interpreting its cultural aspirations.

Reference:

Mary Black, "Ammi Phillips, Portrait Painter," in Stacy C. Hollander and Howard P. Fertig, *Revisiting Ammi Phillips: Fifty Years of American Portraiture* (New York: Museum of American Folk Art, 1994), p. 72.

C. T.

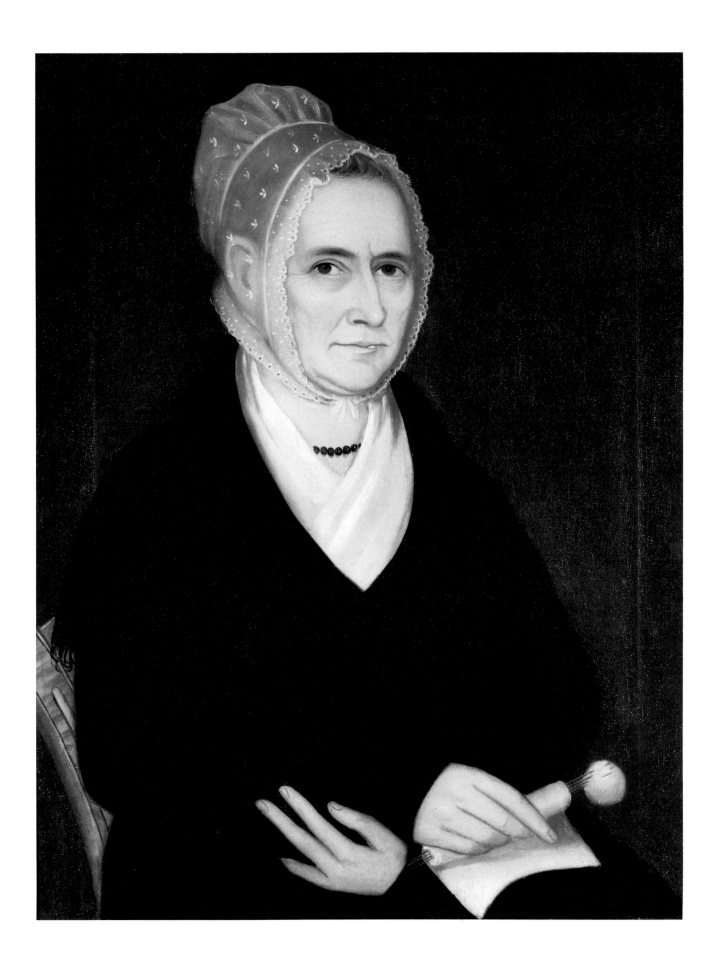

6 | "MR. WILLSON"
(active 1820s)

Levi Jones (of Union, NH),
ca. 1825

Watercolor on ragboard; 22¾ x 19⅞ in.
Gift of Elizabeth Jones, 1974.29

Much more is known about farmer and tavern keeper Levi Jones (1771–1847) than about the "Mr. Willson" who painted him. Born in Lebanon, Maine, to a family with roots in Portsmouth, New Hampshire, Jones served for a number of years (1811–22) as town clerk of nearby Milton and then (1822–24) became Representative to the General Court. It may be that he commissioned this portrait to commemorate his ascension to the latter office. Jones had extensive landholdings in Milton and also kept a tavern on the main road from Portsmouth to Wolfeboro. The sign for his tavern (fig. 5) survives; it bears the date 1810 and the Masonic emblems of keys, square, and compass. Jones was quite active in the Masonic Order, serving three times as Master of Humane Lodge number 21 (which he helped found). His involvement with the Masons was good business as well as good fellowship; his inn probably functioned as a meeting place for the lodge.

Jones was married twice, first in 1801 to Betsy Plummer of Milton, who died in 1815, and again in 1831, to Sally Wallingford of that town. Their only child, Charles Jones, was born three years later. Jones died at the age of seventy-six, in Milton.

The distinctive features of this watercolor portrait of Levi Jones—the bust-length, three-quarter view format, the facial features (including the nose, shown in profile) delineated with a single stroke of paint, the hair rendered with rhythmic, feathery strokes—are characteristic of a group of portraits attributed to a "Mr. Willson." Willson, known only from his signature on a portrait in the New York State Historical Association, Cooperstown, seems to have been active in the 1820s. He was probably from southern New Hampshire, where this and several related portraits attributed to him were found. Willson's clear, linear style was admirably suited to the strong, rugged features of Levi Jones and to his obvious taste for fashion. Jones's brightly patterned vest, pleated stock, and tight-fitting coat with velvet collar are vividly rendered; the

stylishness of his apparel, as well as his commanding expression, promote Jones's stature as a leader of his community.

References:

Paul S. D'Ambrosio and Charlotte M. Emans, *Folk Art's Many Faces: Portraits in the New York State Historical Association* (Cooperstown, N.Y.: New York State Historical Association, 1987), pp. 162–63.

Robert M. Doty, *By Good Hands: New Hampshire Folk Art* (Manchester, N.H.: The Currier Gallery of Art, 1989), pp. 2, 7.

C. T.

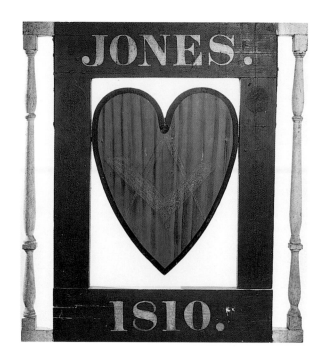

Fig. 5
Artist unknown, Milton, New Hampshire. Inn Sign, 1810.
Painted wood, applied Masonic symbols missing, 34 x 30¾ x 2 in.
The Currier Gallery of Art. Bequest of Miss Elizabeth Jones, 1976.24

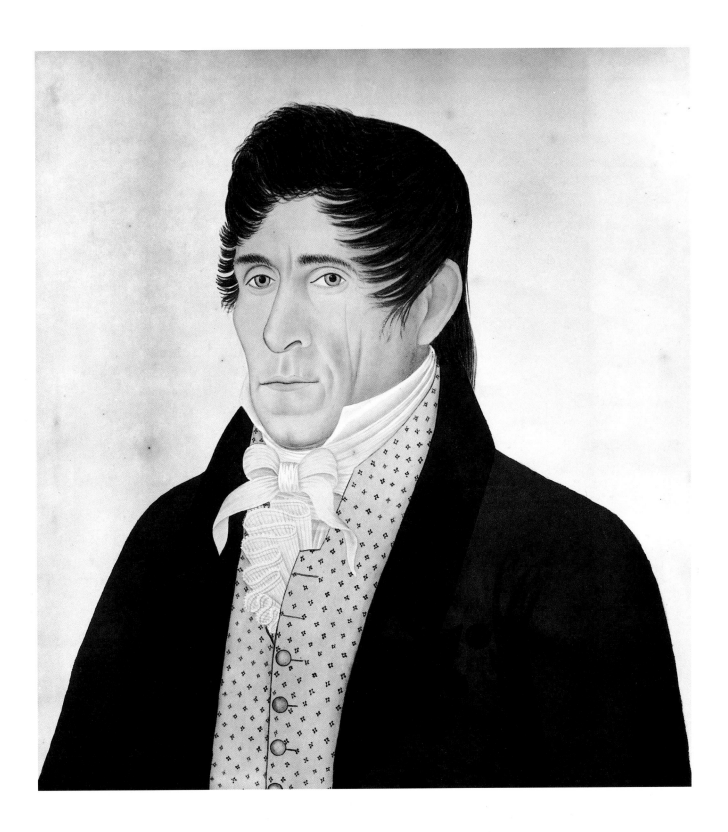

JOSEPH H. DAVIS
(active 1832–37)

Portrait of Mark, Abigail, and Lois Susan Demeritt, 1835

Watercolor, ink, and graphite on paper; 12 x 16⅛ in.
Museum purchase: gift of the friends, 1977.53

Bartholomew Van Dame, 1836

Watercolor, ink, and graphite on paper; 10 x 11⅛ in.
Signed lower left: "JOSEPH H. DAVIS./LEFT HAND-/ PAINTER"
Museum purchase: in honor of Melvin E. Watts, 1981.15

In his five years of documented activity, Joseph H. Davis painted more than 150 watercolor portraits of prosperous middle-class men, women, and children who lived along the Maine-New Hampshire border. These are immediately, and delightfully, recognizable. Adults generally are shown in gaily appointed interiors that attest to the artist's, and the era's, love of decorative patterns. Featured are colorful floor cloths and carpets, wildly grained and painted furniture, and walls ornamented with pictures, banjo clocks, mirrors, and elaborate swags of foliage. Children are shown sitting on their parents' laps or standing at their sides; when portrayed alone, they are customarily seen out-of-doors, walking ceremoniously on carpets of flowers.

Except for the course of travels deduced from his portraits, which are often inscribed with the sitters' names, ages, and places of residence, Davis remains elusive. Recent scholarship has connected him with one Joseph H. Davis from Limington, Maine, who lived from 1811 to 1865. Between 1832 and 1837, the artist worked from Wakefield, New Hampshire, in the north to Lee in the south, and on both sides of the border with Maine, but little else is recorded about him. His name was discovered in 1943 on the watercolor portrait of the Lee, New Hampshire, minister and schoolteacher Bartholomew Van Dame, which in the lower left corner bears the inscription "JOSEPH H. DAVIS./LEFT HAND-/PAINTER." His left-handedness, a trait he shared, and presumably discussed, with Van Dame, is virtually the only personal characteristic known.

Van Dame (1807–1872) sits at a broad, grain-painted table, strewn with books, that also holds an inkwell and quill pen and a lighted candle, implements that allude to his life as a preacher and scholar (he was especially well known for proficiency in mathematics). Like many of Davis's other sitters, he is represented in profile, leaning back, with legs stretched forward in a pose that precisely follows the line of his painted Empire-style side chair. Davis's love of decoration is seen in the inventively patterned rug, the tin box with scallop-edged lid, and—in lively contrast to Van Dame's somber black suit—a spotted vest and socks. The inscription appearing below the image, ornamented with numerous calligraphic flourishes, is recorded in what New England writing masters taught as the Italian Hand. The backward slant of some of the letters may be the result of Davis's left-handedness; it could equally well be yet another decorative elaboration.

The members of the Demeritt family, Van Dame's contemporaries in nearby Farmington, New Hampshire,

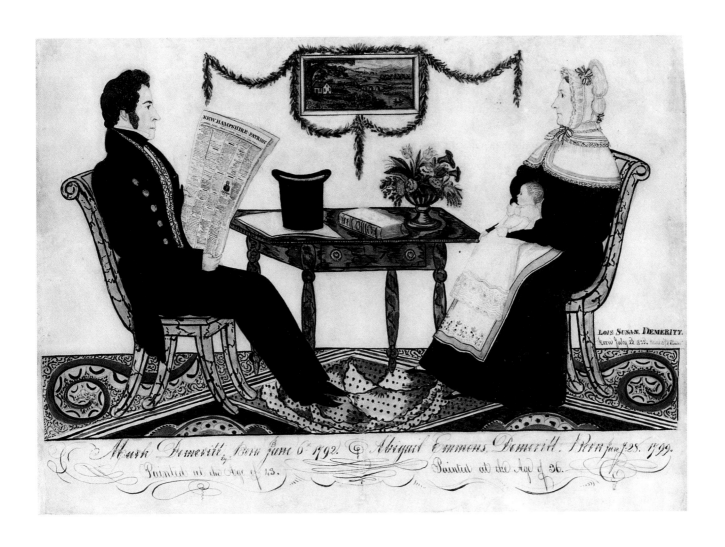

Mark Demeritt, Born June 6 1792. *Abigail Emmons Demeritt, Born June 28. 1799.*
Painted at the Age of 43. *Painted at the Age of 36.*

were painted the previous year, when, as the inscription at the bottom of Davis's portrait of them indicates, Mark (1792–1875) was forty-three; his wife, Abigail (1799–1881), thirty-six; and daughter Lois Susan, a newborn. In 1835 and 1836, Davis would paint other Demeritts—Isaac T., age twenty-four; John F., age thirty-two, and his younger brother Samuel H., age twenty-five, of Barrington, New Hampshire; and Thomas, age sixty-seven, and Sally, age fifty-seven, of Northwood, New Hampshire. Such a sizable number of commissions from one family was rare, though not unique, in Davis's career, and for an artist who is reported to have earned only $1.50 per portrait, the connection with the Demeritt family must have been welcome.

As in the Van Dame portrait, the Demeritts are shown in profile. They face one another in a rigorously balanced arrangement; Mark Demeritt, a magistrate, selectman, and member of the state legislature, holds the *New Hampshire Patriot* while Abigail Demeritt holds the baby. On the grain-painted table in front of him is a top hat, while she sits before a vase of flowers. On the wall behind them hangs a handsome landscape painting featuring a little riverside cottage beneath an enormous tree. Such landscapes, usually invented by the artist rather than based on observation, were often repeated from one portrait to another—the Demeritts' landscape echoes, with minor variations, the painting on the wall in a portrait of Joseph and Sarah Ann Emery of Limington, Maine (1834; New York State Historical Association, Cooperstown). These fanciful scenes signaled the sitters' status as landowners and enhanced the cozy domesticity of Davis's family portraits.

References:

Gail and Norbert H. Savage and Esther Sparks, *Three New England Watercolor Painters* (Chicago: Art Institute of Chicago, 1974), pp. 58, 63.

Arthur and Sybil Kern, "Joseph H. Davis: Identity Established," *The Clarion* 14 (Summer 1989), pp. 45–53.

C. T.

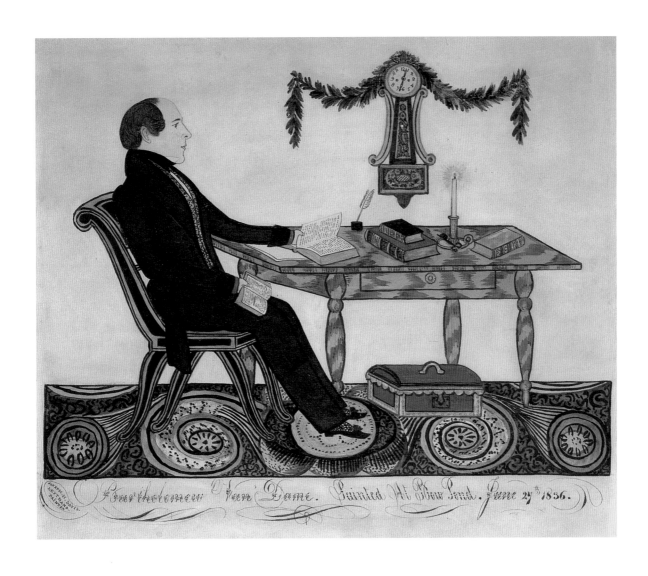

Bartholomew Van Dame. Painted At New Sena. June 27th 1836.

9 | THOMAS COLE
(1801–1848)

Landscape with Tower in Ruin, 1839

Oil on canvas; 22½ x 18⅝ in.
Signed and dated lower left: "T. Cole/1839"
Museum purchase: gift of the friends, 1980.7

Thomas Cole visited Boston in 1837 and secured several orders for pictures. In his list of commissions, Cole identified *Landscape with Tower in Ruin* with the terse notation: "To be painted for Mr. Eliott [Samuel Atkins Eliot (1798–1862), Boston's mayor between 1837 and 1839, later a member of Congress, and father of Charles W. Eliot, future president of Harvard University] the mayor of Boston a small upright picture 22½ by 18½ inches seen in the frame—my own choice of subject." For this, he chose to paint a reprise of the central portion of his allegorical work *The Past*, which, with its pendant *The Present* (1838; Mead Art Museum, Amherst College, Massachusetts), had been exhibited in New York City to much acclaim in December 1838.

Upon receiving the painting in October 1839, the mayor wrote to Cole to express his pleasure: "This time your anticipations were perfectly right & have been fully realized. The picture is very beautiful, & suits me exactly. It has been already much admired & I promise myself much pleasure from examining it more carefully than I have yet had time to do. I shall be ready to honor your draft for $300 whenever you send it." Although Cole's work had been seen in Boston before, *Landscape with Tower in Ruin* did much to enhance the artist's reputation in that city, owing in part to the prominence of its owner and his willingness to place the picture on public view. In 1842, it was the only painting by Cole to be included in the Boston Artists' Association's group exhibition at Harding's Gallery, but it must have excited a fair measure of interest there, for the next year, Cole's works—including his celebrated *The Voyage of Life*—dominated the show.

In *Landscape with Tower in Ruin,* the view Cole presents is imaginary and, as do many of his compositions from this period, draws upon settings observed in Europe and America while tapping into the vogue for the Gothic style then sweeping the country. The tower's pointed arches and quatrefoil piercings are Italian Gothic; the goatherd in the center foreground is a figure type that occurs frequently in Cole's Italian views. Yet the autumn foliage, and particularly the twisted oak at lower left, evoke American scenery, as does the distant prospect of the river.

The theme, too, was a favorite of Cole's, who in canvas after canvas paired the wonders of the natural world with human creations to relate, in his words, the "decaying grandeur" of the "storied past." The tower, a motif Cole used to symbolize man's vain ambitions, was once glorious; here, its heroic contours have been broken down by assaults from rain, wind, and sun, and it is overgrown with vines. Once the fortress of powerful armies, it has become the home of a flock of birds, and a herd of goats grazes peacefully at its base. In the foreground, a goatherd (himself a creature of nature), gazes at the once majestic token of human achievement silhouetted against a golden sunset. In some of Cole's canvases, this theme—nature's surpassing power and the futility of human ambitions—is presented as a stern moral. Here, however, the intimate scale and tender palette create a nostalgic image of pastoral serenity and innocence.

Reference:

Bruce W. Chambers, "Thomas Cole and the Ruined Tower," *The Currier Gallery of Art Bulletin*, 1983, pp. 2–32.

C. T.

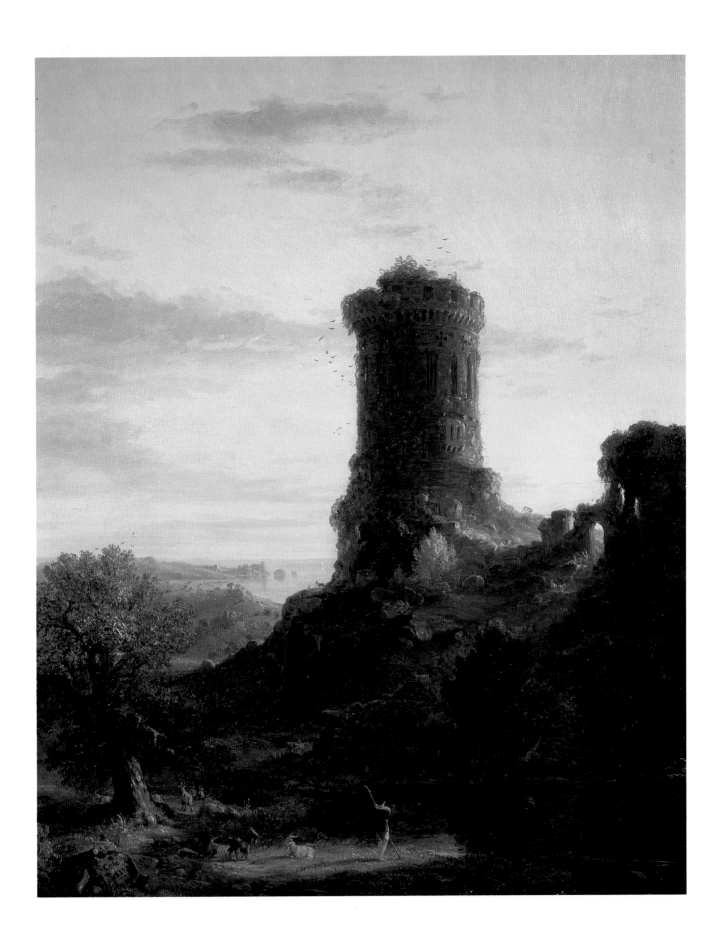

37

SAMUEL MILLER
(ca. 1807–1853)

Emily Moulton, 1852

Oil on canvas; 40¾ x 27⅝ in.
Inscribed on reverse (before relining): "Painted in 1852 by
Mr. Miller who lived on the South Corner of Pearl and Bartlett
Streets, Charlestown, Mass., U.S.A."
Currier Funds and Ruth W. Higgins Memorial Fund, 1976.27

Middle-class Bostonians of the 1840s and 1850s had many artists to choose from if they wanted to have their portraits painted. They could hire Chester Harding or Francis Alexander for a formal portrait in the tradition that stretched back to Gilbert Stuart and, before him, to John Singleton Copley. They could hire William Matthew Prior (or a member of his large workshop) for an academic picture or, if they wished to economize, for "a likeness without shade or shadow at one quarter price." They also could hire Samuel Miller of Charlestown, Massachusetts, who (if the seventeen or so portraits now ascribed to Miller are a fair sample) specialized in full-length portraits of children, often shown with family pets and stylized flower arrangements. The painting *Emily Moulton,* a full-length likeness of a little girl in a black dress and black lace-up slippers, with blue ribbons in her hair and a red book in her hand, is his masterpiece.

The inscription on the back of *Emily Moulton* identified the artist of a group of portraits that feature flat, frontal, stiffly posed figures, generally with full-cheeked, squarish faces and prominent ears. (The blue-green tinge to the flesh tones in these portraits, probably coming from the underpaint with which Miller prepared his canvases, is also typical.) Details of costume and accessory clearly delighted Miller, who in *Emily Moulton* took special pains with the figure's red patterned stockings, her lace pantaloons, her bracelet, and the double strand of beads at her neck. The portrait's delightful decorative quality is enhanced by the fanciful landscape visible through the window at right, and on the window ledge, the equally fancifully shaped urn holding a cheerful arrangement of garden flowers.

According to family history, the sitter in this portrait is Emily A. Moulton of Charlestown, Massachusetts. Emily was one of five children of Andrew and Anne Moulton, and the second of four girls. She was born in 1834 and, if this is indeed Emily, would have been eighteen years old when this portrait was painted. Clearly the sitter here is younger than eighteen, raising the question as to whether the portrait in fact represents one of the younger Moulton daughters or shows someone else entirely.

References:

J. G., "Recent Acquisitions: Samuel Miller," *The Currier Gallery of Art Bulletin,* 1977, p. 27.

Paul S. D'Ambrosio and Charlotte M. Emans, *Folk Art's Many Faces: Portraits in the New York State Historical Association* (Cooperstown, N.Y.: New York State Historical Association, 1987), pp. 111–17.

C. T.

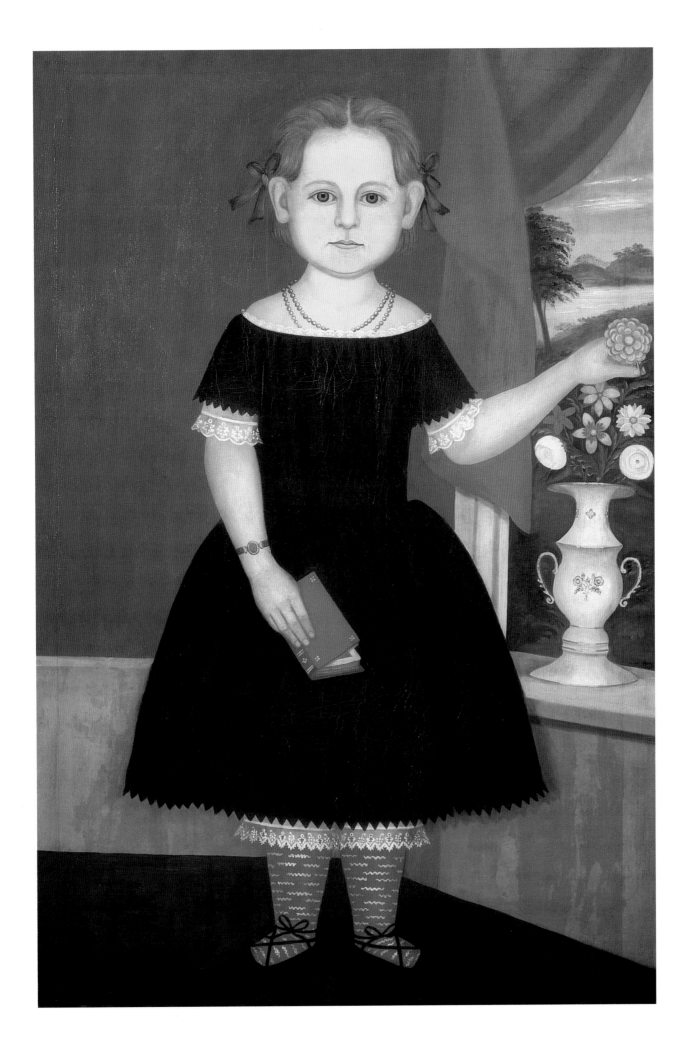

FREDERIC EDWIN CHURCH (1826–1900)

South American Landscape, 1856

Oil on canvas; 14⅜ x 21¼ in.
Signed and dated lower right: "F E Church /-56"
Gift of Henry Melville Fuller, 1981.68

In 1853, Frederic Church made his first visit to South America, where he found the subject matter that would catapult him to international fame. The snow-capped mountains, erupting volcanos, and vast, unsettled plains were the sources of images of a sublime and primeval wilderness that delighted and amazed his fellow New Yorkers. The details of the landscapes—exotic flowers, trees, and vines, brightly colored birds and strange animals, and picturesque natives—were equally fascinating when rendered in Church's clear, sparkling style. The best known of these images—*The Heart of the Andes* (1859; The Metropolitan Museum of Art, New York) and *Cotopaxi* (1862; Detroit Institute of Arts)—were mammoth in scale and spectacularly dramatic in their imagery. But in the years just following the 1853 voyage, Church also painted a series of pictures with a domestic scale and lush, pastoral imagery that were equally persuasive of South America as a natural paradise.

The painting *South American Landscape* was one of a pair of pictures Church executed for the collector John Earl Williams; the companion piece, *North America* (now lost) was an autumnal scene. This painting, presumably based on sketches Church made on his five-month trek through Colombia and Ecuador, seems not to represent any particular place, but rather combines elements from various settings to create an image that is placid and picturesque. The foreground is rich with luxuriantly colored foliage, each leaf of jungle vine and flower painted with eye-catching precision. The figure on a burro, moving slowly across the bridge toward a thatch-roofed hut, provides local color and directs the viewer's eye toward the infinitely receding plane and the chain of mountains and towering bank of clouds on the horizon.

The Indian and the hut occur in a number of other pictures by Church, where they are generally dwarfed by the tropical vegetation and so indicate the insignificance of human endeavor against the grandeur of nature. Here, they are surprisingly large and prominent in the composition, and as such carry a different message. The figure is a witness to

the natural splendor spread out before him (and in his gaze at the spectacular vista he mirrors Church's own awe at discovering such scenery); at the same time, enveloped by the same golden light and painted with the same delicate touch, he is a participant in it. This harmonious coexistence between man and nature is, in the romantic language of Church's day, a token of an edenic world, bountiful and unspoiled.

Reference:

David C. Huntington, *Frederic Edwin Church* (Washington, D.C.: National Collection of Fine Arts, Smithsonian Institution, 1966), p. 61.

C. T.

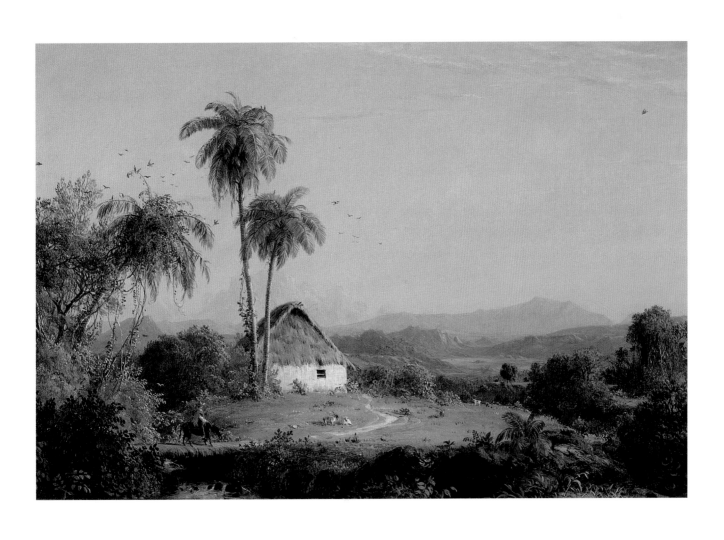

| # JASPER FRANCES CROPSEY (1823–1900)

An Indian Summer Morning in the White Mountains, 1857

Oil on canvas; 39¼ x 61¼ in.
Signed and dated lower left: "J.F. Cropsey N.A./1857"
Currier Funds, 1962.17

The painting *An Indian Summer Morning in the White Mountains* established Jasper Cropsey's reputation in the English-speaking art community and was his rehearsal for what would be the greatest success of his career. It was made in England, where Cropsey had settled in 1856, and, although probably based on sketches done on an earlier tour of the White Mountains, it was clearly a studio picture, a composite of several sites. Cropsey first displayed the painting at the spring 1857 exhibition of the Royal Academy of Arts in London; in the catalogue, the picture's description was accompanied by lines from Henry Wadsworth Longfellow's poem *Evangeline* ("Filled was the air with a dreamy, magical light . . ."). The work was the English public's first exposure to Cropsey's autumnal palette (which critic John Ruskin at first regarded with suspicion but then came to praise for its "radiant truth"). It was also one of the first large-scale, dramatic views of the American wilderness to be shown abroad, and the British were enthralled. Critics called Cropsey an "excellent American painter" and hailed the picture's brilliant color, crisp detail, and especially the water, which was seen as particularly skillfully rendered. J. S. Morgan, the expatriate financier and collector, bought the painting a few months later for one thousand dollars, the highest price Cropsey had yet received. This success emboldened the artist to paint another wilderness view, similarly composed and colored but bucolic rather than wild, and to present it not in a gallery but as a "Great Picture" in his own studio. *Autumn—On the Hudson River* (1860; National Gallery of Art, Washington, D.C.) enjoyed an extraordinary reception, earning Cropsey a space in the art section of the prestigious London International Exhibition of 1862 and an audience with Queen Victoria.

In *An Indian Summer Morning in the White Mountains,* Cropsey depicts the White Mountains as a primeval paradise. The rising sun illuminates a varied prospect: there is a snow-capped, craggy peak, rolling hills ablaze with autumn hues, and a briskly running mountain stream emptying into a deep, still pool that reflects the shapes and colors of the surrounding landscape. There is no sign of human presence; a few deer drink placidly from the stream at right while others nestle in the grass at left. The elemental qualities of the scene are underscored by the swirling mists and the deep shadows cast by the low sun: this is an untouched, wild, sublime place, mysterious and, for the English public, decidedly exotic.

It may well be the public for which he intended this picture that caused Cropsey to forgo the prevailing characterization of the White Mountains as a benign and pleasing setting for human activity. While Thomas Cole in the 1820s had shown the area as a savagely beautiful and forbidding place, the coming of the railroad to the region caused his interpretation of the White Mountains to be supplanted by a bucolic vision, popularized by John F. Kensett and others. Cropsey's return to Cole's imagery, to the White Mountains as the "forest primeval," clearly meshed with his British audience's notion of the New World. His work remained extremely sought after for the rest of his stay in England, and upon his return to the United States in 1863, he found that his celebrity and the market for his pictures had preceded him.

References:

"A White Mountains Landscape by Jasper Francis Cropsey," *The Currier Gallery of Art Bulletin* (February 1963), pp. 1–6.

Donald D. Keyes et al., *The White Mountains: Place and Perception* (Hanover, N.H.: University Press of New England, 1980), pp. 46, 88–89.

William S. Talbot, *Jasper Francis Cropsey 1823–1900* (Washington, D.C.: National Collection of Fine Arts, Smithsonian Institution, 1980), pp. 82–83.

C. T.

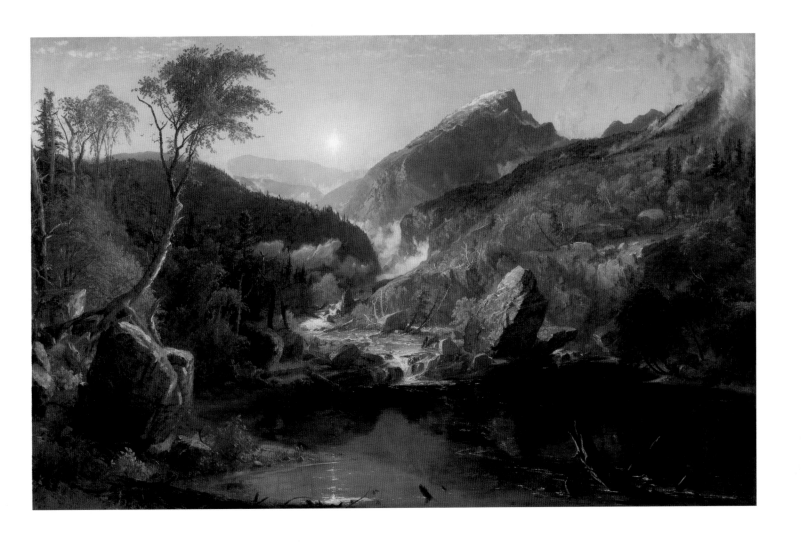

LILLY MARTIN SPENCER (1822–1902)

Listening to Father's Watch, 1857

Oil on academy board; 16 x 12 in.
Signed and dated lower left: "L. M. Spencer/1857"
Gift of Henry Melville Fuller, 1974.34

In 1848, Lilly Spencer moved with her husband and two children (there would be thirteen) from Cincinnati to New York City, where the painter soon gained renown, if not wealth, for her art. Although her first works were literary subjects drawn from Shakespeare and the like, she soon settled on the kind of amusing domestic scene for which she is known today. Drawn from her own experience, such good-natured, humorous renditions of married life as *The Young Husband—First Marketing* (1854; private collection) struck a familiar chord with her admirers, many of whom were young matrons like herself. By the end of the 1850s, her family growing, Spencer embarked on a series of works depicting family entertainments and baby games. These pictures were shown at the National Academy of Design and in other contemporary art exhibitions; many of Spencer's paintings were also reproduced in the pages of the *Cosmopolitan Art Journal*, a periodical aimed at middle-class women, who were particularly attracted to such charming nursery scenes as *Fi, Fo, Fum* (1858; private collection), *This Little Pig Went to Market* (1857; Ohio Historical Society, Columbus), and *Listening to Father's Watch*.

The painting *Listening to Father's Watch* features the artist's husband, Benjamin Rush Spencer, and her two-year-old son, William Henry, in what is, presumably, the family parlor. The father is dressed informally, in a blue patterned dressing gown, and wears carpet slippers on his feet. These are obviously not street clothes; rather, his attire is meant to underscore the coziness of the moment. Sun filters in through a lace-curtained window, lighting the father's genial face and especially the figure of the plump, rosy-cheeked little boy, whose golden ringlets, frilly white dress, and gleeful expression (though they may seem overly sentimental to the modern viewer) epitomized the joys of childhood and virtues of the family circle for Spencer's generation. The picture is rendered in bright, enamel-like colors with a high degree of finish; this vividly detailed technique, as well as the small scale, arched shape (reminiscent of sacred images), and intricate gilt frame make the painting seem gemlike, an object as precious and valued as its message.

Listening to Father's Watch is a reprise of one of Spencer's earliest compositions, *Infant and Time* (1839–41; location unknown), which a contemporary account described as showing "an infant in its mother's arms, playing with a watch held up before its eyes by a very youthful-looking father" (*Marietta [Ohio] Intelligencer,* August 26, 1841). By reducing the narrative from three characters to two, Spencer emphasizes the intimacy of the scene and casts the viewer in the role of wife and mother, who witnesses this tender moment with pleasure and affection.

Reference:

Robin Bolton-Smith and William H. Truettner, *Lilly Martin Spencer 1822–1902: The Joys of Sentiment* (Washington, D.C.: National Collection of Fine Arts, Smithsonian Institution, 1973).

C. T.

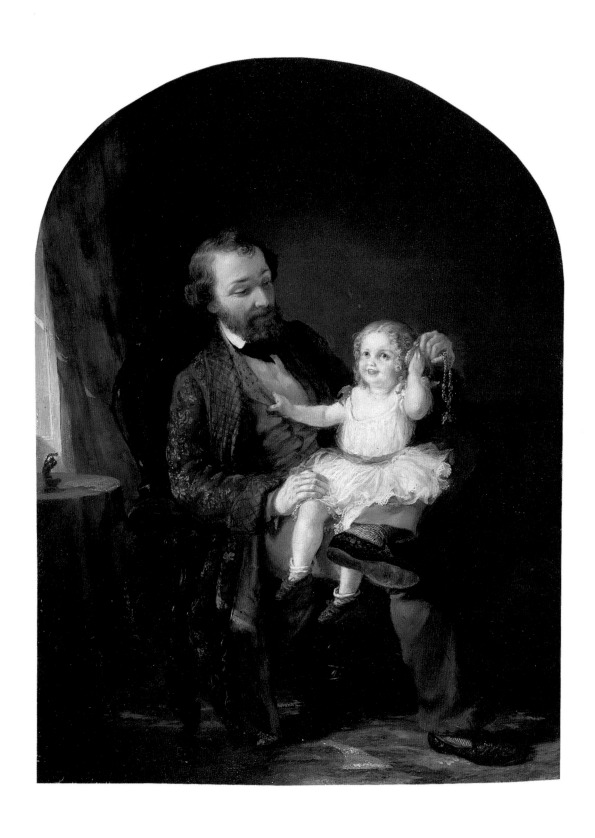

14 | ASHER B. DURAND (1796–1886)

A Reminiscence of the Catskill Clove, 1858

Oil on canvas; 40¼ x 32⅝ in.
Signed and dated lower center: "A B Durand 1858"
Gift of Henry Melville Fuller, 1988.26

Although Asher Durand's reputation was based on the straightforward, meticulous naturalism of his images, many of them were in fact frankly nostalgic and spiritual, conjuring up thoughts of simpler, more innocent times for his urban industrialist patrons. In its combination of botanically accurate detail and reverent atmosphere, *A Reminiscence of the Catskill Clove* is characteristic of Durand's landscapes of the late 1840s and 1850s. The moss-covered, rotting log in the picture's foreground is painted with precision, as are the trunks of the sycamores at left, and the granite boulders in the middle distance. Yet Durand did not simply record nature as he found it; he presented a carefully arranged view. The forest interior is shown as a vaulted space, with majestic trees arching over a tranquil stream, leading the eye to a tiny waterfall in the middle distance. The light is golden and melancholy, the atmosphere is hushed, and there is no indication of human presence. The untouched wilderness, a favorite subject of many nineteenth-century American landscape painters, is interpreted here as a natural cathedral, a place of spiritual purity and veneration.

The painting was made in Durand's New York studio following a visit to the Catskill Mountains in August 1858. It was exhibited the following May at the National Academy of Design, of which Durand, a founding member, had served as president since 1845. His subject, the Catskill Clove, an immense gorge in the heart of the mountains, and the gateway to some of the most spectacular scenery in the region, had long been favored by Hudson River school painters. Durand himself had painted the Clove several times; as early as 1848, he described it as "(rich in) beautiful wildness, beyond all we have met heretofore . . . " The Clove had also been rendered by Thomas Cole and Jasper Cropsey, among others. But whereas Cole interpreted the scene dramatically, showing a vista animated by bold contrasts of light and shadow, and Cropsey won acclaim for broad, panoramic views, Durand's vision was intimate and meditative. The composition of *A Reminiscence of the Catskill Clove* is similar to Durand's earlier successes, such as *In the Woods* (1855; The Metropolitan Museum of Art, New York), many of which had been commissioned by prominent patrons of the arts. This painting, relatively modest in size, seems to have been completed on speculation, and its history following the National Academy exhibition is unknown. The continuing popularity of Durand's vision, however, was confirmed when, the following year, the celebrated Baltimore collector William T. Walters ordered from the painter a large variant of this composition (*In the Catskills;* 1859, Walters Art Gallery, Baltimore).

References:

John K. Howat et al., *American Paradise: The World of the Hudson River School* (New York: The Metropolitan Museum of Art, 1987), pp. 103–18.

The Asher B. Durand quotation is contained in a letter to John Durand, dated 24 September 1848, reprinted in Kenneth Myers, *The Catskills: Painters, Writers, and Tourists in the Mountains, 1820–1895* (Yonkers, N.Y.: Hudson River Museum of Westchester, 1987), p. 70.

C. T.

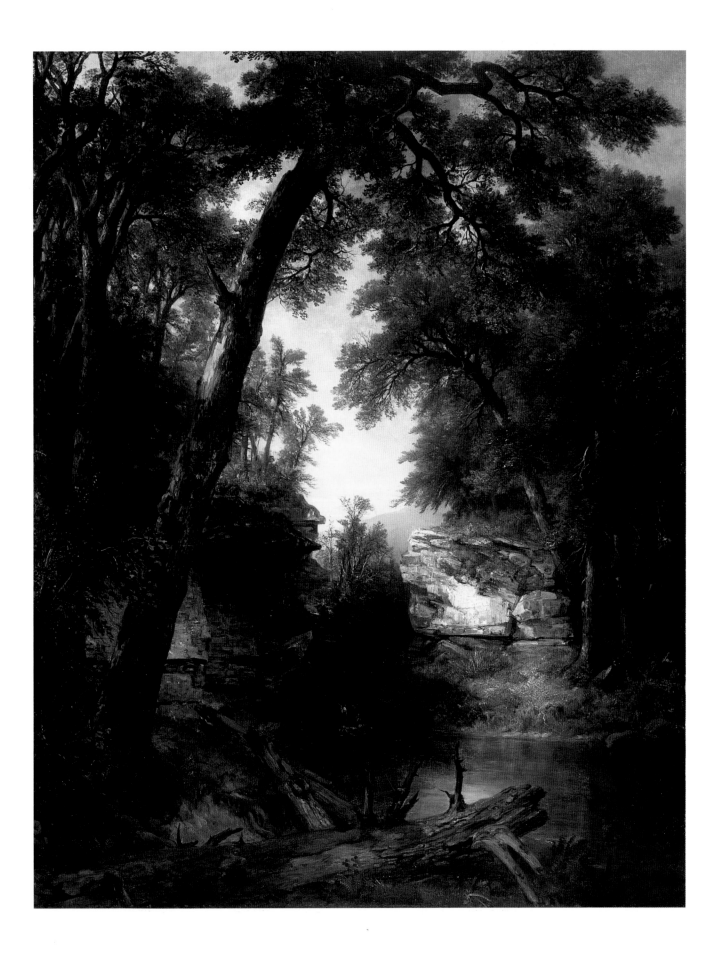

ALBERT BIERSTADT
(1830–1902)

Moat Mountain, Intervale, New Hampshire, ca. 1862

Oil on canvas; 19⅛ x 26⅛ in.
Signed lower right: "ABierstadt"
Currier Funds, 1947.3

In September 1862, Albert Bierstadt registered at the Conway House in the White Mountains, adding his name to a long roster of artists who came to paint the spectacular scenery of New Hampshire. This was Bierstadt's fifth visit to the area, and the third in as many summers. He made some of these trips with his brother Edward, who was a photographer in New Bedford, Massachusetts. Bierstadt helped his brother identify picturesque scenes to photograph; their efforts resulted in the album *Stereoscopic Views Among the Hills of New Hampshire*, published in 1862. He also sketched avidly during these summers. A number of the resulting pictures were based on Edward Bierstadt's photographs. In others, including *Moat Mountain*, the wide angle of vision, the sharply delineated foreground elements that seem to project toward the viewer, and the dramatic clarity of the space were informed by the aesthetic of the stereoscopic photograph.

Many of the artists who preceded Bierstadt in the White Mountains (for example, Jasper Cropsey; see cat. no. 12) chose to paint breathtaking peaks, plunging waterfalls, deep, forbidding forests, and other landscape elements that emphasized the wild grandeur of the region. The area surrounding Moat Mountain, however, located about seven miles northwest of Conway, seems to have called for a more serene and beautiful treatment. In the late 1850s, both Benjamin Champney and Aaron Draper Shattuck, two frequent visitors, painted small, delicate views of Moat Mountain and the Conway meadows that may have inspired Bierstadt's interpretation. (In turn, *Moat Mountain* may have influenced Champney, who in the 1870s painted at least three images of the scene from a vantage point nearly identical to that in Bierstadt's picture.) Bierstadt describes a view from Intervale southwest to White Horse and Cathedral ledges, with Moat Mountain (elevation 3,201 feet) rising in the distance. The view was described as "a suburb of Paradise" by Thomas Starr King, a contemporary travel writer, who claimed that "we have seen no other region of

New England that is so swathed in dreamy charm. A few years ago the Mote [*sic*] Mountains were ravaged with fire; and yet their lines give such delight, that few mountains look so attractive in verdure as they in desolation. The atmosphere and the outlines of the hills seem to lull rather than stimulate. There are no crags, no pinnacles, no ramparts of rock, no mountain, frown, or savageness brought into contrast, at any point, with the general serene beauty" (*The White Hills: Their Legends, Landscape, and Poetry*, 1860, p. 152).

Bierstadt paints Moat Mountain as storm clouds move past, leaving broad strips of sunlight and shadow across the valley floor. The craggy faces of the ledges are shown in crisp detail. The mountain itself emerges from the mist, its strong profile softened by the passing clouds. Wildflowers animate the immediate foreground, and trees of "aristocratic elegance" lead the eye through the expansive valley. Yet this is no untamed wilderness: the meadows in the middle distance are crisscrossed by low fences, indicating the benign and harmonious presence of civilization in the midst of this scene of natural magnificence.

References:

William C. Lipke and Philip N. Grime, "Albert Bierstadt in New Hampshire," *The Currier Gallery of Art Bulletin*, no. 2 (1973), pp. 20–37.

Catherine H. Campbell, "Albert Bierstadt and the White Mountains," *Archives of American Art Journal* 21, no. 3 (1981), pp. 14–23.

C. T.

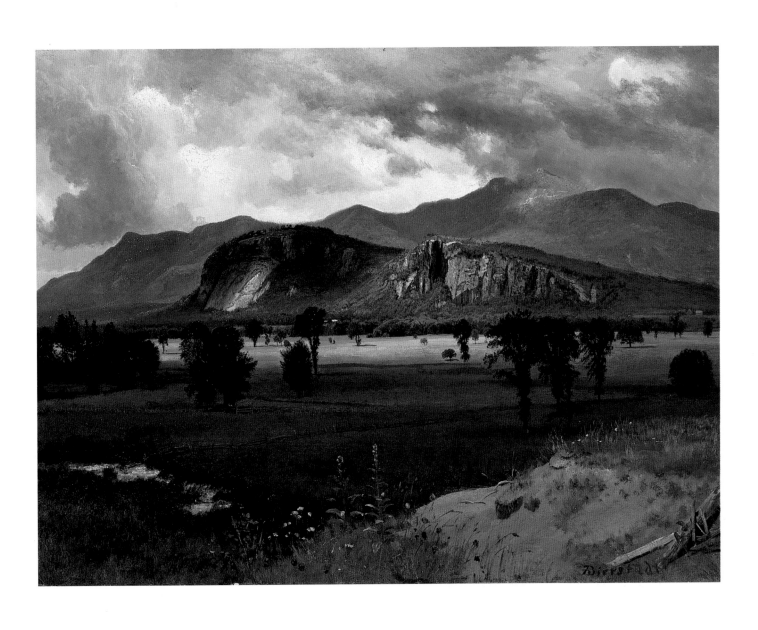

| ## WILLIAM HOLBROOK BEARD (1824–1900)

Susanna and the Elders, 1865

Oil on canvas; 15⅝ x 21⅛ in.
Signed lower left: "WH Beard 1865"
Gift of Henry Melville Fuller, 1984.23

William Beard began *Susanna and the Elders* five years after he arrived in New York City from Buffalo, where he had established a modest reputation as a portrait painter and had also begun to paint the animal parodies for which he would become famous. He had already shown such boisterous pictures as *Bears on a Bender* (1861; location unknown) and *The March of Silenus* (1862; Albright-Knox Art Gallery, Buffalo, N.Y.) in which bears impersonate humans on a drunken spree. *Susanna and the Elders* is one of Beard's first attempts at a biblical subject; his wit, appropriately, is restrained rather than raucous.

Beard painted at least four versions of *Susanna and the Elders* in the mid-1860s, two of which appear to be studies for this work. Although the formats and the backgrounds vary from version to version, in all of them the cast of characters is the same: two great horned owls (representing the lecherous elders) peer through the reeds at an elegant swan (Susanna), who emerges from a dark grotto and glides past them, her wings raised slightly in alarm. The story Beard relates is from the Book of Daniel (13:1–64). Two unprincipled elders spy upon the virtuous Susanna as she bathes. They accost her, demanding that she yield to their desires or they will claim to have witnessed her adultery with another. In Beard's painting, the tension of the biblical confrontation is defused by using birds to portray the protagonists; at the same time, their encounter humorously dramatizes the bestial aspect of human relations.

In depicting this moralizing biblical tale, Beard had many distinguished predecessors among the old masters. Rembrandt and Rubens, among others, painted Susanna surprised in her bath (see, for example, Rubens's *Susanna and the Elders*, ca. 1607, Galleria Borghese, Rome); in their work, the temptations of the flesh were made manifest in the voluptuous rendering of the female nude. But in using animals to parody human behavior, Beard follows the example of Sir Edwin Landseer, whose richly painted, heroic animal portraits were on occasion tinged with humor or were used to satirize human foibles. A host of lesser artists and political cartoonists, both English and American, painted animal fables. As is clear in *Susanna and the Elders*, Beard, like Landseer, was rare among them for being able to suggest living creatures who, whatever their human attributes, still retain the character of real beasts. Despite the liberties taken with scale in this picture, the birds are accurately rendered and are painted with such deftness and sensitivity to texture that their downy feathers seem almost palpable. The landscape elements are also painted with careful attention to detail. Each blade of grass, each wildflower, is crisply depicted, with a precision that approaches the meticulous, almost obsessively observed nature studies of the American Pre-Raphaelites, who also came to prominence in the mid-1860s.

A version of *Susanna and the Elders*, possibly this picture, was exhibited at the Brooklyn Art Association in 1875. Beard was then at the height of his popularity—his paintings commanded as much as six thousand dollars (though this one, being relatively small, was undoubtedly more modestly priced), and he numbered among his patrons such distinguished collectors of American art as the railroad magnate Henry Keep, Metropolitan Museum president John Taylor Johnson, and the famous connoisseur Thomas B. Clarke. By the end of his life, however, Beard's popularity had fallen off dramatically, and by the beginning of the twentieth century he was virtually forgotten. With the revival of interest in minor American masters in the mid-1970s, Beard's work was rediscovered and his reputation restored. *Susanna and the Elders* was one of the first of his major works to enter a museum collection in modern times.

Reference:

William H. Gerdts, *William Holbrook Beard: Animals in Fantasy* (New York: Alexander Gallery, 1981), pp. 11, 16, 34.

C. T.

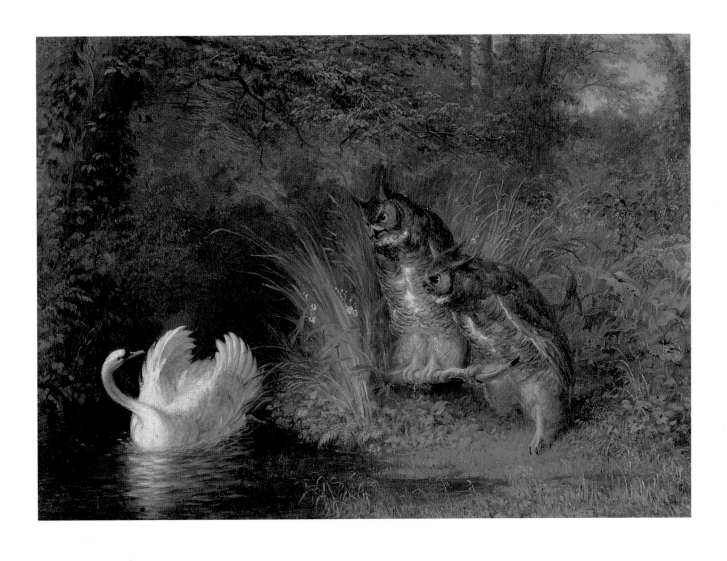

ELIHU VEDDER
(1836–1923)

Bordighera, 1872

Oil on canvas; 27⅝ x 15⅛ in.
Signed lower right: "18V72"
Museum purchase: gift of the friends, 1967.1

For Elihu Vedder, the charms of the small Italian hill town of Bordighera were pleasantly connected with the events of his own history. His initial visit to Bordighera, about twenty miles from the French border on the Ligurian Sea, was in the spring of 1857, during his first trip to Italy. He subsequently spent three weeks there with his fiancée, Caroline Rosekrans, in 1866 (they may even have become engaged while visiting the town). His next visit, and the one on which he made some of the sketches on which this painting was based, was on his honeymoon in 1869. Vedder would remain in Italy for the rest of his life; for him, Bordighera would always be associated with "happy days."

Vedder painted a number of small views of Bordighera in the late 1860s and 1870s. Some of these are carefully detailed renderings concerned with topographical accuracy; others, like this picture, are composites, which Vedder produced in his studio from memory, drawing on elements from a number of different sketches, not all of them representing Bordighera. In *Bordighera*, the narrow format and tall jumble of buildings recall sketches done in San Remo and Perugia in the late 1870s; the device of framing an appealing vista with local buildings cropped at the top and sides comes from an 1869 sketch, *Bordighera Street* (location unknown); while the peasant sitting on the step in the shade at left first appears in *Near Perugia* (1870; private collection).

In *Bordighera*, Vedder employs an ingenious composition, one that combines intimacy and panoramic grandeur, though in a manner that is suggestive rather than explicit. He shows a tall, thin sliver of space that perfectly conjures up the steep, winding roads of the hill town. Viewed close up, the humble buildings seem unusually tall, blocking the sun; the viewer descends the cramped passageway in welcome shade, first passing the peasant lighting his pipe and then two women conversing. These deliberately placed anecdotal vignettes are succeeded by topographical ones: the tall cypress towering above the small, sun-drenched outbuilding leads the eye upward and across a picturesque vista that encompasses the townscape, a slice of brilliant blue sea,

rolling hills, and sky. Whereas other Americans painting in Italy at this time might have used a similar high vantage point to dramatize the broad, sunny panoramas that could be seen *from* the hills of such ancient towns as Bordighera, Vedder was attracted to the crooked streets and simple architecture as well. He chose to look *through* the town to the sea, capitalizing on the surprising contrasts between familiar scenes of everyday life in the foreground and the dazzling view beyond.

Although modest in size compared to many of the landscapes produced by George Inness, Albert Bierstadt, and other Americans working in Italy after the Civil War, *Bordighera* was a large, finished work for Vedder, designed to appeal to the increasing numbers of American tourists who visited Rome, and his studio, after the war. He seems to have been successful, for *Bordighera* may be the *Large Bordighera Landscape* sold in 1872 to Henry A. Dike of New York for five hundred dollars, a respectable, if not record-breaking, price at the time.

References:

Regina Soria, "Vedder's Happy Days in Bordighera," *The Currier Gallery of Art Bulletin* (January–March 1970), n.p.

Karen Quinn, "Bordighera," in Theodore E. Stebbins, Jr., *The Lure of Italy: American Artists and The Italian Experience, 1760–1914* (Boston: Museum of Fine Arts/Harry N. Abrams, 1992), pp. 316–17.

C. T.

18 | MARTIN JOHNSON HEADE (1819–1904)

Marshfield Meadows, ca. 1878

Oil on canvas; 17¾ x 44 in.
Signed lower left: "M. J. Heade"
Currier Funds, 1962.13

Although today Martin Johnson Heade is considered one of the most important of the Hudson River school painters, in his own lifetime he enjoyed only moderate success. He had rooms in the Tenth Street Studio Building, where Albert Bierstadt, Worthington Whittredge, and others painted; he traveled to South America with Frederic Church, perhaps the most highly regarded painter of the group; and in the 1860s, along with such artists as John F. Kensett and Sanford Gifford, he introduced a style of quiet, atmospheric, light-filled landscape painting now known as luminism. For more than twenty years, beginning in the mid-1860s and continuing until 1883 when he moved to Saint Augustine, Florida, Heade painted the salt marshes of the Northeast, from Newburyport, Massachusetts, to Hoboken, New Jersey. He persisted with this subject despite the fact that these views of the marshes, carved up by tidal streams and dotted with haystacks, never quite captured the public's imagination, and he rarely commanded more than five hundred dollars for a canvas. *Marshfield Meadows* seems to have been highly regarded by the artist, for he submitted it to the 1878 exhibition of the Massachusetts Charitable Mechanics Association in Boston. The painting disappeared from view until the early 1960s, however, when it was acquired by the Currier. Since then, this gentle view of the Cut River (or one of its many tributaries) twisting through the flat marshland just south of Plymouth, Massachusetts, has been recognized as one of Heade's most beautiful luminist pictures.

The salt marshes are a seemingly unglamorous subject for landscape painting. Flat, monotonous, and familiar, they could not compete with the grandiose effects of the Adirondacks in autumn, or the snowcapped Rockies, or the tropical spectacles of South America—subjects preferred by Heade's contemporaries. Yet the very emptiness of the marshes made them seem vast and uncompromised. While they were nearby, they were by no means controllable: the salt marshes were constantly affected by the weather and by the action of the tides; and the marsh hay, so essential to

New England's agrarian economy, could only be harvested—it could not be cultivated. Heade painted these bogs with a romantic's reverence for the infinite power of nature. In his small canvases, the sense of panoramic expanse is immense, and the figures, who load the hay onto wagons, or fish, or sweep up loose hay, are dwarfed by the infinitely receding space. At the same time, Heade's sensitivity to the smallest atmospheric changes, and the magical light filtering over the terrain, anticipated that of the impressionists, although his technique remained wedded to the Hudson River school tradition of tiny brushstrokes, local color, and concern for detail.

In the 1870s, Heade's style loosened somewhat: he preferred gentler, damper atmospheric effects and broader brushwork. A Marshfield image painted several years earlier (*Marshfield Meadows, Massachusetts,* ca. 1865–75; Amon Carter Museum, Fort Worth, Texas) shows the high drama of a passing thunderstorm and the resulting contrasts of bright sun and deep shadow. Here, effects are more subtle: Heade shows a changeable cloudy sky, and his palette is delicately grayed, punctuated only by bits of red in the laborers' shirts.

References:

Theodore E. Stebbins, Jr., *Martin Johnson Heade* (New Haven, Conn., and London: Yale University Press, 1975), no. 200.

John Wilmerding, *American Light: The Luminist Movement, 1850–1875* (Washington, D.C.: National Gallery of Art, 1980), pp. 46–47, 116.

C. T.

JOHN LA FARGE
(1835–1910)

Sunrise in Fog over Kyoto (Kyoto in the Mist), 1886

Watercolor and graphite on paper; 7⅛ x 11¾ in.
Signed lower left: "LF. Kioto. Sept 10 86"
Gift of Clement C. Houghton, 1948.5

In June 1886, John La Farge left New York with his friend the historian and essayist Henry Adams for a three-month voyage to Japan. Both were fleeing traumatic situations at home: La Farge, the collapse of his business, "The La Farge Decorative Art Company"; and Adams, the nightmare of his wife's recent suicide. They were, they claimed, in search of Nirvana, but Nirvana proved disappointingly elusive. Adams complained constantly of the food, the accommodations, and the heat; La Farge, though less finicky about creature comforts, spent the three months in Japan compulsively buying bric-a-brac but painting little. Most of the works that document his trip to Japan were in fact made in his New York studio upon his return and were based on photographs made or bought in the Orient. *Sunrise in Fog over Kyoto* is one of a very few works painted on the spot; along with a companion watercolor, *View over Kyoto from Ya Ami* (1886; Museum of Fine Arts, Boston), it is probably the most important work of art he produced on the journey.

La Farge painted *Sunrise in Fog over Kyoto* from the veranda of his hotel, which was located near the Kiyomisu temple, to the east of the ancient city of Kyoto. It was done very quickly: according to La Farge's inscription along the lower margin, it was produced "Early—6:30 to 7 Sept 10./ 1886." The many marginal notes on the watercolor suggest that it was conceived as a sketch, and in fact La Farge used it a decade later as the basis of a wood engraving illustrating his 1897 memoir, *An Artist's Letters from Japan*. The print accompanied La Farge's poetic account of the creation of such watercolors: "Early on most mornings I have sat out on our wide veranda and drawn or painted from the great panorama before me—the distant mountains making a great wall lighted up clearly, with patches of burning yellow and white and green, against the western sky. The city lies in fog, sometimes cool and gray; sometimes golden and smoky. The tops of pagodas and heavy roofs of temples lift out of this sea, and through it shine innumerable little white spots of the plastered sides of houses . . . near us, trees and houses and

temples drop out occasionally from the great violet shadows cast by the mountain behind us" (p. 231).

Sunrise in Fog over Kyoto was one of at least four watercolors La Farge painted from the same vantage point during his two weeks in Kyoto. Two others—Boston's and another, described as "Morning with slight mist" (location unknown), were painted at dawn, while a fourth, *Sunset in Fog over Kyoto* (private collection), was painted at the end of the day. La Farge's aim in these watercolors was both to capture accurately the specific features of the view—on one of his marginal notes he reminds himself that the top of the pagoda at left appearing above the fog "should be further up beyond Honguanji"—and to suggest the spirit and atmosphere of a particular moment. To achieve these ends, La Farge worked with a delicate palette of blue, green, pale salmon, and yellow and used a variety of adventurous watercolor techniques to create the effect of sun coming through the fog. He applied color in very thin washes in the sky and mountains, while tiny dots of opaque white in the middle distance represent the houses in the town. In depicting the hills, La Farge blotted his color to evoke the texture of lush tropical foliage, and layered broad strokes of opaque white above to conjure up patches of fog. In the foreground, La Farge allowed his paint to pool and flow to suggest rising mists. Anchoring the composition at lower right—and providing a sense of scale to the vast panorama he magically evokes on this tiny sheet—is a large house, the deep red of its pediment the only intense color accent in the picture. The result of La Farge's half-hour painting exercise is an image that is abstract and modern while remaining believably descriptive.

Reference:

James L. Yarnall, "John La Farge and Henry Adams in Japan," *American Art Journal* 21, no. 1 (1989), pp. 40–77.

<div align="right">C. T.</div>

WINSLOW HOMER
(1836–1910)

In the North Woods (Playing Him), 1894

Watercolor on paper; 15⅛ x 21½ in.
Inscribed on the reverse: "This is not so bad W.H. 1894"
Gift of Mr. and Mrs. Frederic H. Curtiss, 1960.13

Although Winslow Homer generally declined to interpret his own work, he occasionally penned marginal comments on his watercolors that indicate his degree of satisfaction with what he had made. "This will do the business," he crowed on the bottom margin of one watercolor. "A picture for a dark corner," he wrote on the back of a particularly bright example. And on the reverse of *In the North Woods* he wrote, "This is not so bad."

In the North Woods was painted in the Adirondacks, probably from Homer's usual base at the North Woods Club, a private hunting and fishing association he helped found in 1886. The club was located on the shores of Mink Pond, near Minerva, New York. Homer spent at least a week there, and sometimes as long as two months, almost every year in the 1890s. He went to the Adirondacks to fish, hunt, and paint in watercolors, and the works he produced in these surroundings are among his greatest in the medium.

In the North Woods followed such watercolors as *Adirondack Lake* (fig. 6) and *Sunrise, Fishing in the Adirondacks* (1892; Fine Arts Museums of San Francisco), which also feature a solitary fisherman in a canoe, his rod and line a taut arc against a dark screen of foliage. In these works, the fisherman is seen from a great distance and is small and anonymous; the focus is on the great masses of trees and water. Here, it is the solitary woodsman who is emphasized; the tension and excitement of the strike is dramatized by his outstretched arms, which become an extension of his fishing rod, and by his head, turned back to regard his prey.

Homer's response to nature was intense, and although this image has a fresh, just-observed quality, it was actually rather heavily worked. His technique here is a vigorous mixture of layered washes, areas of color scraped away and then painted over (the ripples of water at lower right), and blotted passages in the distant hills. To render the fishing line, a nearly invisible arc of white against the dark trees, Homer scraped away color in a single long curve, then painted over yellow for the pole and brown where the line is visible against the gray sky. The mysterious depths of the pond are suggested by layers of wash; the play of light on the water is indicated by the juxtaposition of strokes of opaque and transparent color.

The fisherman's unspoiled solitude, seen in the pale morning light, the figure's concentrated expression, and the companionable silence of the water, is typical of the idealized view of nature that Homer created in his Adirondacks watercolors. He presents nature as the preserve of the true fisherman, completely at home in the wilderness, rather than as the playground of the convivial recreational fishermen who began visiting the Adirondacks in great numbers by the 1870s.

Ironically, it was the increased popularity of fishing as a sport among the middle class, and Homer's genius at expressing the lure of rural outdoor life, that led the Boston lithography firm of Louis Prang and Co. to purchase *In the North Woods* in 1894. Prang used it as the basis of a handsome lithograph, *The North Woods*, produced that same year, a print that was unusually successful in reproducing Homer's subtle colors and layers of tone. Inexplicably, it was not a commercial success, and Prang soon abandoned its ambitious project to issue "Water Color Facsimilie(s)[*sic*]" of Homer's paintings. The watercolor was then sold at the 1899 auction of the Prang firm's collection. It was purchased "for something under $500," as its new owner, Frederic Curtiss of Boston, recalled. The Curtisses hung it in their home for many years before donating it to the Currier in 1960.

References:

"Winslow Homer's *North Woods:* A Recent Acquisition," *The Currier Gallery of Art Bulletin* (November 1960), pp. 1–2.

Helen A. Cooper, *Winslow Homer Watercolors* (New Haven, Conn., and London: Yale University Press, 1986).

C. T.

Fig. 6
Winslow Homer. *Adirondack Lake*, 1889. Watercolor, 14 x 20 in.
William Wilkins Warren Fund, Museum of Fine Arts, Boston, 23.215

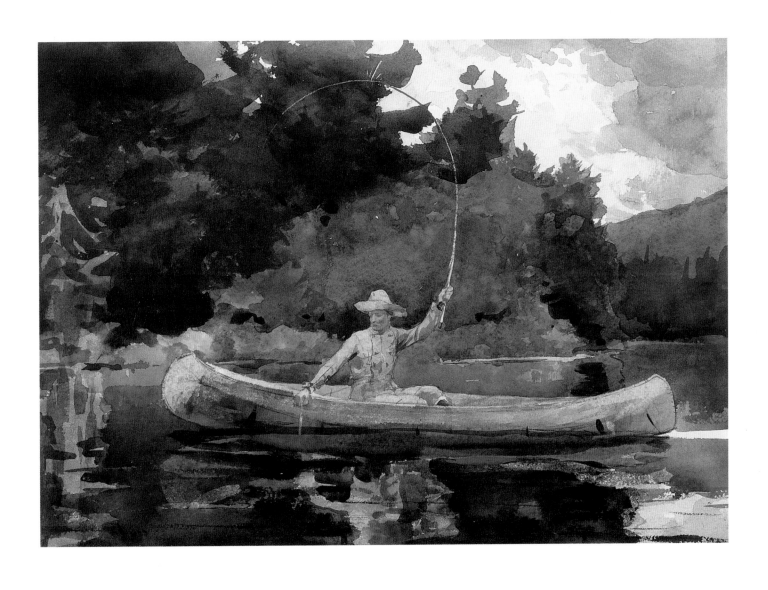

MAURICE PRENDERGAST (1859–1924)

The Stony Pasture, ca. 1896–97

Watercolor and graphite on paper; 19⅜ x 13⅞ in.
Signed lower right: "Prendergast"
George A. Leighton and Mabel Putney Folsom Funds, 1959.6

The Bay (Figures by the Shore), ca. 1910–13

Watercolor, pastel, and graphite on paper; 15⅝ x 22½ in.
Signed lower right: "Prendergast"
Gift of Eleanor Briggs, 1977.1

Maurice Prendergast was perhaps the first major American artist whose primary reputation came from his achievements in the demanding medium of watercolor. Born in Newfoundland, Canada, and raised in Boston, he was trained as a painter of signs and advertisements, developing early on a proficiency with water-based mediums. Although he would work in oils all his life, until 1900 watercolor was his preferred mode of expression and experimentation. Even after that time, when his art moved from an impressionist-inspired style to a more avant-garde, modernist one, some of his most daring works were in watercolor.

Regardless of the style or medium in which he was working, Prendergast again and again chose to paint the urban parks and seaside resorts to which city dwellers gravitated for recreation. Franklin Park, represented in *The Stony Pasture,* is a large, hilly preserve laid out in the 1880s as part of Boston's famed "Emerald Necklace" by the landscape architect Frederick Law Olmsted. It contained a "Country Park," dedicated to the enjoyment of natural scenery, and areas for sports, for a zoo, and for promenading. The terrain was characterized by the huge boulders that fill the foreground here. The park was enormously popular in Prendergast's day, and the artist painted a number of watercolors featuring middle- and working-class Bostonians enjoying the various facilities of the park. *The Stony Pasture* is unusual in that it seems to depict the "Country Park"; Prendergast generally preferred the livelier sections of the park where carnivals, sporting events, and other activities took place.

The figures in *The Stony Pasture* are dressed in their Sunday best. They form bright patterns of color against the transparent layers of green wash that define the meadow. Grouped in narrative vignettes, the figures create a chain of activity leading the eye back to the pavilions along the horizon. In the foreground, little girls seem to make a game of traversing the boulders, while at center, their mothers (or older sisters), their parasols held high, lift their skirts and gingerly navigate the rocky field. Elsewhere, fathers carry small children or hold the hands of older ones. Prendergast's subject was the human parade; his skillful rendering of people moving through a public space makes this scene feel spontaneous and directly observed.

Between *The Stony Pasture* and *The Bay (Figures by the Shore),* Prendergast made several trips to Europe. On the first trip, in 1898–99, he discovered Italy; on the second, in 1907, he was struck by the work of the French avant-garde artists. He admired the schematized figures, the festival atmosphere, and the pure, brilliant color in the work of

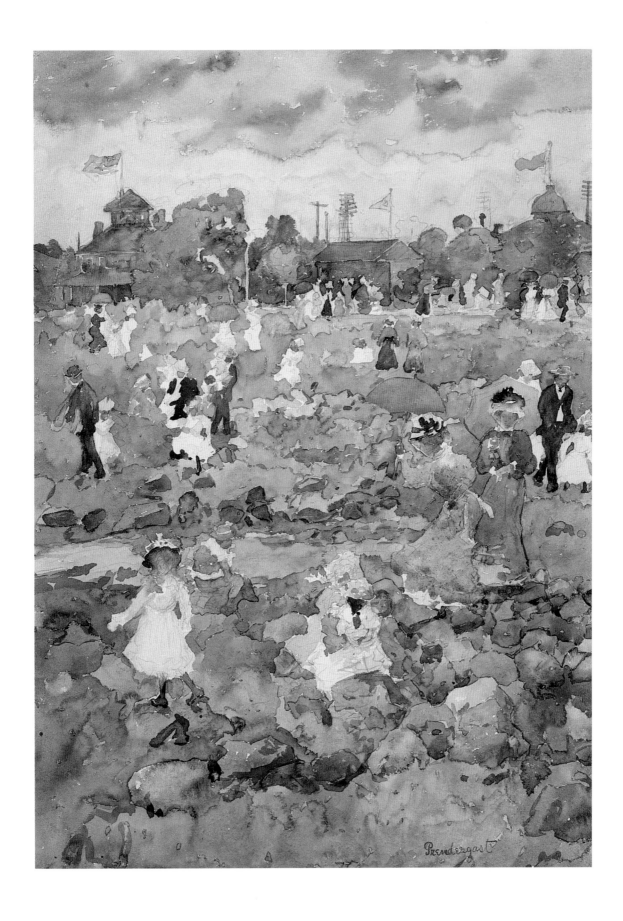

Matisse and Derain but reserved his greatest enthusiasm for the watercolors of Cézanne, whose simplicity and suggestive qualities he strove to emulate. *The Bay* represents a return to one of Prendergast's favorite subjects, a holiday by the sea, but it is also informed by the idealized images of bathers produced by the French masters. His rhythmically grouped figures, with their thick contours and liquid shapes, demonstrate his delight in patterns of color, shape, and movement. Although this watercolor was undoubtedly painted on Massachusetts's North Shore, where Prendergast took his working vacations almost every summer, the precise location cannot be identified; the generalized landscape here likewise indicates the triumph of suggestion over representation. During this period, Prendergast's technique was as adventurous as his style. Here he combines grainy pastel with very wet watercolor. The broad areas of wash create depth and luminosity, while the chalk reinforces the bathers' outlines, gives a rough texture to tree trunks, and appears in the sky on the underbellies of fast-moving clouds. The alternation of textures—translucent wash and dense, opaque pastel—enlivens the surface of the painting. The result is an image that is at once idyllic and quite animated, a distillation of the experiences of a summer's day.

Reference:

Carol Clark, Nancy Mowll Mathews, and Gwendolyn Owens, *Maurice Brazil Prendergast, Charles Prendergast: A Catalogue Raisonné* (Munich and Williamstown, Mass.: Prestel-Verlag and Williams College Museum of Art, 1990), cat. nos. 613, 1105.

C. T.

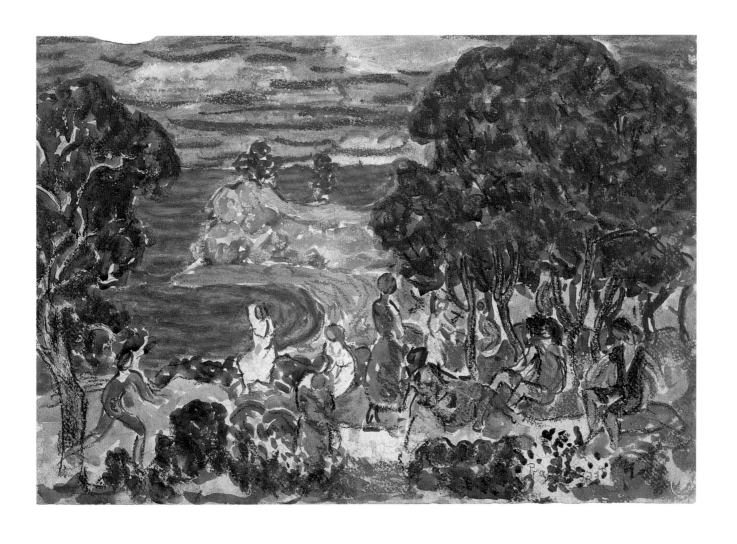

23 | EDMUND C. TARBELL (1862–1938)

Summer Breeze, 1904

Oil on canvas; 30⅛ x 25⅛ in.
Signed lower right: "Tarbell."
Anonymous gift, 1992.1

Boston's two favorite painters in the 1880s and 1890s were John Singer Sargent and Claude Monet. Their work was avidly collected in the city, and their styles studied and emulated by a group of young artists who became known as the Boston school. Edmund Tarbell was perhaps the most talented of this group of painters, who came to prominence at the turn of the century after studying (and, in many cases, later teaching) at the School of the Museum of Fine Arts, Boston. Like Sargent, Tarbell skillfully combined a career as a fashionable portrait painter with an interest in impressionist landscape painting and figure studies inspired by Monet.

Also like Sargent, Tarbell frequently used family members as models for his fresh, lively outdoor scenes, pictures that, though they quickly found an appreciative audience, initially were painted for his own pleasure. The model for *Summer Breeze* may well have been Tarbell's eldest daughter, Josephine, who appears in a number of his paintings beginning shortly after her birth in 1890. Most of these works, including *Summer Breeze*, were done at Tarbell's vacation home in New Castle, New Hampshire. Precedents for this picture can be found in Monet's and Sargent's works, for in the 1880s both artists executed informal, *plein-air* studies of young women in big white hats silhouetted against sparkling blue skies. Characteristic of such paintings as Monet's *Woman with Parasol* (1886; Musée d'Orsay, Paris) and especially Sargent's *A Morning Walk* (1888; private collection)—which Tarbell no doubt saw in Boston when it was shown at the St. Botolph Club in 1890—is a high-keyed palette and long, flowing strokes. Tarbell would use these elements in his own work to suggest the charming effects of a brisk summer wind on a figure in full sunlight.

Tarbell himself had addressed this theme before: in a full-length figure study of 1901 entitled *On Bos'n's Hill* (private collection), and in a half-length composition, *The Picture Hat* (private collection), which he showed at the annual exhibition of the Pennsylvania Academy of the Fine Arts in Philadelphia in 1902. The success of those works may have inspired him to try the subject again, but in a far more audacious and dramatic composition. In *Summer Breeze*, Tarbell's model is seen from below, leaning into the wind so that her figure is arranged diagonally across the canvas in a delightfully animated and, for Tarbell, unusually abstract composition.

Tarbell's technique is equally adventurous here; in fact, he comes closer to a true impressionist style in this picture than in most of his work of the period. The paint handling is loose and suggestive, and the figure nearly dissolves into a pattern of lively brush strokes. The translucent ribbons on Josephine's hat and the sash at her waist mingle with the wispy clouds behind her, and the shadows at the back of her blouse blend into the sky, for all are rendered in the same shade of blue. The entire picture is conceived in blue and white, with touches of pink and yellow; its sunny, decorative quality is enhanced by the bright gilt frame produced for the picture by Carrig-Rohane, one of Boston's most illustrious frame-making companies.

Summer Breeze was acquired by Frank P. Carpenter of Manchester, New Hampshire, shortly after it was completed. During the next three decades, it was seen in Boston, New York, and Washington, D.C., in both group shows and exhibitions devoted exclusively to Tarbell's work.

C. T.

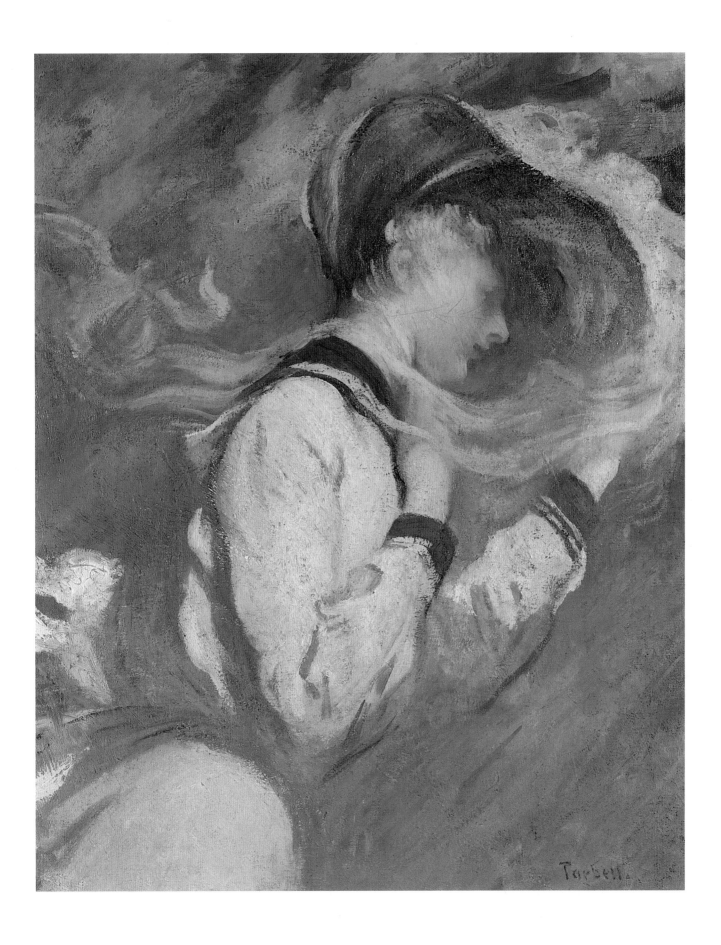

THOMAS EAKINS
(1844–1916)

Florence Einstein, 1905

Oil on canvas; 23⅞ x 20⅛ in.
Henry Melville Fuller and Currier Funds, 1979.25

The painting *Florence Einstein* is one of a series of extremely personal portraits of women Thomas Eakins made around the turn of the century. Among the best known of these are *Mary Adeline Williams (Addie)* (ca. 1900; Philadelphia Museum of Art), *Susan MacDowell Eakins* (ca. 1900; Hirshhorn Museum and Sculpture Garden, Smithsonian Institution, Washington, D.C.), and the poignant *Mrs. Edith Mahon* (1904; Smith College Art Museum, Northampton, Mass.). Most of these were not official commissions but represented members of Eakins's family circle in Philadelphia, close friends, or admired colleagues. Florence Einstein (d. 1919) was the head of the Department of Theoretical and Technical Design at the Philadelphia School of Design for Women (later Moore College of Art), which since 1886 had been headed by Emily Sartain, a longtime friend of Eakins's. Einstein and Eakins also had known each other for many years; among the tokens of connection between them is a collotype (1876; Philadelphia Museum of Art) of Eakins's dramatic painting *The Gross Clinic* (1876; Thomas Jefferson University, Philadelphia), which Eakins dedicated "To Florence A. Einstein/from her friend Thomas Eakins."

As is typical of this group of portraits, Eakins shows his subject at bust-length, against a blank background, without any props or attributes of her profession. He shows Florence Einstein in a soft, floral-patterned dress and shawl that emphasize her femininity and are, in their almost girlish delicacy, somewhat at odds with the plainness of her features and the sobriety, even sadness, of her expression. Eakins used the profile format infrequently; here, by silhouetting Einstein's strongly modeled features against a dark background, he gives her the dignity of a classical portrait bust. At the same time, she seems anxious, worn by care. Eakins's biographer, Lloyd Goodrich, noted that "Like Rembrandt, Eakins loved old age . . . and sometimes made sitters look older than they were" (*Thomas Eakins,* 1982, vol. 2, p. 59). Thus Florence Einstein, who graduated from the Philadel-

phia School of Design for Women in 1887 and could be as young as thirty-eight in this picture, exhibits the puffy skin, downturned mouth, and disappointments of an older woman.

References:

Marian S. Carson, "Notes on a Portrait by Thomas Eakins," *The Currier Gallery of Art Bulletin* (Fall 1981), pp. 14–19.

Lloyd Goodrich, *Thomas Eakins,* 2 vols. (Cambridge, Mass.: Harvard University Press, 1982).

C. T.

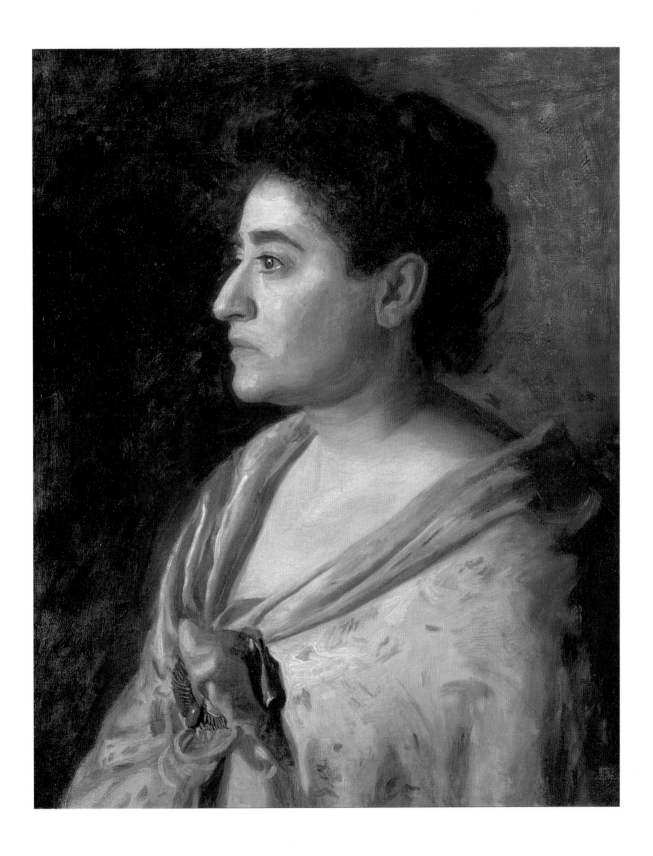

CHILDE HASSAM
(1859–1935)

Newfields, New Hampshire, 1906

Watercolor on paper; 13¾ x 19¾ in.
Signed lower left: "Childe Hassam/1906"
Currier Funds, 1963.1

The year 1906 was a remarkable one for Childe Hassam: he was named an academician of the National Academy of Design and won the Carnegie Prize awarded by the Society of American Artists, the Walter Lippincott Prize from the Pennsylvania Academy of the Fine Arts, and a Third Prize Award at the Worcester Art Museum's Ninth Annual Exhibition. It was also an unusually peripatetic year, even for an artist who styled himself "the Marco Polo of the painters." Hassam was in New York in the winter, and in the months that followed he made at least four separate trips to Old Lyme, Connecticut, and also went to Branchville and New London, Connecticut, to Long Island, and to the Isles of Shoals, New Hampshire. In most of these places, he worked on major canvases. His visit to Newfields, on the other hand, seems to have been purely for relaxation, and the watercolor he painted there has all the hallmarks of a work done purely for the artist's pleasure.

Hassam probably stopped at Newfields, located several miles inland from Portsmouth, in August 1906, when he was based on the Isles of Shoals. He had been coming to New Hampshire since the early 1880s, frequently as the guest of poet Celia Thaxter, whose dazzling gardens at Appledore, Isles of Shoals, had often been a subject for his brush. Hassam seems to have produced little work at Newfields, although the pretty country town inspired at least one other watercolor, executed in August of 1907, and an etching and drypoint completed in 1916. His decision to record his impressions of this small, picturesque town in watercolor reflects his lifelong interest in the medium.

Hassam's rendering of Newfields on a high summer day shows him to be a master of the transparent wash technique: the fields in the foreground and the trees in the middle distance are rendered in a succession of long strokes of wet pigment, the very liquidity of the paint conveying the shimmering heat of an August day. The sky—which fills two thirds of the picture—was painted even more wetly, with a series of loose, parallel strokes and pools of color that evoke the movement of clouds across the sky. Hassam's palette consists of the bright blues and greens he favored in the contemporary landscapes he made in oils, accented with dots of red on the chimneys. The white of the paper, used to define the reflections of the clouds in the pond and the houses at center, adds to the brilliance of the image. Hassam organized his composition into a series of horizontal bands, a measured structure that suggests stability, while his energetic brushstrokes create a sense of impending atmospheric change. *Newfields, New Hampshire* was undoubtedly painted quite rapidly, probably at a single sitting. It reveals no underdrawing that would indicate careful planning in advance of picking up the brush, and no corrections or changes of mind. Rather, it is direct, spontaneous, and self-confident; Hassam would have considered it a good day's work.

References:

"A Watercolor by Childe Hassam," *The Currier Gallery of Art Bulletin* (March 1963), pp. 1–3.

Ulrich W. Hiesinger, *Childe Hassam: American Impressionist* (Munich and New York: Prestel-Verlag, 1994).

C. T.

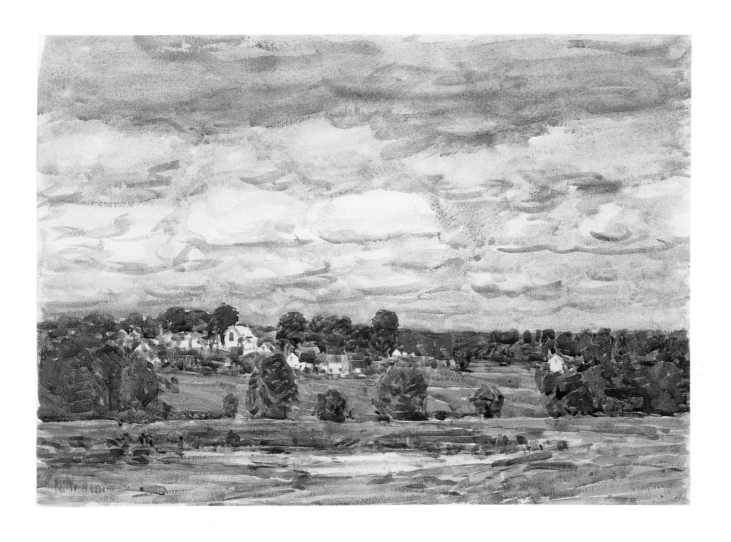

WILLARD L. METCALF
(1858–1925)

The Trout Brook, 1907

Oil on canvas; 26 x 29⅛ in.
Signed and dated lower right: "W. L. Metcalf. 1907"
Bequest of Louisa A. Wells, 1945.4.1

When it first appeared in New York in a 1909 one-man exhibition at the Montross Gallery, Willard Metcalf's *The Trout Brook* moved critics to poetry: "It is as if he plucked a violet from its springtime bed and incorporated its shy loveliness on his canvas, for the running brook is of violet hue and the tender green of the new grass has just the hue of the bud's surrounding leaves . . ." (*New York American,* January 2, 1909). The Montross Gallery was a prestigious venue; the significance of *The Trout Brook* can be further measured by the number of important exhibitions of contemporary art in which it appeared. It had been displayed at the annual exhibition of the Pennsylvania Academy of the Fine Arts in Philadelphia in 1908 and would be included in an exhibition of The Ten American Painters (an impressionist group) held in the spring of 1909 at the Copley Gallery in Boston. There it was praised by the *Christian Science Monitor* for its "bright green banks, rolling hills, and tender-toned trees" (April 17, 1909). The enthusiastic reception of this painting was indicative of the increasing esteem in which Metcalf's work was held. In subsequent years, his paintings won numerous awards and honors and were sought after by many discerning collectors.

The Trout Brook was painted in Old Lyme, Connecticut, a popular artists' colony where Metcalf spent the summers of 1905–07. The quiet simplicity of this New England town was something of a departure for Metcalf, who earlier in his career had preferred more exotic painting locales: the American Southwest, Brittany, Tunisia, and Morocco. In the 1890s, he had been active as a teacher and portrait painter in New York, and he was a founding member of The Ten American Painters, a group that also included Childe Hassam (see cat. nos. 25 and 28) and Frank Benson. But around 1903, he retreated to his parents' farm in Maine and dedicated himself almost exclusively to landscape painting; he soon became known for views of the New England countryside rendered in an impressionist style. He spoke of this late development in his career—he was by this time forty-five—as his "renaissance," and it led to increased fame and financial security. A 1906 exhibition of his Old Lyme landscapes at Boston's St. Botolph Club nearly sold out. *May Night,* a painting produced the year before *The Trout Brook,* won the Gold Medal and a one-thousand-dollar prize at the Corcoran Gallery of Art and was subsequently bought by the Corcoran for three thousand dollars. The success of this picture encouraged numerous other artists to come to Old Lyme to paint and reinforced Metcalf's interest in depicting the pastures and farmlands of southern Connecticut.

In *The Trout Brook,* Metcalf shows a rocky hillside in late spring, the soft light and the lacy, light green foliage of the trees being ideal vehicles for Metcalf's impressionistic technique. The canvas is nearly square, and Metcalf's composition recalls the impressionists' penchant for unconventional views. Here the horizon line is high, and the meandering stream leads the eye back through the gently ascending terrain. A few cows graze placidly at right, and an old, low, stone fence zigzags through the middle distance, a reminder of Connecticut's colonial past. Except for the deep violet-blue of the stream, Metcalf's colors are pale and cool. The air seems crisp, the temperature brisk. The setting is unspectacular; however, Metcalf has so skillfully recreated the quiet pleasure of coming upon such a scene that even Connecticut's boulder-strewn fields seem to possess a special beauty.

Reference:

Connecticut and American Impressionism (Storrs, Conn.: William Benton Museum of Art, University of Connecticut, 1980), pp. 59, 72, 167–68.

C. T.

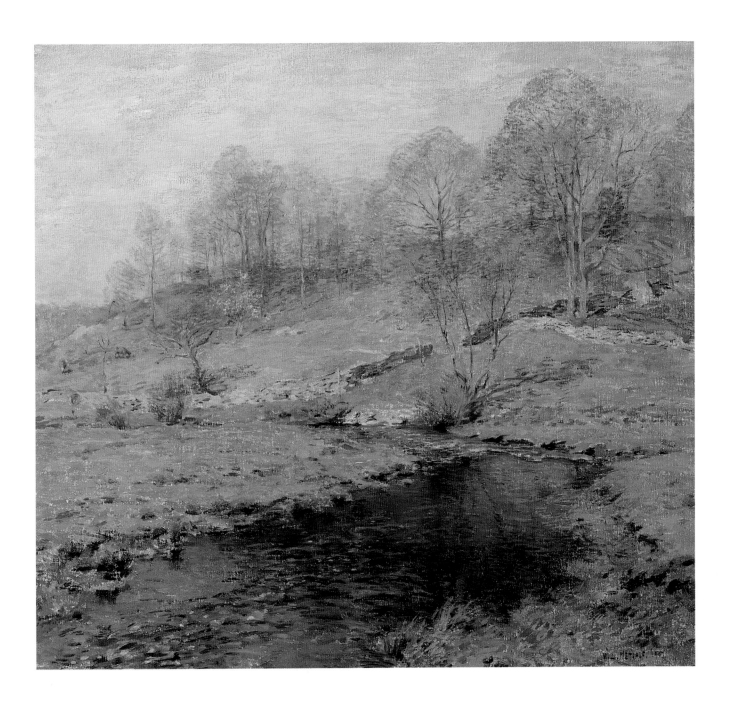

LILLA CABOT PERRY
(1848–1933)

The Black Hat, 1914

Oil on canvas; 50¼ x 36¼ in.
Signed upper left: "L. C. Perry/—1914—"
Gift of Mrs. Albert Levitt, Mrs. Anita English, and Mrs. Cecil B. Lyon, 1982.28

Lilla Cabot Perry's contribution to the arts in turn-of-the-century New England was twofold. She was one of the first American artists to admire and promote the work of the French impressionist Claude Monet among Boston patrons of the arts, and she also was an early practitioner of his style. Beginning in 1889, she spent many summers painting with him at Giverny and, in that year, brought one of his paintings, a view of Etretat, to Boston. She was one of Monet's principal advocates in New England, crediting him with "having opened the eyes not merely of France but of the whole world to the real aspects of nature and having led them along the path of beauty, truth, and light." Perry was extremely well-connected—she was related to the Cabots, Jacksons, and Lowells—and in part because of her influence, by the 1890s, many of the most socially prominent Bostonians owned paintings by Monet.

Perry was more than just the artist's friend and patron; she was also his disciple. After a period of study at the academies Julian and Colarossi in Paris, where she was trained in the French academic manner, she went to Giverny and learned to paint in a radically different style—Monet's dazzling impressionism. Her landscapes were among the first produced by a Boston school painter to emulate the light-drenched, pastel-colored style of the French painter; at the same time, in her figural compositions and society portraiture, she blended impressionism with French academic techniques.

The painting *The Black Hat* is one of a group of images of women that Perry produced during the second decade of the twentieth century. In several of these works, her subjects wear elaborate hats that both shade their eyes and draw attention to their thoughtful expressions. Like other artists associated with the Boston school, such as Edmund Tarbell (see cat. no. 23), Perry often had family members, particularly her three daughters, pose for her; she also used professional models. For this painting, she may have employed the same wide-eyed, high-cheekboned model who appears in *Lady with a Bowl of Violets* (ca. 1910; National Museum of Women in the Arts, Washington, D.C.).

Like her male counterparts Frank Benson and Edmund Tarbell, Perry became well known for such idealized images of women. Interestingly, except for an aura of sexuality sometimes found in Benson's and Tarbell's pictures, there seems to be little difference between the men's approach to their female subjects and Perry's. Artists of the Boston school, whether male or female, tended to present women as personifications of an aesthetic ideal and showed their subjects as decorative, ladylike, and occupied with such genteel feminine pursuits as playing music, arranging flowers, or simply meditating, as here. The women in these pictures generally wear stylish clothing—this sitter is wearing a handsome, lace-trimmed black gown, a simple strand of pearls, and a large velvet hat—but they are not merely fashion plates. Perry, in particular, frequently showed them to be contemplative, even melancholy. Here, the woman's thoughtful gesture of hand to face, her averted eyes, and her complicated, compressed pose (she sits, somewhat hunched over, on a rather diminutive settee) cause the viewer to wonder at her thoughts, even as she seems unaware of the presence of any onlooker.

Reference:

Meredith Martindale et al., *Lilla Cabot Perry: An American Impressionist* (Washington, D.C.: National Museum of Women in the Arts, 1990).

C. T.

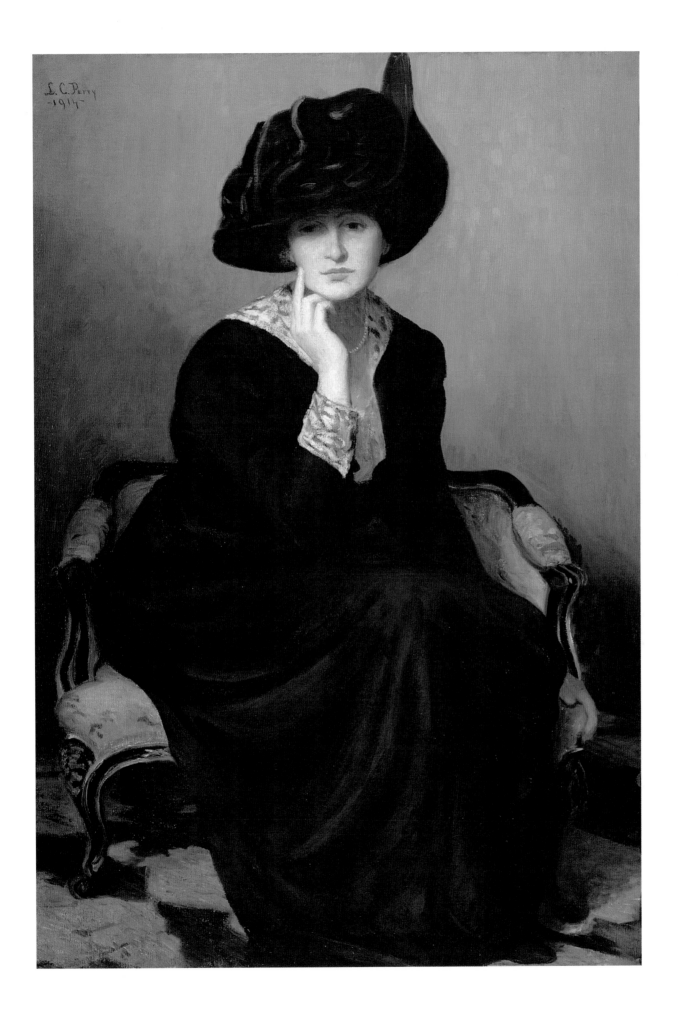

CHILDE HASSAM
(1859–1935)

The Goldfish Window, 1916

Oil on canvas; 34⅜ x 50⅝ in.
Signed and dated upper left: "Childe Hassam 1916"
Currier Funds, 1937.2

Childe Hassam, for more than twenty years one of the country's leading impressionist painters, began *The Goldfish Window* at the artists' colony in Cos Cob, Connecticut, in the summer of 1915 or 1916 and finished it in his New York studio in 1916. Hassam worked periodically at Cos Cob between 1894 and 1923, often staying at the famed Holley House, the gathering place for artists. Like a number of other members of the Cos Cob group, Hassam spent winters painting and exhibiting in New York and occasionally returned to France to renew his acquaintance with European styles. His 1910 trip to Paris, while reinforcing his commitment to the impressionists' focus on the effects of light, also renewed his interest in classicism and traditional formal problems. These concerns are paramount in a group of paintings, begun at about the time Hassam went abroad, that came to be known as the Windows series. *The Goldfish Window* is one of the most successful renderings of the theme.

In these paintings, a contemplative young woman is posed in front of a large window in a handsomely furnished interior, generally with a still-life arrangement on a table beside her. Sunshine pours in, backlighting the figure and creating a halo around her that adds to her ethereal beauty. Most of the Windows pictures were staged in Hassam's Manhattan studio. *The Goldfish Window* is unusual for having been painted at the Holley House; one of the summer colony's art students may have posed for the picture. The loose kimono in which the model is dressed may have been a studio prop of Hassam's, for other figures in the series wear similar robes. Yet it also reflects the general taste for aestheticism at Cos Cob, where students aspired to Oriental elegance, dressing up in kimonos and practicing flower arranging and tea ceremonies. The combination of Oriental objects (not the least of which is the glass bowl, filled with giant goldfish) with American antiques—the ladder-back, rush-seated chair and mid-eighteenth century, country-type table—is furthermore a reflection of Hassam's Boston roots. Just at this time, such Boston school painters as Frank Benson and Edmund Tarbell were painting similarly

contrived, elegantly appointed interiors, with their typically Boston mix of New England antiques and Oriental *objets d'art.*

Hassam painted the last of the Windows pictures about 1920. They had been an important source of income and critical acclaim for him, winning prizes and selling quickly, quite a number of them to museums. In a 1927 interview, he described his interest in compositions such as these in purely formal terms: "[I enjoyed] using . . . figures with . . . flowers in an arrangement to make a beautiful combination of color and line." But as *The Goldfish Window* makes clear, these are also paintings of mood: the contrast between the brilliant, sunlit garden and the shadowy interior, painted in cool tones, reinforces the contemplative mood of the figure. The carefully structured room suggests both security and confinement, while the model's wistful gaze directs the viewer's eye to the relative freedom of the garden beyond.

Reference:

Ulrich W. Hiesinger, *Childe Hassam: American Impressionist* (Munich and New York: Prestel-Verlag, 1994), p. 148.

C. T.

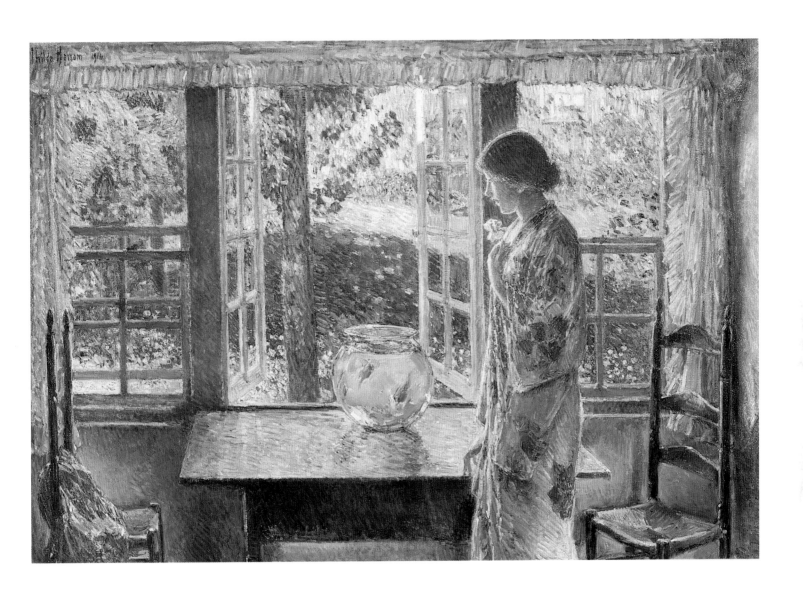

JOHN SINGER SARGENT (1856–1925)

Grace Elvina, Marchioness Curzon of Kedleston, 1925

Oil on canvas; 50⅞ x 36⅜ in.
Signed upper left: "John S. Sargent"; dated upper right: "1925"
Currier Funds, 1936.5

John Singer Sargent's last completed painting, and one of the few portraits he consented to paint in the final decade or so of his career, was *Grace Elvina, Marchioness Curzon of Kedleston*. Lady Curzon sat for him in January 1925, three months before the artist's death, during a period when his principal—in fact, almost his entire—artistic effort was dedicated to the murals decorating the rotunda and stairwell of the Museum of Fine Arts in Boston. Although he was repeatedly offered portrait commissions (many of them potentially lucrative and from celebrated personages), he refused almost all of them. He declined to paint Lady Curzon when he was first approached by her husband, who had sat for him in 1914. He relented, according to family tradition, after meeting her at a private dinner party arranged by their mutual friend (and Sargent's eventual biographer) Evan Charteris. Sargent's only condition in agreeing to the commission was that Curzon, who had been extremely critical of other portraits of his wife, be barred from seeing the portrait until it was finished. Sargent's effort was quite successful, apparently moving Curzon to tears: "But it is ideal," Lady Curzon remembers him saying, "I could not wish for anything better."

Lady Curzon (1879–1958), who was about forty-five when Sargent painted her, was born Grace Elvina Hinds, daughter of Lucy Triglia and Joseph Monroe Hinds, a career diplomat. During Hinds's term as United States Minister to Argentina, Grace met and married Alfred Duggan, a wealthy Anglo-Argentine with vast landholdings in South America. After Duggan's death in 1915, she moved to London with her three children. Shortly thereafter, she met Lord Curzon, a brilliant politician who in the course of his career would serve as Secretary of State for Foreign Affairs, Viceroy of India, Minister for Foreign Affairs, and leader of the House of Lords, as well as president of the Royal Geographical Society. They married in 1917. The marriage was not a success, however, and at Lady Curzon's request, the couple lived apart for much of the period before Lord Curzon's death in 1925.

Sargent painted Lady Curzon in his Tite Street studio. She wears an elegant gown of silvery-white silk, with a transparent stole draped loosely around her. A triple rope of pearls and drop earrings continue the pale tonalities of her attire, to which the purple sash and star of the Grand Cross of the British Empire provides a dynamic contrast. She is seated on a small settee upholstered in a delicate patterned fabric, the gilt arms and pastel tones of which underscore the opulence and femininity of many of Sargent's famous portraits of the Edwardian age. But unlike portraits such as *Mrs. Carl Meyer and Her Children* (1896; private collection), here Sargent does not rely on dramatic foreshortening or swooping perspective to animate the composition; rather he chooses a more subtle arrangement. Lady Curzon perches at the edge of the sofa, which has been turned away from the picture plane; she then twists back slightly to address the viewer. Sargent experimented with this pose in several sketches for the portrait (1925; Museum of Art, Rhode Island School of Design, Providence). In one of these, Lady Curzon's head is thrown back, her arms akimbo, in an attitude that is both flamboyant and haughty. The final pose is more restrained, yet more expressive. While not minimizing his sitter's elegance and luxurious beauty, Sargent focuses on Lady Curzon's face and hands. As she fingers her pearls, her lips pressed tight and her eyes opened wide, Lady Curzon reveals an eloquent tension and lingering sadness.

Reference:

Donelson F. Hoopes, "Sargent's Portrait of the Marchioness Curzon of Kedleston," *The Currier Gallery of Art Bulletin* (April–June 1970), pp. 11–21.

C. T.

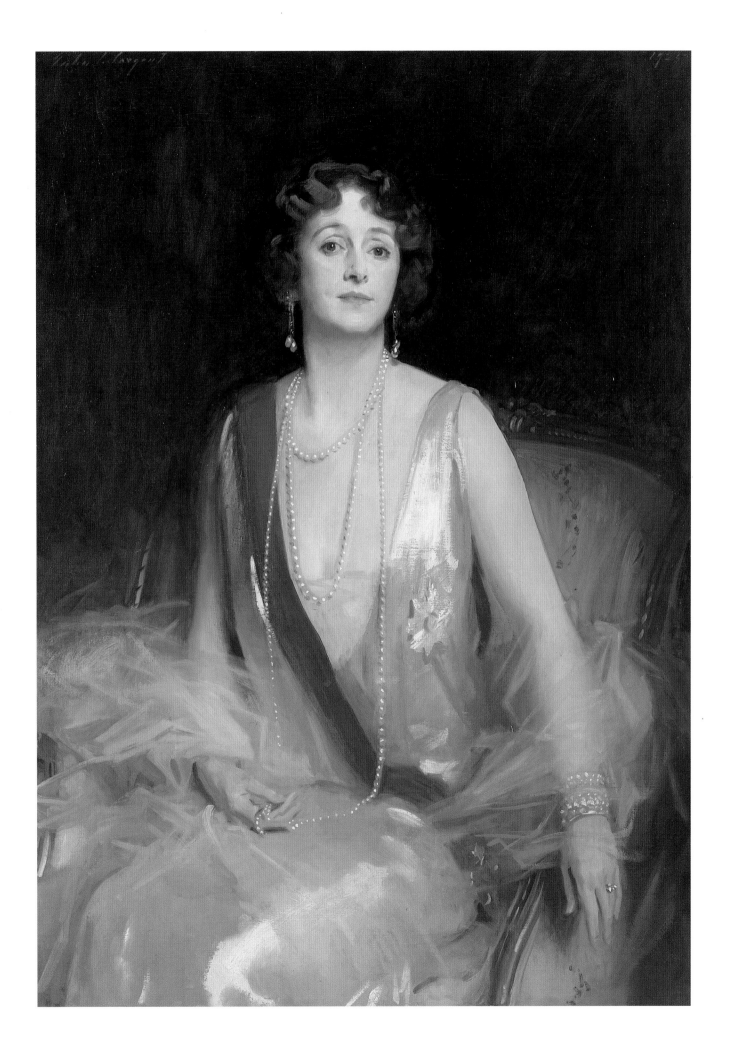

AUGUSTUS SAINT-GAUDENS (1848–1907)

Diana, 1894

(this cast, after 1899, by E. Gruet Fondeur, Paris)
Bronze; 27½ x 17½ x 5½ in.
Stamped on sphere: "© A. Saint Gaudens MDCCCXCV"
Bequest of Katherine H. Faulkner, 1977.55

Augustus Saint-Gaudens was at the height of his career in 1886 when he completed the head of his model and mistress Davida Clark (d. 1910). The marble bust, about half life-size, showing the sitter with her hair drawn back in a Grecian knot, would be an inspiration. Soon he had made a small sketch of the mythological Diana, the final sculpture of which would serve as the finial/weathervane of his friend and architect Stanford White's Madison Square Garden Tower.

Stanford White (1853–1906) was inspired by the Giralda Tower in Seville, Spain (which also had a weathervane at the top), when he designed the new Madison Square Garden for New York City. Saint-Gaudens modeled an eighteen-hundred-pound Diana for him, which, at eighteen feet high was installed three hundred forty-seven feet above the ground on the cream-colored brick tower in October 1891. Once in place, the figure proved to be too large. At their own expense, the sculptor and architect removed it, and Saint-Gaudens remodeled the piece, making changes in the drapery (which acted as a rudder) and repositioning the spherical mount. The new copper-gilded figure, thirteen feet high, was installed on top of the Madison Square Tower in 1893. As it was mounted on ball bearings, a wind pressure of one-quarter pound to the square foot was sufficient to move the now fifteen-hundred-pound figure. On opening night, lighted by sixty-six hundred incandescent lamps, and with ten giant carbon arc spotlights trained on it, the first lighted sculpture of its time was especially dramatic to the pedestrians below and the patrons of the roof garden restaurant and night club above.

The popularity of *Diana* is recalled in the many cartoons, photographs, and verses that it inspired. Edward Cary described it in *Century Magazine* in 1894 as "the first generous tribute to pure beauty erected within the careless sight of busy New York." The figure remained in place until 1925, when the New York Life Insurance Company replaced Madison Square Garden. The sculpture was dismantled, and in 1931 it was given to the new Philadelphia Museum of Art, where it was installed at the top of the main staircase.

Saint-Gaudens was urged by both his French artist friends as well as Stanford White to begin an edition of his *Diana* in a reduced version. The first casts of Saint-Gaudens's *Diana,* on a half-sphere with bow, arrow, and string, were thirty-one inches high. These were cast in bronze in New York City by the Aubry Brothers Foundry. A smaller version, with only the bow, remodeled from the early sketch, was twenty-one inches high, mounted on a full sphere that sat on a low, square tiered base, also of bronze. Saint-Gaudens used the Gruet foundry in Paris for these casts. Located at 44 Avenue de Chatillon, Gruet was the foundry that Saint-Gaudens used for the Farragut Monument (1800–01) and the Robert Louis Stevenson Memorial (1901–03; St. Giles Church, Edinburgh). Gruet also cast the reductions of the Frederick MacMonnies *Diana.* The editions were sold through Tiffany and Co. in New York City and Paris and Doll & Richards Gallery in Boston, as well as through the studio of the sculptor. He presented his wife, Augusta, with a cast of the twenty-one-inch version on Christmas 1894. A copyright was registered in January 1895 for the *Diana of the Tower.* These editions were not limited nor were they numbered. Saint-Gaudens sold the larger version for $200 and the smaller versions for $150 each.

The Currier's cast represents the twenty-one-inch version on a sphere, with the whole mounted on a marble-cube base. This cast was a gift from the sculptor's widow in 1916 on the occasion of the wedding of Katherine Kingsbury to Philip Faulkner in Keene, New Hampshire. Augusta Saint-Gaudens enlisted Faulkner as a founder and secretary/treasurer of the Saint-Gaudens Memorial in Cornish, New Hampshire, in 1919.

In 1899, while Saint-Gaudens was in Paris, he renewed his interest in the production of the editions of his sculpture. He developed a new base for the *Diana;* the full sphere was retained and he remodeled the bow, incorporating both a string and arrow into the ensemble, which was mounted on a Renaissance-style tripod with winged griffins.

After Saint-Gaudens's death, his widow copyrighted an edition of reductions of the bust of the *Diana,* which was remodeled from the smaller version with a slight change in the hairstyle. The remodeling was probably done by the sculptor's brother, Louis Saint-Gaudens (1854–1913), and the changes were also included in a continued casting of the editions mounted on the tripod base.

References:

John H. Dryfhout, "Augustus Saint-Gaudens," in Jeanne Wasserman, ed., *Metamorphoses in Nineteenth-Century Sculpture* (Cambridge, Mass.: Fogg Art Museum of Harvard University, 1975), pp. 181–218.

John H. Dryfhout, *The Work of Augustus Saint-Gaudens* (Hanover, N.H.: University Press of New England, 1982).

J. H. D.

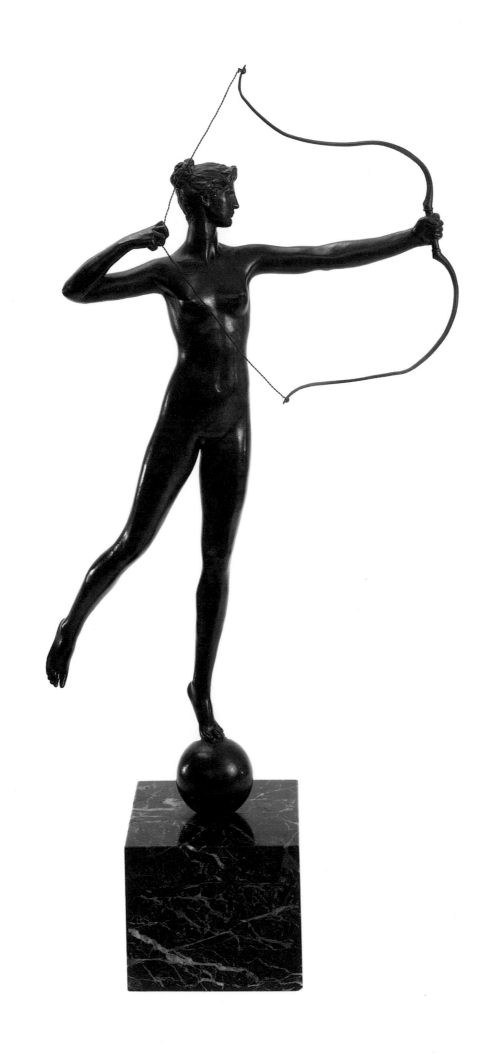

FREDERIC REMINGTON
(1861–1909)

The Bronco Buster, 1895

(this cast, no. 24, by Henry-Bonnard Company, New York)
Bronze; 26 x 19 x 14 in.
Signed on top of base: "Frederic Remington"; inscribed on back of
base: "COPYRIGHTED BY / FREDERIC REMINGTON 1895"
Bequest of Florence Andrews Todd in memory of her mother, Sally
W. Andrews, 1937.8

The illustrator, painter, and sculptor Frederic Remington was one of the so-called Independent American artists who captured the disappearing Wild West during the late nineteenth century. A native of Canton, New York, Remington enrolled in 1878 at Yale University, where he took a drawing course taught by John Niemeyer. After his father's death, he left school and in 1881, at the age of eighteen, he went west. He roamed from Mexico to Canada, rode the wagon trains and cattle trails from Texas to Montana, prospected for gold in the Apache country of the Arizona Territory, and worked as a hired cowboy. He became the owner of a small ranch in Kansas and part owner of a cowboy saloon in Kansas City.

He returned east in 1885, broke but determined to become an artist. In New York City, he enrolled at the Art Students League, where he studied with the painter J. Alden Weir in 1886. The following year, his first sketches were published in *Harper's Weekly* and *Outing*. Remington quickly became one of the most popular and highly paid illustrators. His *Pitching Bronco* for *Harper's Weekly,* which appeared in 1892, would serve as the preliminary sketch for his first piece of sculpture, *The Bronco Buster.*

Following a lull in the reception of his paintings in 1892, Remington began to look for another medium. Watching the sculptor Frederic W. Ruckstull modeling his equestrian sculpture of Major General John F. Hartrauft in 1894, Remington was encouraged to begin modeling. He started work on *The Bronco Buster,* and by January 1895 Remington wrote his friend the writer Owen Wister, "my watercolors will fade—but I am to endure in bronze—even rust does not touch—I am modeling—I find I do well—I am doing a cowboy on a bucking bronco" (Letter to Owen Wister, 1895, Library of Congress, Washington, D.C.). By the end of March he could crow to his Yale College classmate Poultney Bigelow, "It's the biggest business I ever did and if some of these rich sinners over here will cough up and buy a couple of dozen I will go into the 'mud business'" (Letter of Poultney Bigelow, 1895, Poultney Bigelow Collection of Remington

Letters, Saint Lawrence University, Canton, N.Y.).

The Henry-Bonnard Company reproduced *The Bronco Buster,* as Remington copyrighted it on October 15, 1895: "Equestrian Statue of Cowboy mounted upon and Breaking in Wild horse standing on hind feet. Cowboy holding onto horse's mane with left hand while right hand is extended upwards."

The bronze was exhibited in the windows of Tiffany and Co., on West 16th Street in Union Square, New York City. The bronzes were sold for $250 each. *Harper's Weekly* published an illustration of the sculpture in its October 19, 1895, issue. The art critic Arthur Hoeber wrote in the text that accompanied the illustration: "Breaking away from the narrow limits and restraints of pen and ink on flat surface, Remington has stampeded, as it were, to the greater possibilities of plastic form in clay" (*Harper's Weekly,* October 19, 1985, p. 993). *Century Magazine* followed with four views of the sculpture. The foundry issued a circular on the piece with an endorsement by Saint-Gaudens. During the next several years, more than forty-five castings of *The Bronco Buster* were sold. Before 1900, seventy sand-cast bronzes were made by Henry-Bonnard. The figure and base were cast separately with the reins, stirrups, whip, and other details added in the process of finishing and chasing. The Currier cast was made in the very first years of the production.

During the next three years, Remington would complete other bronzes on the western theme: *The Wounded Bunkie* (1896), *The Wicked Pony* (1898), and *The Scalp* (1898). After 1900, Remington turned his production over to the newly formed Roman Bronze Company in Greenpoint, New York. Roman Bronze carried out "lost-wax" castings of *The Bronco Buster;* some 305 casts were done in the twenty-three-and-a-half-inch size and approximately twenty-two in a larger thirty-two-inch size, which Remington modeled in 1909.

During his lifetime, Remington completed over twenty separate sculptures, but the most popular of all was *The Bronco Buster.* Indeed, *The Bronco Buster* became the most popular American bronze statuette of the nineteenth and twentieth centuries. The "Rough Riders" presented then Colonel Theodore Roosevelt with a bronze cast of the piece when they were mustered out in 1898.

References:

Beatrice G. Proske, *Brookgreen Gardens Sculpture.* (Murrells Inlet, S.C.: Brookgreen Gardens, 1943), pp. 61–65.

Michael E. Shapiro, *Cast and Recast: The Sculpture of Frederic Remington.* (Washington, D.C.: National Museum of American Art, Smithsonian Press, 1981).

Peggy and Harold Samuels, *Frederic Remington: A Biography.* (Garden City, N.Y.: Doubleday, 1982).

Michael E. Shapiro and Peter H. Hassrick, *Frederic Remington: The Masterworks.* (New York: Harry N. Abrams, 1988).

J. H. D.

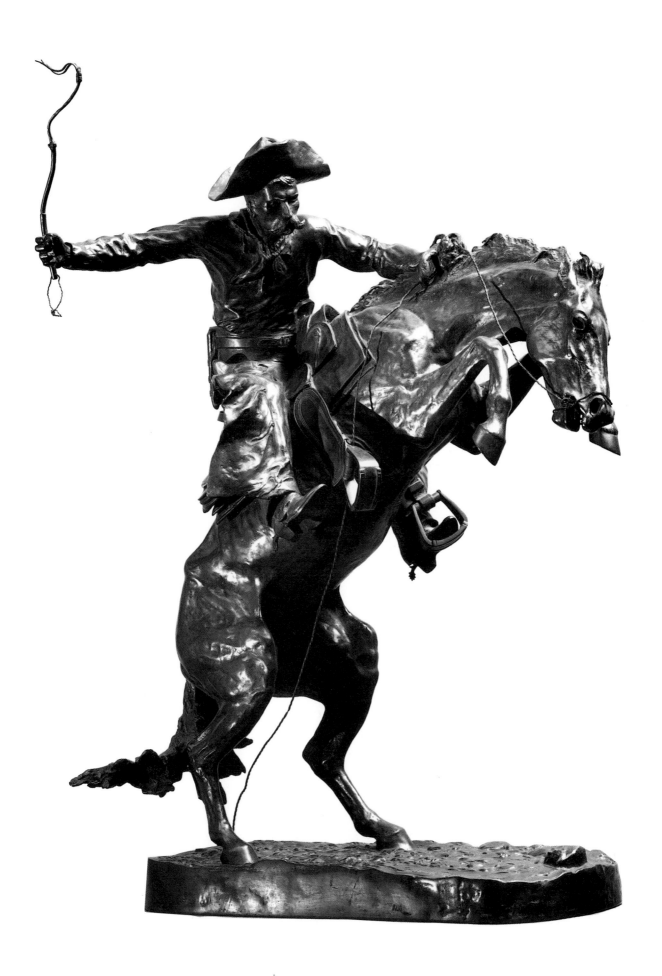

32 | DANIEL CHESTER FRENCH (1850–1931)

Jennie Delano, 1898

(this cast, Henry-Bonnard Company, New York)
Bronze; 24¼ x 18½ x 1¼ in.
*Signed lower left: "*DANIEL CHESTER FRENCH*/Sc. 1898";*
*inscribed across bottom: "*JENNIE WALTERS DELANO—
AT EIGHT YEARS*"*
Anonymous gift, 1972.27

Although Daniel Chester French made his reputation with his public sculpture, he was also adept at intimate portraiture—busts and reliefs. His bust of Ralph Waldo Emerson was an early success and one that was replicated in editions.

The Currier's portrait of Jennie Delano is French's fourteenth relief and was completed during his summer at "Chesterwood," the artist's summer home and studio at Glendale outside Stockbridge, Massachusetts. Jennie (Jean Walters) Delano (1889–1953), the fifth of seven children of Jennie Walters and Warren Delano III of East Orange, New Jersey, was depicted by French at the age of eight. Jennie Walters, the sitter's mother, was the granddaughter of Henry Walters, the founder of the Walters Art Gallery in Baltimore, Maryland. The sitter, Jennie, later married George H. Edgell, former director of Fine Arts and dean of the Architectural School, Harvard University, and director of the Museum of Fine Arts, Boston.

The Henry-Bonnard bronze foundry cast the relief. At the time, it was considered the best sand-cast bronze works in the United States. This was the foundry that French chose for casting his monuments as well. There is another bronze in a private collection, (descended through the Lyman [brother of Jean] Delano family), Saint Paul, Minnesota, and a plaster at "Chesterwood."

French's career spanned six decades during which time he executed nearly one hundred portrait statues, allegorical memorials, and architectural sculptures. His allegorical sculptures include the *O'Reilly Memorial* (1896; Museum of Fine Arts, Boston), the *Spencer Trask Memorial* (1915; Saratoga Springs, N.Y.), and the *First Division Memorial* (1924; Washington, D.C.). His portrait monuments include the *Ulysses S. Grant* (1899; Fairmount Park, Philadelphia), the *Abraham Lincoln* (1912; Lincoln, Nebraska) and the most memorable of all, the *Seated Lincoln* (1922; Lincoln Memorial, Washington, D.C.).

French was a founder and officer of the National Sculpture Society and president of the National Commission of Fine Arts from 1912 to 1915. He collaborated with the leading architects of his time: Henry Bacon, Cass Gilbert, Thomas Hastings, and Charles McKim. As trustee and chairman of the Sculpture Committee of the Metropolitan Museum of Art, New York, from 1904 on he was responsible for the collection and acquisition of a most significant group of American contemporary sculpture.

References:

Beatrice G. Proske, *Brookgreen Gardens Sculpture* (Murrells Inlet, S.C.: Brookgreen Gardens, 1943), pp. 15–20.

Margaret French Cresson, *Daniel Chester French: American Sculptors Series*, 4 (New York: W. W. Norton for the National Sculpture Society, 1947).

Michael Richman, "Daniel Chester French," in Jeanne Wasserman, ed., *Metamorphoses in Nineteenth-Century Sculpture* (Cambridge, Mass.: Fogg Art Museum of Harvard University, 1975), pp. 219–58.

Michael Richman, *Daniel Chester French: An American Sculptor* (New York: The Metropolitan Museum of Art for the National Trust for Historic Preservation, 1976).

J. H. D.

Decorative Arts

33 | DRESSING STAND
Probably Boston, 1680–1700

Maker unknown

Painted oak, pine, and cedar; 34¼ x 28½ x 18⅞ in.
Currier Funds, 1932.1.136

The dressing stand is one of the most celebrated forms of American seventeenth-century furniture. The few known examples are all believed to have originated in Boston or Salem, Massachusetts, colonial America's most cosmopolitan and commercially successful port communities. The form was used by both men and women to store toiletries, linens, jewelry, and other articles used in personal grooming. Its owners were the merchants, government officials, and clerics who made up the colonial elite.

Wallace Nutting, the legendary collector famous for his love of "pilgrim furniture" had a special fondness for what he called "small chests-on-frame." In his acclaimed *Furniture of the Pilgrim Century* (1924), Nutting stated how "these alluring little pieces of furniture excite our interest partly because they are small. Any miniature piece of furniture is like a child of the human species. We seem to love it more." Citing their rarity, beauty, and the "mystery" of their use, Nutting concluded that the dressing stand form was "fascinating" and ultimately "more ornamental than absolutely necessary."

Fascination is the breeding ground of intrigue. Even before Nutting's time, dressing stands were faked for the antiques marketplace. Authentic dressing stands like this one outnumber authentic "pilgrim" chests twenty-five to one. The form is simple, featuring a compartment that can be reached by lifting a hinged top over a single drawer that hangs from runners let into the front and rear posts. The "side hung drawer" was a common feature of joined furniture that became obsolete with the advent of cabinetwork. This stand has the unusual feature of a large, single pine-board back with two wide tenons, top and bottom, on each side. These are fit into mortises cut into the rear posts. A more standard approach would be to fit the back into grooves cut in the rear posts and rails, in the manner of the side panels.

The chest shown here is an example of unimpeachable integrity, even retaining traces of its original painted decoration. Its oak frame is turned at the legs and chamfered around pine panels dressed with cedar moldings and paint.

The evidence of surviving painted ornament is quite astonishing not only for its rarity but also for its character. Because early collectors favored the natural wood finish of pilgrim furniture, most of the work that exists today is stripped bare of its original paint. How much of this furniture was originally painted and how lavish the paint treatments might have been has caused spirited debate among scholars. Bold swirls of black on red paint—what may have been the most common style of painted ornament used by American seventeenth-century joiners—probably covered the entire surface of the chest originally but are now visible only in traces on the rails. The front panels, typically the most outstanding design element, might have been decorated with birds, flowers, trees of life, or other such elements occasionally found on comparable chests and stands.

W. N. H. and K. B.

CHEST
Taunton, Massachusetts, 1729

Robert Crossman
(1707–1799)

Painted pine; 32⅝ x 37⅞ x 18⅜ in.
Gift of Marjorie Park Swope, 1988.5

Among examples of "pilgrim furniture," the painted chests made and decorated by the Taunton, Massachusetts, drum maker Robert Crossman are among the most distinctive and original treasures of the early colonial period. Although not as expensive or as serviceable as the chests of drawers and high chests then in vogue among affluent urbanites, Crossman's Taunton chests are almost unrivalled in early American furniture for innovation and exuberance of design.

The 1720s and 1730s were a period of tremendous change in the quantity and style of possessions owned by New Englanders. Increasingly affluent and acquisitive households demanded new evidence of their material success. Paint-decorated board chests of inexpensive domestic woods were made in small or rural towns in interior New England at a time when cabinetwork fashioned from imported or exotic domestic hardwoods threatened the livelihood of craftsmen trained in the old techniques. The need to compete spawned an inventive approach to design that is heralded today as one of the great achievements in the history of American furniture making.

The work of Crossman was first recognized and documented by the pioneer antiquarian Esther Stevens Fraser, who discovered his work at an exhibition in Boston in 1925 and subsequently published a landmark study that convincingly attributed a significant group of early painted chests to this previously unknown maker. Half a dozen chests, bearing owner's initials and dates ranging from 1727 to 1742, together with almost two dozen more chests either lacking dates, original decoration, or both, comprise the known body of work attributed to this intriguing maker. During the decade and a half in which paint-decorated chests were popular in Taunton, Crossman probably produced several dozen chests. He was a joiner by trade who built houses and did interior woodwork, and he maintained the specialty in drum making first practiced in Taunton by his grandfather. The methods of the woodworking trade in colonial New England typically were passed on to successive generations within families. Representing the third generation of one of Taunton's most active woodworking families, Robert Crossman was perhaps able to arbitrate the tastes of his clientele by offering unconventional products. The painted chests, first developed when Crossman was just twenty-one years old, represent a unique and apparently successful response to the changing tastes of the time.

Crossman employed a vocabulary of ornament that included trees of life, birds, tulips, scrolling vines, and geometric patterns of densely spaced wavy lines, applied in thick yellow, green (now appearing white), and orange paint on pine finished with a black-on-red painted ground. The chests frequently contain false drawer fronts. Here only one of what looks like three drawers is real, an obvious concession to the growing status attached to multicompartmental chests of drawers. Like many of the Taunton chests, this example is dated and bears the initials of its first owner, "S.A." The chest is believed to have belonged to Sarah Andrews, about whom little is known. To date, all chests bearing the initials of a known owner's name have belonged to females. Like the well-known flower-and-vine decorated "Hadley chests" of the Connecticut Valley, Crossman's paint-decorated chests might been used as part of the custom in which adolescent girls were provided with a chest containing goods for setting up house. Flowers and other symbols of fertility represent an expectation of fruition at a time when family prosperity and female fertility were entwined.

Reference:

Esther Stevens Fraser, "The Tantalizing Chests of Taunton," *Antiques* (April 1933), pp. 135–38.

W. N. H. and K. B.

35 | BANNISTER-BACK ARMCHAIR
Western New England, 1730–50

Maker unknown

Maple and ash with rush seat
46¼ x 23⅛ x 19 in.
Currier Funds, 1932.1.87

The New England "crown" or "great" chair was the literal seat of authority in most early eighteenth-century homes. In spite of greater attention paid to more stylishly ornamented and upholstered chairs, turned "banister-back" chairs like this one were the most popular type of formal seating used in New England during the first half of the eighteenth century and almost the only type found in rural and western New England homes before 1750. Although designed to emulate the new baroque-style caned and upholstered chairs first introduced to Boston at the turn of the century, the form and the methods used in making these chairs owe more to the turning techniques of the seventeenth century.

The seventeenth century was the golden age of turned furniture, and the traditions of turned ornament remained a significant factor in American chair design well into the nineteenth century. The skill of the turner is evident in the crisp outlines of the posts and rails and the delicately tapered banisters. Lathe-turning was the language of ornament, and chairs like this were easily recognized as agents of fashion.

In spite of their prominence, turned great chairs have not been adequately studied, and only a handful of the dozens of shop traditions have been identified. This chair, which has no verifiable history of ownership, resembles work produced in the Connecticut Valley and along the coast of Connecticut. Chair makers along the New Hampshire coast and as far west as the Berkshires in Massachusetts also made turned banister-back armchairs during the middle and late eighteenth century. Typically, chairs like this were painted black or red.

W. N. H. and K. B.

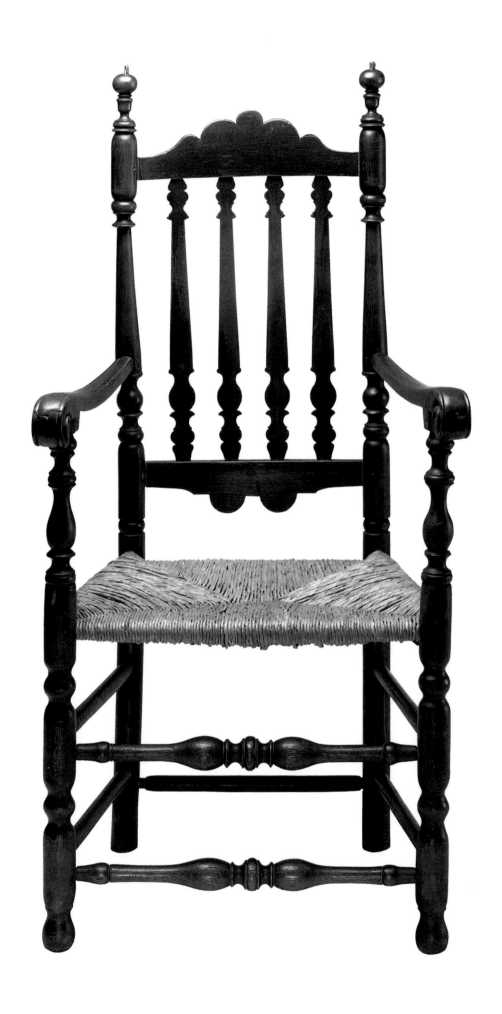

SIDE CHAIR
Portsmouth, New Hampshire, ca. 1740

Attributed to John Gaines III (1704–1743)

Maple with modern upholstered seat; 40⅝ x 21¼ x 20⅛ in.
Markings: "XI"
Museum purchase: gift of Mr. Christos Papoutsy, Cogswell Benevolent Trust, Amoskeag National Bank and Trust Company: Estate of Benjamin S. Cohen, Priscilla Sullivan, Henry Melville Fuller, Sturm, Ruger and Company, Inc., William S. Banks Foundation, Mrs. Mary Shirley, Anne and Norman Milne, and Mrs. Ruth B. Drake, 1987.58

John Gaines is the most important name in the early history of New Hampshire furniture making. Gaines, who was a member of a prominent woodworking family from Ipswich, Massachusetts, settled in Portsmouth, New Hampshire, during a period of economic expansion. At the time of his death in 1743, Portsmouth was one of the fastest-growing ports in colonial America. Growth and the desire of the city's merchant class to participate in the international consumer revolution created a market for chairs of remarkable vitality and ostentation.

The Ipswich of Gaines's youth boasted a vibrant local economy. Situated between Boston and Salem, it was not wholly dependent on either place for its prosperity or aspirations. John Gaines's father, John Gaines II (1677–1748), was a farmer whose livelihood involved turning on a lathe everything from hoe handles, rolling pins, and cider barrel taps to church pew balusters and chairs. A rare surviving family account book documents the Gaineses' labor and production. The Gaines family specialized in turned work at a time when most joiners offered a general range of products and services. The family is remembered today almost exclusively for its chairs, widely regarded as among the most artful creations in American furniture. It is not certain whether the father or the son was primarily responsible for the design elements of the most admired chairs, but clearly John III's move to Portsmouth furnished patronage that enabled him to adapt and refine them.

This chair is typical of the more sophisticated examples of John Gaines III's production at the time of his death in 1743. The signature features of the old-model Gaines chairs—intricately carved yoke crests, complex vase and flange-shaped splats, and excessively turned legs and stretchers—are further exaggerated, resulting in a piece that is unmatched among American chairs for its exuberance of ornament and form. Here, the baroque idea of verticality and excessive curvature is taken to new heights and crowned with a deeply carved and tightly sculptural compound shell. The turner has now merged another specialization—that of the wood-carver—to create a splendid hybrid of great distinction.

Not surprisingly, John Gaines III attracted a clientele that included several of the leading merchant families of New Hampshire, including Sir William Pepperrell and John Moffatt. The original owner of this chair is not known, but it was one of a set of twelve of Gaines's most expensive chairs and thus inevitably found a place in one of Portsmouth's wealthiest families.

References:

Helen Comstock, "An Ipswich Account Book 1707–1762," *Antiques* (September 1954), pp. 188–92.

Brock Jobe, *Portsmouth Furniture: Masterworks from the New Hampshire Seacoast* (Boston: Society for the Preservation of New England Antiquities, 1993), pp. 295–300.

W. N. H. and K. B.

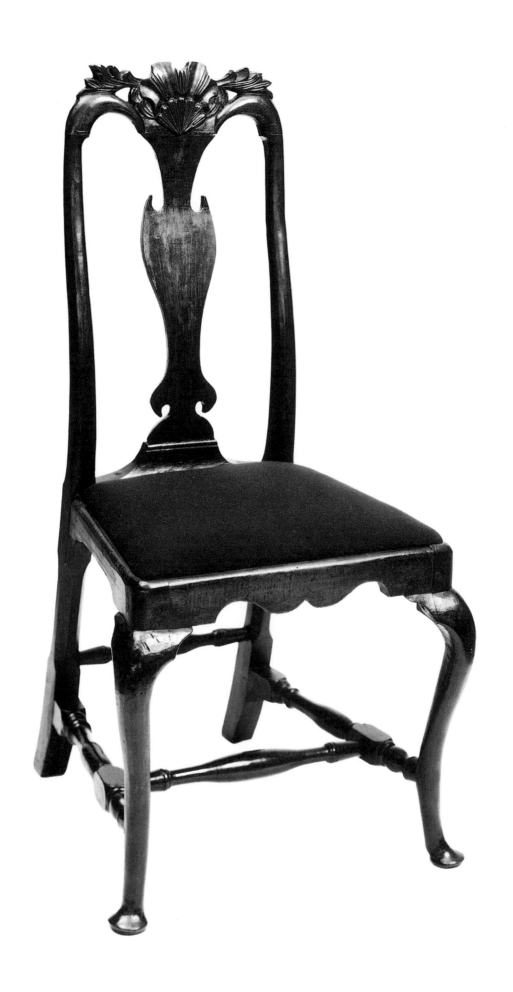

CARD TABLE
Newport, Rhode Island, 1770–80

Goddard and Townsend shop
Attributed to John Townsend
(1732–1809)

Mahogany and pine; 29¾ x 31⅞ x 15⅞ in.
Markings: branded "W.S. CROWELL"
Gift of Anna Stearns, 1964.12

Eighteenth-century New England saw the development of many regional furniture styles. A number of factors contributed to this phenomenon, including the common training of joiners, tightly knit artisan communities in urban areas, and well-connected patrons. In Newport, Rhode Island, the role of the Goddard and Townsend families in shaping local style during the second half of the eighteenth century cannot be underestimated. These two cabinetmaking families, linked first by craft (John Goddard was apprenticed to Job Townsend), then by marriage (Goddard married Townsend's daughter in 1746), formed a dynasty whose influence and prominence in turn shaped a Newport style. One of the styles believed to have been created in Newport, perhaps by John Townsend or his cousin Edmund (1736–1811), was the stop-fluted (describing the carved decoration on the legs), serpentine-front card table. Both men are known to have produced stop-fluted furniture. Many examples of this type of table exist, but few can be attributed to the Townsends or the Goddards. An analysis of construction techniques supports the attribution of the table shown to John Townsend. Very fine dovetail joints: tenoned, rather than nailed, corner brackets; and the use of a knuckle joint for the hinge, which allows the back legs to swing, are found together only on Townsend's tables.

Card tables, like tea tables, were linked to the specific social practices and fashions of the parlor. When not in use, card tables stood neatly against a wall, occupying very little space due to the hinged top, which folded to produce a functional half table in its closed state. When a game of cards, which had become an acceptable pastime in stylish homes, was desired, the table (or tables, as they often were sold in pairs) was pulled out and unfolded, the back legs swiveling to support the unfolded half of the tabletop. The presence of a pair of card tables in a room signified wealth and luxury, not only because the furniture was finely crafted and obviously expensive, as in the case of this table, but by virtue of the abundance of leisure time implied by a game of cards.

Like all the finest Newport card tables, this example is meticulously crafted, from the fine carving that enhances the serpentine curves of the apron to the glue blocks underneath the tabletop and the tenoned fretwork corner brackets. The table is made entirely of mahogany, with the exception of the backboard underneath, which is pine. Mahogany, while expensive, was easily found in the port town and was well suited to carving. Typical of the tables made by the Goddard-Townsend family of cabinetmakers, and in particular those made by John Townsend, are the stop-fluted legs and deep curves of the apron, which echo the shape of the hinged top. The straight legs, their straightness emphasized by fluted carving, are introduced to the curved skirt with carved, tenoned, Chinese-inspired fretwork brackets. This combination of serpentine curves (which the English artist and social critic William Hogarth called the natural "line of beauty"), with straight, architecturally inspired, classical column/legs and Chinoiserie embellishments, represents the epitome of the Newport Chippendale style, which tended to emphasize shapes rather than decoration.

References:

Brock Jobe and Myrna Kaye, *New England Furniture: The Colonial Era* (Boston: Houghton Mifflin Company, 1984), pp. 3–46, 291–94.

Michael Moses, *Master Craftsmen of Newport: The Townsends and Goddards* (Tenafly, N.J.: MMI Americana Press, 1984), pp. 13, 89–91.

W. N. H. and K. B.

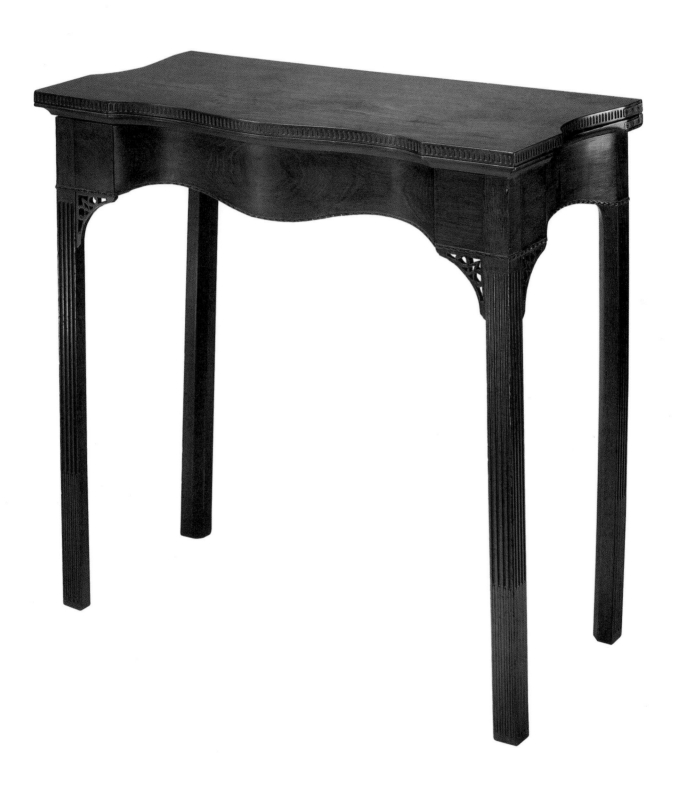

38 | PAIR OF LADDER-BACK SIDE CHAIRS
Northeastern coastal Massachusetts, 1780–1800

Maker unknown

Mahogany; 37⅝ x 21¼ x 21¼ in.
Currier Funds, 1932.1.95.1–2

After the Revolutionary War, affluent Americans continued to furnish their homes in the latest available English styles. As soon as the American ports were reopened to British trade, English goods were welcomed by an eager clientele. The appearance in Boston of imported English carved slat-back upholstered chairs with straight, or Marlborough, legs in the 1770s created a fashion for the form that local cabinetmakers satisfied with their own versions for nearly three decades. English examples of this type of Chippendale-style chair with histories of ownership in or near Boston bear close resemblance both in construction and form to the ones pictured—of unidentified origin—and wealthy citizens from all over New England are known to have acquired sets of such chairs from Boston makers.

The sophisticated features of the chairs shown betray an urban sensibility, if not origin. Notable details include the finely carved slats with honeysuckle (or anthemion) decoration, a molded and carved crest rail, molded legs, a serpentine seat front, and over-the-rails upholstery (recently restored following the original brass-tack pattern). Less elaborate versions were also made, but for those who could afford it, more decoration was more desirable, which would have placed these chairs in high esteem when they were made. Today, they are considered to be among the best American examples of the form.

Besides the requisite design features, this pair of chairs shares particular construction and decoration details with an English example that was imported to Newburyport, Massachusetts, and used in the Bartlett-Atkinson House, which now belongs to the Society for the Preservation of New England Antiquities. The chairs have in common mahogany-veneered rear seat rails and diagonal bracing glued into the front corners of the seats. These selective features suggest that the unknown American cabinetmaker had firsthand knowledge of the latest English styles and techniques and perhaps was himself English trained, enabling him to supply fashionable clients with equally fashionable furnishings.

References:

Brock Jobe and Myrna Kaye. *New England Furniture: The Colonial Era* (Boston: Houghton Mifflin Company, 1984), pp. 423–25.

William N. Hosley and Gerald W. R. Ward, eds., *The Great River: Art & Society of the Connecticut River Valley, 1635–1820* (Hartford: Wadsworth Atheneum, 1985), p. 245.

W. N. H. and K. B.

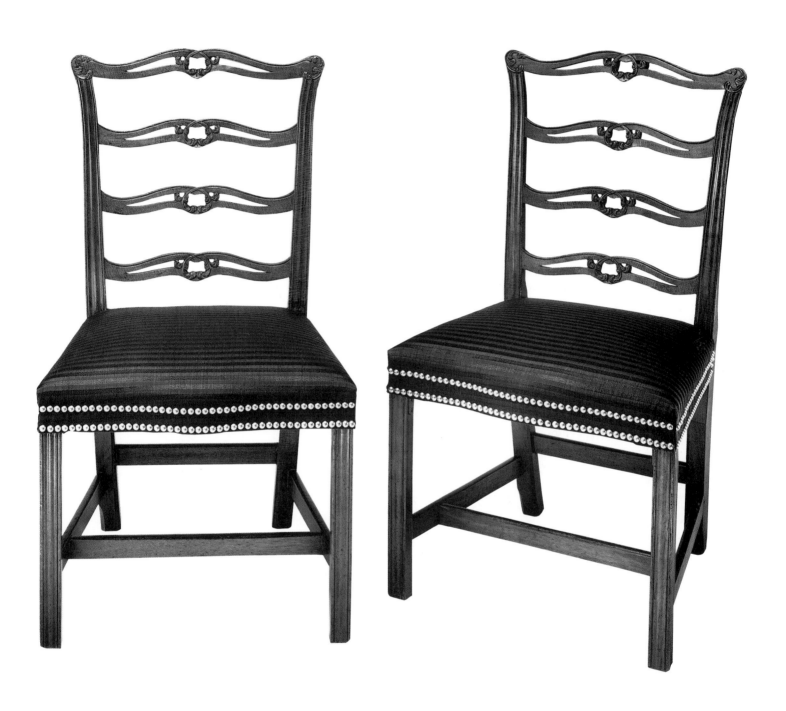

CHEST-ON-CHEST
Southern New Hampshire, ca. 1785

Maker unknown

Maple and white pine; 89⅛ x 44½ x 22¾ in.
George A. Leighton Fund, 1960.7

This monumental, block-front chest-on-chest belongs to an enigmatic, loosely associated group of furniture that features an unusual ornamental fan, carved with winglike, outward-sweeping lobes. The fan itself, however, cannot determine the origin of the piece. Both in eastern Connecticut and southern New Hampshire, this style of fan is found on regional cabinetwork and is undoubtedly the work of skilled but unspecialized joiners adept at customizing their furniture to appeal to a narrow local market. Typically, such work is among the rarest and most distinctive American furniture. Creative, but not entirely original, regional joiners excelled at amalgamating features, both borrowed and invented, to arrive at stylish designs.

Generally, block-front furniture was not produced anywhere in New Hampshire outside Portsmouth, the state's only cosmopolitan port. This chest is not Portsmouth work. In spite of the blocking, it actually shares more with the work of the Dunlaps, interior New Hampshire's premiere furniture-making dynasty. The blocking signifies other influences as well. Its form and structure represent a coarse and joinerlike imitation of classic Boston and Salem block-fronts, including such details as engaged and fluted pilasters and an enclosed bonnet pediment. Boston block-fronts, however, are never made of maple, a local wood inconsistent with the cosmopolitan aspirations of the block-front style, and they are not so roughly constructed or architectural in detail. The sides of the drawers are made of thick local pine stock, finished with a thick beaded molding on the upper edge. The drawer bottoms are also much thicker than in typical Boston or Salem work and are finished with deep chamfering where the edges fit into the drawer sides, which are cut with grooves to receive them. The most unusual feature—not surprising in joiner-made "country furniture"—is that the drawer bottoms are fastened to the backs of the drawers with wooden pins. Cabinetmakers almost always used nails for that purpose.

Mounting evidence indicates that maple furniture, such as the piece shown, was often, if not always, stained or painted. This chest bears evidence of what was probably an imitation mahogany finish, now largely invisible. Maple furniture stained to resemble mahogany was less expensive than mahogany, the imported exotic wood preferred by eighteenth-century furniture makers and owners.

Still, it cannot be determined where, when, and by whom this chest was made. Although block-front furniture was introduced to urban ports like Boston and Portsmouth as early as the 1730s and 1740s, no examples from smaller inland towns are believed to have been made before the Revolutionary War. Indeed, the latest research establishes that large bonnet-topped hardwood chests in the baroque, curved-line style remained fashionable in prosperous rural towns as late as 1805. In many places, this style first became popular after 1785.

A cabinetmaker named Moses Hazen of Weare, New Hampshire, has been associated with this type of chest, and it relates to another group that originated in Gilmanton, New Hampshire. Conclusive evidence, however, must await the discovery of a better-documented chest by the same maker. This chest has no family history, information furniture historians often find essential in determining a place of origin for regional work.

Reference:

Special thanks to furniture historians William Upton of Concord, New Hampshire, Donna Belle Garvin of the New Hampshire Historical Society, and Philip Zea of Historic Deerfield for their insights on this chest.

W. N. H. and K. B.

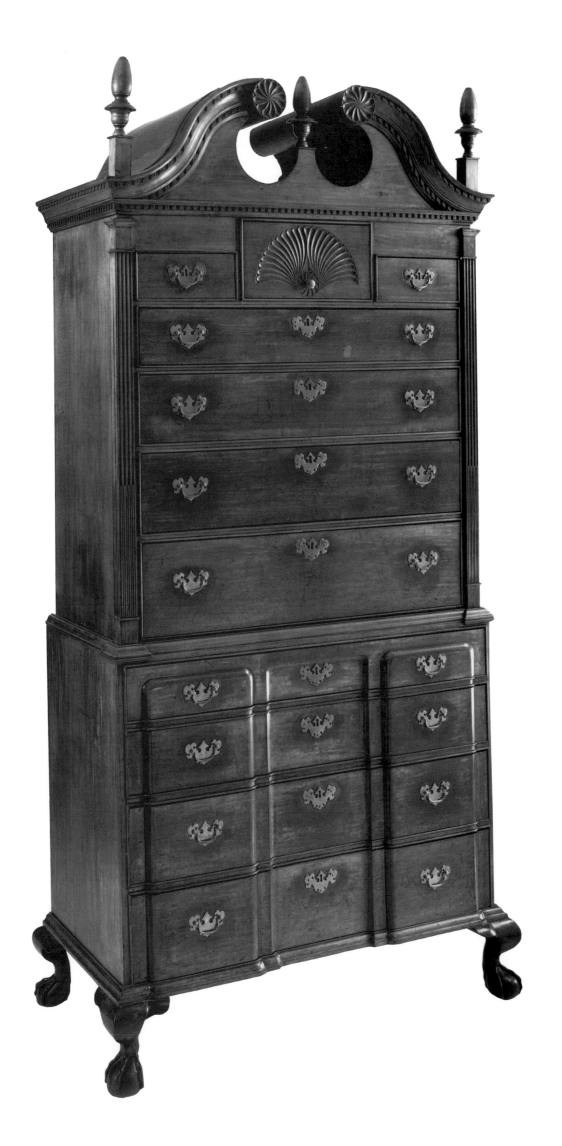

CHEST-ON-CHEST-ON-FRAME
Hennicker or Salisbury, New Hampshire, 1790–95

Dunlap school
Possibly Lieutenant Samuel Dunlap (1752–1830)

Maple and pine; 82⅝ x 41⅛ x 20 in.
Currier Funds, 1959.3

The Dunlaps of the Merrimack Valley region constituted New Hampshire's most acclaimed dynasty of furniture makers. The reputation is based on the survival of an astonishing collection of business records and drawings that document two generations of work by the Dunlap family from its origins in the 1760s through the nineteenth century. More important, the Dunlaps' furniture is the standard by which American regional furniture is measured. Few shop traditions anywhere produced so much furniture of such originality and inventiveness.

The Dunlap school originated with Major John Dunlap (1746–1792), who began work in Goffstown around 1768 and over the next decade directed the work of several apprentices, including his youngest brother, Lieutenant Samuel Dunlap. Both John and Samuel were general practitioners who alternated between designing, building, and repairing houses; painting, carving, and turning; and making chests, chairs, and other items from window sashes and bread troughs to drumsticks and gun stocks. None of these forms was produced in great quantity, which partially explains why common details and elements vary among related objects. John Dunlap's account book records the production of fewer than four chests per year during the 1770s, hardly the image of mass-production.

Lieutenant Samuel Dunlap is the most likely candidate to have made the chest shown, in part because of its history of ownership in Weare, New Hampshire, a town only nine miles from Hennicker, where Samuel worked. After training with his brother John, Samuel moved to Hennicker. He was a more prolific furniture maker, producing more than three hundred objects during the 1790s. He employed journeymen and apprentices almost constantly. Following his move to Salisbury, New Hampshire, in 1797, Samuel continued to make furniture. In this chest, skill, patronage, and inventiveness converged to create one of the most spectacular and monumental examples of American regional furniture.

With its fans, Gothic S-scrolls, and curved cabriole legs, the chest might ordinarily be assigned a date as early as 1775. But there is no evidence that the towering and resplendently carved chests for which the Dunlaps are famous were produced any earlier than 1780. This version, which includes cut nails in its construction, either was made late in the career of Lieutenant Samuel Dunlap or is the work of one of the Dunlaps' many journeymen and apprentices. In any event, it was probably made during the 1790s. Recent scholarship has noted the persistence of baroque-style furniture in interior New England as late as 1810.

The chest features a boldly executed example of a motif—the "flowered ogee" molding—that is one of the signature characteristics of the Dunlap school. The piece suggests a patron with an appetite for spectacle. The cornice is replete with Dunlap features, giving the chest a whimsical and monumental character. Fans, plumes, diagonal hatchwork, and compound moldings with dentils make this one of the most theatrical crowns in American furniture. The base or frame is similarly ornamented with expansive Gothic S-scrolls and compressed legs with exaggerated knee returns. The distinguishing features are not confined to ornamentation. The drawer fronts bear deep kerf marks, used in fastening the dovetailed sides to the front. The base, which is detachable, is assembled with massive bracing. The drawer arrangement is deceptive. Although the lower case appears to contain five drawers, it actually has only two; the top two are one and the bottom three are one. False fronts were designed to accentuate style and ostentation. This feature, although common enough in rural work, was rarely taken to such extremes. An added dimension of the Dunlap style involves the uses of painted finish. Here, the figured maple is so striking it is hard to imagine coating it with paint. The chest was ruthlessly stripped, however, and its hardware replaced during the 1930s. Microscopic analysis of the finish has not been undertaken, but would probably reveal evidence of a stained or painted finish. The Dunlaps not only stained their maple furniture to resemble mahogany, but offered other treatments to provide chromatic luster. Most intriguing of all is evidence of a chest-on-chest at the New Hampshire Historical Society with a multicolored pediment, rendered green, gilt, and mahogany. As spectacular as the Dunlap work appears now, it was without doubt even more so when new.

References:

Charles S. Parsons, *The Dunlaps & Their Furniture* (Manchester, N.H.: The Currier Gallery of Art, 1970), pp. 1–74.

Philip Zea and Donald A. Dunlap, *The Dunlap Cabinetmakers* (Harrisburg, Pa.: Stackpole Books, 1994).

W. N. H. and K. B.

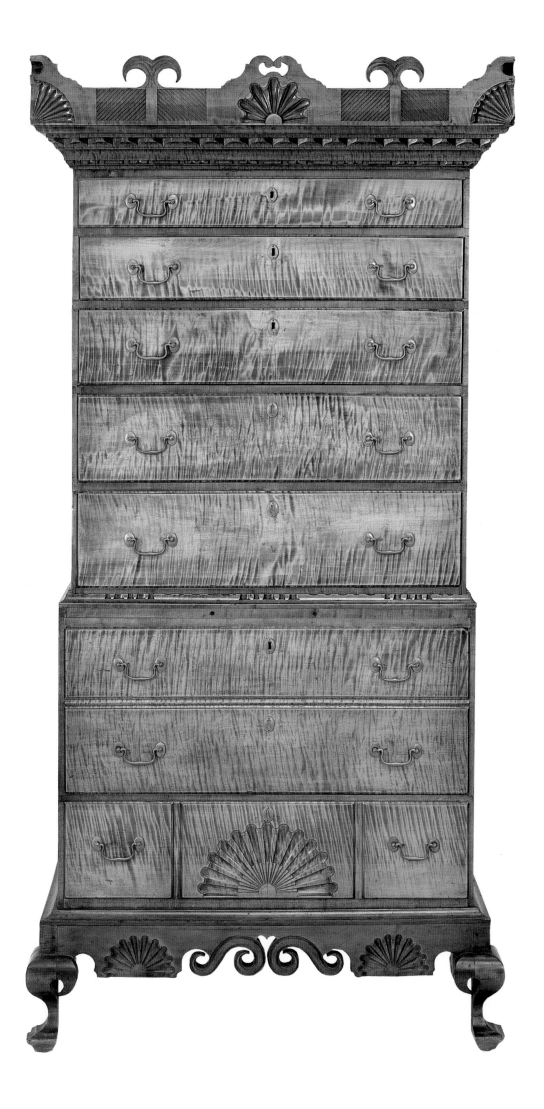

SIDE CHAIR
Hartford, Connecticut, 1795–1800

Maker unknown

Mahogany, cherry, and pine; 37⅞ x 22⅝ x 20¾ in.
Gift of Richard Varick, 1941.2.4

Before the end of the eighteenth century, Hartford's cabinet-makers began adopting cosmopolitan designs from English pattern books. This was a departure from the tradition of local design that gave Connecticut Valley furniture its character throughout the colonial era. George Hepplewhite's *The Cabinet-Maker and Upholsterer's Guide* (1788) was advertised by Hartford booksellers as early as 1799. A pattern from the book was the source for the chair shown, a type first developed for the Hartford market in 1791 by Aaron Chapin (1753–1838). The style was popularized by another Hartford cabinetmaker, Lemuel Adams (d. 1821), renowned for the commission he received to furnish Connecticut's first State House (1796). It represents the earliest evidence of neoclassical detailing in the furniture of interior New England. The baroque vase-shaped splat is rendered here as ribbons ornamented with a carved neoclassical urn and a pair of rosettes.

The 1790s were a period of dramatic transformation for Hartford's cabinetmaking industry. By the turn of the century, Hartford dominated the regional market for stylish furnishings, and its several competing cabinetmaking establishments were characterized by a high level of operational skill and specialization and the aggressive pursuit of new markets. Lemuel Adams and his partner, Samuel Kneeland, advertised their furniture as far north as Windsor, Vermont, a growing town 160 miles from Hartford. The Hartford cabinetmakers relied less on the tradition of custom work and more on marketing, component production, and product differentiation. Whereas before the Revolutionary War the variety of sophisticated chairs offered in the Hartford market was extremely limited, in 1795 there were at least twenty distinct types, varying more in ornament and detail than in proportion or construction. In 1792, the city's cabinetmakers codified their practice by publishing a price list that only begins to hint at the variety available. This chair, with a contoured seat, over-the-rails upholstery, and molded legs, all in mahogany, represents the most expensive version of the style. A nearly identical chair, made entirely of cherry, with a flat trapezoidal seat, a slip cushion, and unmolded legs, is much like the one described in the price list as having "urn'd banisters for loose seats" and costing twenty-nine shillings, or about five dollars. The chairs were usually owned in sets of six or twelve and represented a significant investment at a time when tradesman typically were paid less than a dollar per day.

This chair is said to have belonged to Colonel Richard Varick (1753–1831), mayor of New York City at the time the piece was made. Although this style of chair has never been directly associated with New York cabinetmakers, New York products and New York styles were popular in the Connecticut Valley, and it is conceivable that this chair was exported from Hartford or that a presently unrecognized New York cabinetmaker made chairs like this. The style was not unique to Hartford. A version of it, also based on Hepplewhite's design, was manufactured in Providence, Rhode Island.

Reference:

"Cabinetmakers' Price List" (Hartford: Hudson & Goodwin, 1792), as reproduced in *The Great River: Art & Society of the Connecticut Valley, 1635–1820* (Hartford: Wadsworth Atheneum, 1985), pp. 471–73.

W. N. H. and K. B.

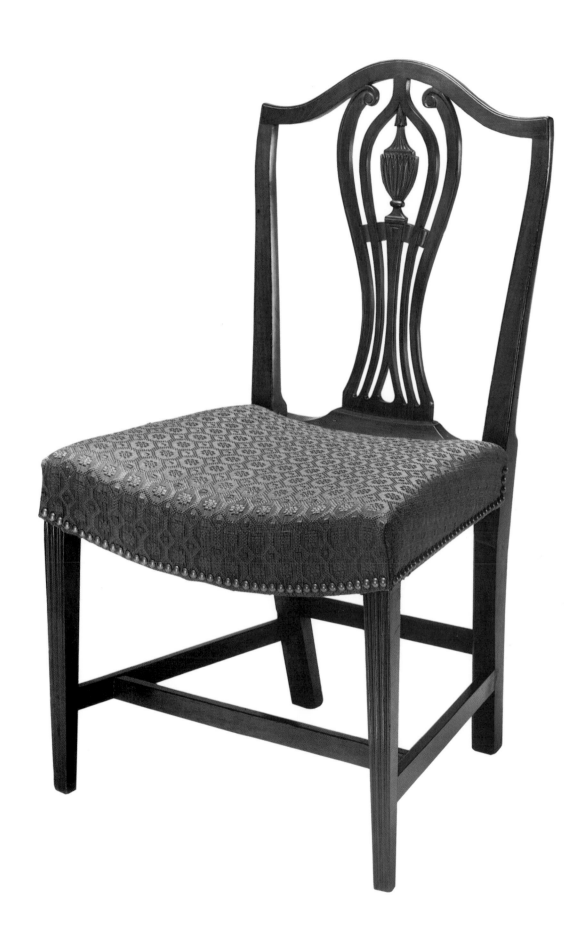

SOFA
Portsmouth, New Hampshire, ca. 1810

Maker unknown

Mahogany with birch veneer and horsehair upholstery
35 x 85¾ x 27¾ in.
Currier Funds, 1963.3

Furniture making in early nineteenth-century Portsmouth, New Hampshire, was a thriving business supported by successful merchants and ship captains who were mostly involved in the lucrative lumber and speculative goods trades. This segment of Portsmouth's population built imposing mansions, which were furnished with the finest available goods from Boston, England, and the town's highly skilled local cabinetmakers, such as Langley Boardman, who owned a mansion on Middle Street by 1820.

While its maker is unknown, the sofa shown has been associated with Portsmouth because six very similar examples of the form have well-documented Portsmouth histories. A total of twenty-six upholstered sofas with veneered crest rails are known, suggesting that this type of sofa was a staple of the fine furniture trade in Federal Portsmouth.

An upholstered sofa was best suited for a fashionable parlor, where its cushioned luxury could be enjoyed by its owner's important guests. Originally this sofa, and others like it, probably had several more cushions, loosely placed along the back. It did not have a separate seat cushion, however, a feature that was probably added as the original stuffing compressed and became less effective over time.

The level of detail desired, and expense of materials used, determined the cost of a sofa, which ranged from thirty-five to forty-five dollars, prices comparable to those of large pieces of case furniture. Carving and expensive veneer could elevate the cost considerably. Expensive options selected for this sofa include delicately foliate-carved arm supports, elegantly turned and reeded legs, a patterned birch-veneered crest rail, and veneered baluster turnings at the base of the arm supports. The carefully balanced contrasts that characterize Federal-period case furniture, have also been applied to the design of the sofa. Here, light, smooth, patterned birch veneer on the crest rail and baluster turnings is contrasted with the dark, carved, turned, and molded mahogany that caps the crest rail and forms the legs and arms of the sofa. A measured and refined elegance is the result.

Reference:

Brock Jobe, *Portsmouth Furniture: Masterworks From the New Hampshire Seacoast* (Boston: Society for the Preservation of New England Antiquities, 1993), pp. 378–81.

W. N. H. and K. B.

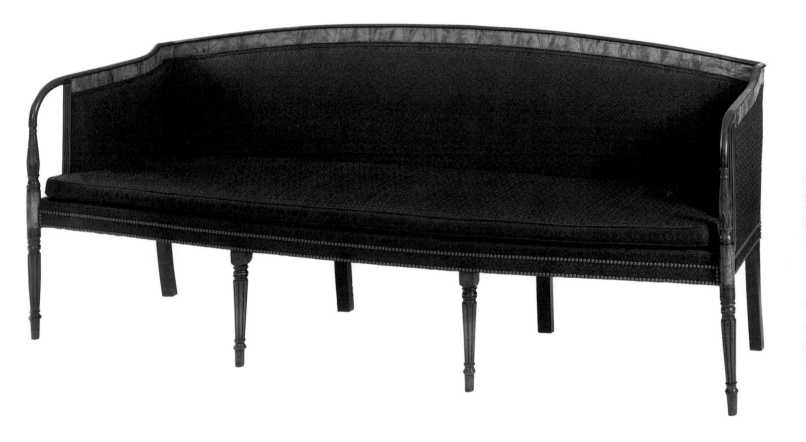

43 TALL CLOCK
Probably Concord,
New Hampshire, ca. 1810

Case maker unknown
Movement by Levi Hutchins
(1761–1855)

Curly maple, bird's-eye maple, rosewood, and satinwood
100 x 22¼ x 10½ in.
Currier Funds, 1962.1

Innovations in clock making during the late eighteenth century revolutionized the production and distribution of timepieces throughout New England. The Willard family of clock makers in Massachusetts was responsible for many of these changes, most of which had the effect of making the business of clock manufacture more efficient and therefore more profitable for the maker. The Willard family attracted clients from all over New England, where it became known for dependable clocks in the latest fashions, sold at a reasonable cost. The Willards' reputation set the stage for the next generation of clock makers who were both directly and indirectly influenced by the famous family.

Following his apprenticeship to Simon Willard in Grafton, Massachusetts, Levi Hutchins returned home to Concord in 1788 and built a successful clock-making business with his brother Abel (also a Willard apprentice). In Concord, the Hutchinses carried on their business in the Willard tradition, primarily making tall and shelf clocks. The brothers dissolved their partnership in 1806 but continued to make clocks—Levi until 1824, excluding a five-year foray into the textile business, and Abel until 1819, when he turned to the hotel business. Levi Hutchins, like the Willards, was interested in the latest inventions, and in addition to his staples of shelf clocks and tall clocks, was known to carry patent timepieces and is even credited with inventing the first alarm clock.

The tallest and most elaborately cased tall-case clock made in New Hampshire, the masterpiece pictured here is distinguished both inside and out. Since only Levi's name appears on the face of this clock, it is thought to postdate Abel's involvement. A clock with an almost identical case and similarly painted dial bears Abel Hutchins's name, suggesting that the brothers were still collaborating, albeit not formally. The hunting scene painted in the crescent over the face has been attributed to the Boston painter John Ritto

Penniman (1782–1841), but there is no documentary evidence to support this claim. Several Willard clock faces are known to have been painted by Penniman, however, and he did paint an oil on canvas of the same scene at about the same time (now in the Atkinson-Lancaster Collection of the New England Historic Genealogical Society). Willard apprentices are known to have utilized their masters' network of craftsmen, a practice that reinforced the Willards' dominance of the New England clock-making business and illustrates their profound influence on a generation of the area's finest clock makers.

The clock's case, made by an unknown cabinetmaker, was probably made locally, in the grandest style available. Notable features include curly maple quarter columns, string inlay outlining all of the major components, and traces of red and black paint, suggesting that at one time the case may have been grained to simulate rosewood. The size of the case has led to speculation that the clock was intended for a public space. Whatever its intended location may have been, this clock's elaborate details were calculated to leave an impression of wealth and power.

References:

Carol Damon Andrews, "John Ritto Penniman (1782–1841), An Ingenious New England Artist," *Antiques* (July 1981), pp. 147–70.

Philip Zea and Robert C. Cheney, *Clock Making in New England, 1725–1825: An Interpretation of the Old Sturbridge Village Collection* (Sturbridge, Mass.: Old Sturbridge Village, 1992).

W. N. H. and K. B.

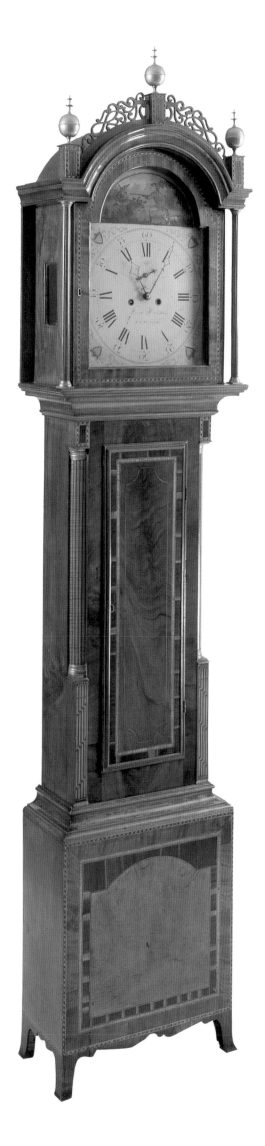

CHEST OF DRAWERS
Greenland or Portsmouth, New Hampshire, ca. 1813

Joseph Clark (1767–1851)

Mahogany, birch, and white pine with birch, mahogany, and maple veneers

Markings: history of ownership inscribed on underside of top drawer about 1930; original stamped brass hardware marked "H.J." for the Birmingham, England, firm of Hands and Jenkins

32⅝ x 37⅝ x 18⅜ in.

Gift of Mrs. Howard C. Avery in memory of her husband, 1979.83

During the post-revolution building boom that created an expanding market for furniture, Portsmouth's colonial joiners and turners were displaced by a new professional class of self-styled "cabinetmakers." Although a few names gained prominence and became rooted in the community, the industry was generally characterized by high mobility, high risk, and frequent business failure. Eventually, furniture making became so consolidated that most community-based suppliers were driven out of business by highly concentrated, technologically advanced firms able to mass-produce and mass-market the latest styles.

The chest shown was made by Joseph Clark, a cabinetmaker whose story echoes the changes at hand. He was born, raised, and practiced woodworking in Greenland, a town near Portsmouth. Born too early to be part of the rising generation of cabinetmaking entrepreneurs, he never quite rose above the horizon of obscurity. He did not advertise in the local newspapers, experienced legal problems, and eventually relocated to a remote part of northern New Hampshire where he was, perhaps, able to ply his trade and eke out a modest livelihood.

This chest was presented to Clark's daughter, Mary, at the time of her wedding in 1814. As one of the only works firmly attributed to this maker, it does not convey a convincing picture of expansive patronage. It does, however, reveal Clark's considerable skill and his ability at mimicking the work of Portsmouth's best neoclassical-style cabinetmakers. Portsmouth cabinetmakers perfected a program of ornament involving intricate bands of inlay, drop panels at the center of the skirt, and vividly contrasting veneers on the drawer fronts. Neoclassical exuberance was rarely achieved with such an economy of materials and such a conservative formal structure. The basic chest of four drawers was not new. But here the lightness of color and smoothness of surface had a transforming impact that assured its appeal. The use of expensive imported mahogany was kept to a minimum—the sides of the case are made of birch stained to resemble mahogany—but Clark succeeded in creating a look that was an unmistakable expression of its time and place.

W. N. H. and K. B.

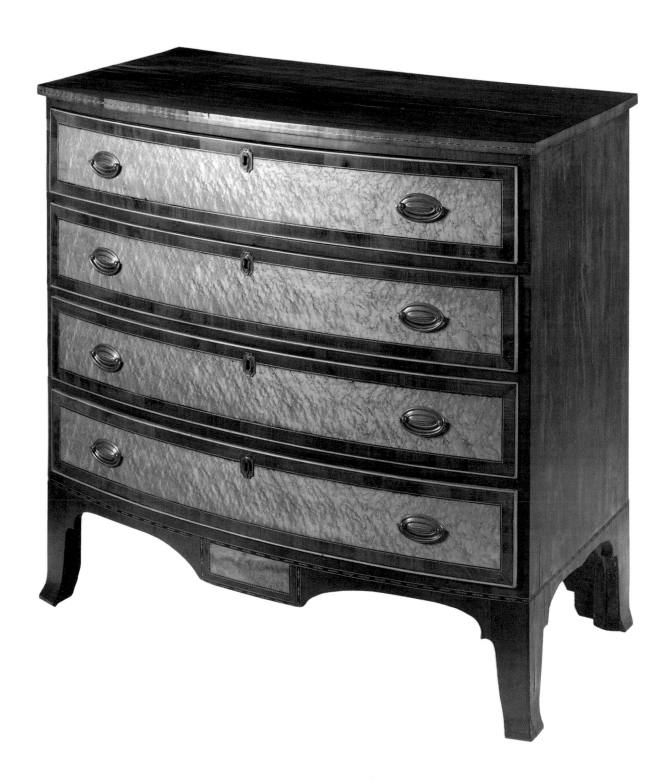

45 | SECRETARY AND BOOKCASE
Portsmouth, New Hampshire, ca. 1815

Attributed to Judkins and Senter (active 1808–26)

Mahogany and white pine with mahogany and birch veneer and lightwood inlay; 76 x 39 x 19¾ in. (closed), 27¾ in. (open)
Museum purchase: gift of the friends, 1974.24

The cabinetmaking shop of Jonathan Judkins (1776–1844) and William Senter (ca. 1784–1827) has long been associated with the colorful and flamboyant style of furniture produced in Portsmouth during America's early Federal period. Judkins and Senter reached beyond the pattern-book elegance associated with the names Hepplewhite and Sheraton to create a look that expressed the blustery confidence of new money in a rapidly expanding part of the fledgling nation. They were not the largest or most prolific of Portsmouth's cabinetmakers, but their work epitomizes the regional style at a time when Portsmouth was a vital center of New England's furniture industry.

Judkins and Senter's cabinetwork emphasizes contrasting colors, blaze-figured veneer, orderly arrangements of geometric panels, doors and drawers, and fine inlay. Portsmouth cabinetmakers originated this style, which is regarded as among the most exuberant expressions of Federal-period cabinetmaking, but they did not monopolize it. Cabinetmakers in interior Vermont and New Hampshire mimicked Portsmouth work with equally animated patterns of light and contrasting veneer.

Judkins and Senter, and their most successful competitor, Langley Boardman, enjoyed a vigorous export market, not only around Portsmouth and northern New England, but by venture cargo to the South, to Newfoundland, and as far away as the West Indies. At the time of William Senter's death in 1827, his shop had fifty-three pieces of furniture on hand, an indication of the growing importance of retail sales and marketing to the viability of a merchant-cabinet-making enterprise.

The secretary with bookcase is one of the most emblematic furniture forms of the Federal period. It became increasingly popular with the advent of industrialization. Whereas merchants and ministers were the primary and nearly exclusive users of desks during the eighteenth century, desks in the Federal period increasingly belonged to mechanics, farmers, and educated women. The ownership of books increased correspondingly. Most colonial families owned only a Bible and a psalmbook, but by 1810 it was not uncommon for people to own books of science, history, political economy, poetry, and literature. The secretary combines three functions—writing, the display and storage of books and writing implements, and the storage of clothes and textiles. The presence of large storage drawers is a legacy from the time when desks were used in multifunctional rooms furnished to accommodate eating and sleeping. Traditional back-parlor usage bespeaks informality, which runs contrary to the styling evident in this desk. Eventually, elaborate desks and bookcases were incorporated into "libraries," one of several special-purpose rooms adopted by affluent Americans during the 1830s.

The secretary and bookcase shown have Gothic-style pointed-arch glass doors and a bookcase interior that features a birch-veneered prospect door flanked by small drawers and symmetrically arranged pigeonholes. There is evidence that the exterior bookcase doors were originally furnished with curtains, probably bright and colorful.

Reference:

Brock Jobe, *Portsmouth Furniture: Masterworks from the New Hampshire Seacoast* (Boston: Society for the Preservation of New England Antiquities, 1993), pp. 178–81.

W. N. H. and K. B

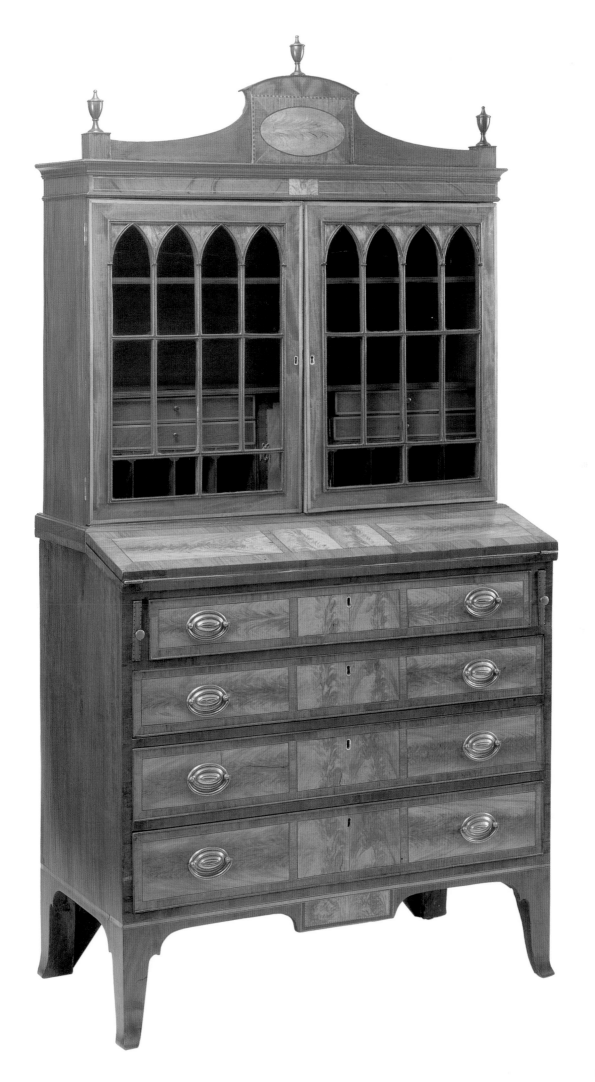

FRENCH SECRETARY
Boston, ca. 1825

Maker unknown

Mahogany, pine, cedrela, and marble
59¾ x 41⅜ x 18¼ in. (closed), 35⅞ in. (open)
Museum purchase: gift of the friends, 1986.16

The fall-front secretary, or *secrétaire à abattant*, is a French form that gained acceptance among American urbanites during the 1820s. Its bold geometric form, ingenious mechanical system of weights and levers, and multiplicity of small, elegantly fitted compartments made it the perfect form for an age that revered science and classical details. The fall-front never displaced the more common secretary and bookcase for which it was an expensive substitute. When and where this type of secretary form was introduced in the United States is unclear. As early as 1802, the British pattern-book author Thomas Sheraton included a fall-front secretary based on the French form in his publication *The Cabinet-Maker and Upholsterer's Drawing Book*. A growing population of French and German immigrant craftsman also may have introduced it. The French pattern-book author Pierre de la Mésangère illustrated and described the form in the 1803 issue of *Collection des Meubles et Objets de Goût*, a periodical available to American cabinetmakers. The form was not produced outside the major cities, where it found special favor with the merchant elite.

Long overlooked by American museums and collectors, the form was rediscovered during the early 1980s and became almost instantly the subject of great scholarly interest. The Currier was one of several museums to acquire a French secretary during this time, and examples have appeared subsequently in numerous publications and surveys. Stylistic distinctions have been attributed to Philadelphia, New York, and Boston. The most elaborate examples were made in Philadelphia and combine carved and veneered mahogany with marble, ormolu mounts, and a type of intricate brass inlay and marquetry known as buhl work. The Boston examples are more chaste, relying on their architectural massing and radiantly figured Santo Domingo mahogany veneer. The only documented Boston-made example of the form bears the label of Isaac Vose and Son. The Vose firm had roots in late eighteenth-century Boston and remained in business under various names until 1825, when it was sold to Thomas Emmons. Emmons and

Archibald is one of several prominent Boston cabinetmaking firms that could have made the secretary shown here. Frequently, the Boston examples have large paired columns or pilasters with an arched interior bookcase on small detachable columns over a standard set of five drawers. This example bears the label of one of Boston's Victorian interior decorators, Miss S. R. Hall, who presumably handled the secretary on the secondary market when it was a generation old.

Reference:

Page Talbot, "Boston Empire Furniture, Part I," *Antiques* (May 1975), pp. 878–87, and "Part II" (May 1976), pp. 1004–13.

W. H. and K. B.

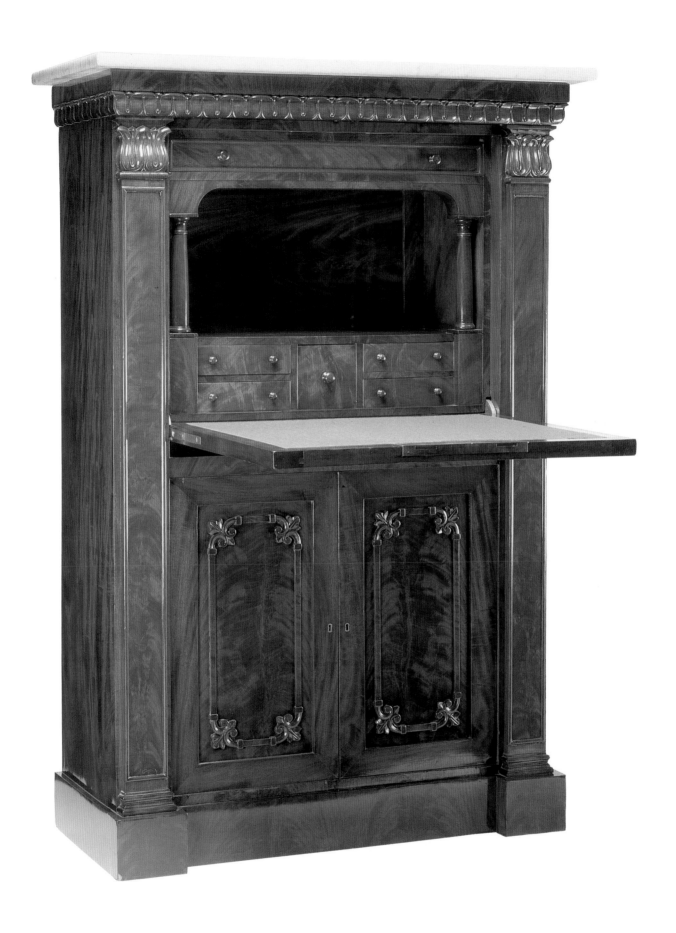

| # CENTER TABLE
Boston, ca. 1860

Buckley and Bancroft

Walnut and marble; 30¼ x 39¼ x 30 in.
Markings: "From Buckley & Bancroft furniture & upholstery
goods. Opposite U.S. Hotel Boston"
Museum purchase: gift of the friends, 1982.1

No furniture form epitomizes parlor life in Victorian America better than the once-ubiquitous center table. In private homes and in the public rooms of city hotels, the center table was a magnet for family and social gatherings. Contemporary prints show women gathered around the center table sewing or in conversation, men and women socializing, and family members, young and old, reading, talking, and looking at pictures. *Godey's Lady's Book,* a popular and influential Victorian periodical, carried a regular column titled "Center-Table Gossip," which encouraged the exchange of ideas among family members. Reading aloud was common in social gatherings during the nineteenth century, and it is no surprise to find the center table supporting a lamp and covered with books, prints, or the ever-present stereoscopic views. Uses of the table revealed a family's attitudes about formality. Although families were advised by proscriptive literature to use center tables for informal socializing, photographic evidence suggests that such tables were also used to hold formal—and almost immovable—displays of handiwork, sculpture, and artificial flowers.

The form, although introduced during the 1830s during the age of classical Greek influence and still in use a half century later, is most widely associated with the 1850s, a time of resurgent naturalism and picturesque design. During a decade that witnessed the triumph of the railroads, the proliferation of machine-tool manufacturing, and the campaign of "manifest destiny" involving expansion and conquest, it is small wonder that the arts would manifest a destiny of their own, by revealing an underlying ambivalence about "progress." The rococo-revival style celebrated nature. Few eras in modern history have witnessed a more profound change in taste than is represented by the shift from the rigid symmetry and formality of Greek classicism to the informality and naturalism of the rococo revival. Carried out with the utmost realism and an emphasis on handcraftsmanship, birds, fruit, leaves and vines, and complex scrolls were popular decorative motifs at the very time when ma-

chines and mass-production were destroying ancient traditions of artisanry.

The center table shown here is a masterpiece of the rococo-revival style and one of the finest and best-documented examples of deluxe parlor furniture produced in Victorian Boston. The underside of the marble top is stenciled with the label of Buckley and Bancroft, identified as makers of furniture and upholstery goods, located opposite the United States Hotel. Little is known about this firm. It was probably related to a prominent cabinetmaking establishment in nearby Worcester, operated by Timothy W. and Charles P. Bancroft during the 1830s and 1840s. During the 1880s, the firm of Bancroft and Dyer (see cat. no. 50), was one of Boston's most prominent manufacturers of top-quality furniture, suggesting the longevity of the Bancroft name in the region's nineteenth-century furniture industry, which, in spite of growing competition from the Midwest and an increasing emphasis on middle-market furnishings, was stronger and survived far longer than in most New England towns and cities.

Reference:

Jan M. Seidler, "A Tradition in Transition: The Boston Furniture Industry, 1840–1880," *Victorian Furniture* (Philadelphia: The Victorian Society in America, 1983), pp. 66–83.

W. N. H. and K. B.

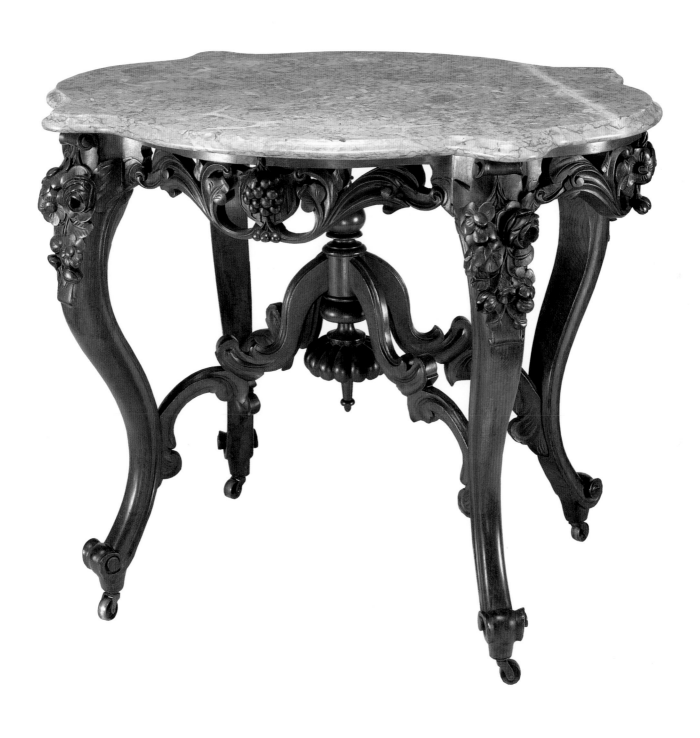

48 | PARLOR CABINET
New York, 1871

Herter Brothers (1864–1907)

Rosewood with inlay and painted decoration; 47½ x 51⅞ x 18 in.
Museum purchase: gift of the friends, 1989.9

Herter Brothers, New York's best-known nineteenth-century interior furnishings firm, led the American Aesthetic movement of the last quarter of the nineteenth century, a movement that sought to reform the excessive nature and declining quality of the decorative arts. The German-born and trained half brothers, Gustave (1830–1898) and Christian Herter (1840–1883), established their business in 1865, five years after Christian's arrival in the United States. By this time, Gustave, who had emigrated to New York in 1848, had already formed and dissolved several partnerships with other highly skilled cabinetmakers such as Auguste Pottier and Erastus Bulkley. Christian Herter's trips to Paris and England during the 1860s exposed him to the tenets of the Aesthetic movement just as it was taking hold in those countries. One of the leading English reformers, E. W. Godwin, specialized in the Anglo-Japanesque designs that would distinguish Herter Brothers from other American furniture designers. It is quite likely that Christian Herter had firsthand knowledge of Godwin's designs.

After the Civil War, a number of revival styles in furniture design enjoyed moments of popularity, but none offered as wide a range of interpretive possibilities as the Renaissance revival. Loosely based on the architecture of sixteenth- and seventeenth-century Italy, the Renaissance-revival style could also incorporate neo-Grec, Moorish, Egyptian, and other historical motifs, often layered atop one another. This parlor cabinet is an excellent example of the ebullient, eclectic style. While best known for its later outstanding Anglo-Japanesque designs, Herter Brothers developed its exclusive clientele and established its reputation for exquisite marquetry by furnishing mansions in the Renaissance-revival style.

The survival of this cabinet's original bill of sale, dated July 17, 1871, is remarkable. From this document, the original owner, a Mrs. Cobby, also of New York, is known, as is the original price of the cabinet, $307.50. Mrs. Cobby probably used the cabinet in her parlor to display sculpture and decorative art objects of the type she could have found in the showrooms of Tiffany and Company. While Christian Herter called this piece a "rosewood gilt inlaid cabinet" on the bill of sale, the primary function of such a piece was to exhibit items rather than to store them. Not only was the cabinet's design well-suited to the presentation of a small sculpture group, perhaps of the muses or other classical characters, it also, by virtue of the three rectangular front panels, proved an ideal vehicle for showcasing the decorative painting and marquetry skills advertised on Herter Brothers' billhead.

The cabinet's decoration can best be termed "Owenesque," after Owen Jones, the author of *Grammar of Ornament*, first published in London in 1856. In his book, Jones summarized the decorative motifs of the world's cultures, using one page of brilliantly colored designs for each. Acanthus leaves, associated with Egypt, are carved and gilded in a frieze around the top of the cabinet shown here and inlaid in the panel of the central section. The pedestal and vase marquetry decoration on the central panel serves as a metaphor for the cabinet's intended function and introduces classical shapes of urn, vase, and column. Outlining the doors of the side sections are intricate marquetry borders, identical in design to the skirt border of a Herter Brothers table in the collection of the Toledo Museum of Art, Ohio, but composed of different woods. Five different woods were used to create the inlaid decorations on this cabinet. The ornamental painting on the side panels is more naturalistic than the inlaid or incised decoration and introduces an element of trompe l'oeil. Here, butterflies and vines of flowers (which echo the stylized borders of vines outlining the doors) emerge from simulated panels that are actually painted on the doors. The unusual combination of marquetry and decorative painting, and the survival of the original bill of sale render this cabinet a unique example of a popular Victorian style.

References:

Doreen Bolger Burke et al., *In Pursuit of Beauty: Americans and the Aesthetic Movement* (New York: The Metropolitan Museum of Art, 1986) pp. 438–40.

The Bulletin of the Cleveland Museum of Art, (May 1987), pp. 193–202.

Frank Donegan, "Mid-Victorian Furniture," *Americana* (July–August 1990), pp. 62–64.

American and European Furniture and Decorative Arts, Butterfield and Butterfield, Los Angeles, California, (March 1991), sale 4524V (auction catalogue).

Katherine S. Howe, Alice Cooney Frelinghuysen, and Catherine Hoover Voorsanger, eds., *Herter Brothers: Furniture and Interiors of a Gilded Age* (New York: Harry N. Abrams in association with the Museum of Fine Arts, Houston, 1994).

W. N. H. and K. B.

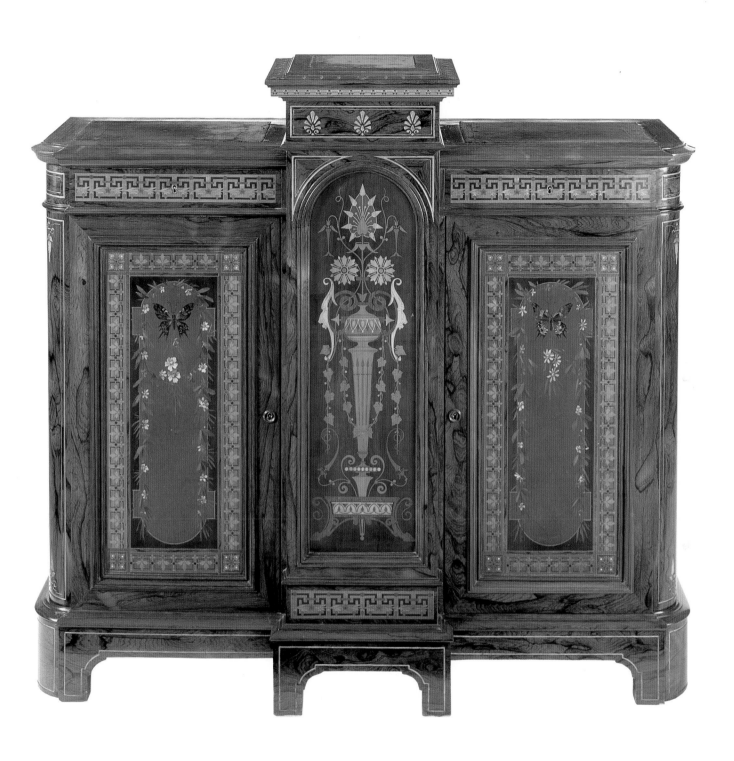

SIDE CHAIR
New York, ca. 1880

Herter Brothers (1864–1907)

Ebonized cherry with incised and gilded carving and oak
34⅛ x 17⅝ x 18⅝ in.
Markings: "4095" stamped on bottom right seat rail; "II"
stamped on back seat rail and "I" on top of front seat rail;
"Store" written in pencil on inside of back seat rail
Museum purchase: gift of Dr. and Mrs. Russell C. Norton in
memory of Dr. and Mrs. Daniel Capron Norton, and Currier
Funds, 1981.80

While custom treatments for the very rich were a Herter Brothers specialty, the firm also sold furnishings to a more modest clientele that was interested in the latest designs but did not require one-of-a-kind exclusivity. For these customers, stock such as this finely crafted, and expensive, but not unique chair was kept on hand in the brothers' East Eighteenth Street wareroom. The word "Store," penciled on the inside of the back seat rail, may refer to this location or may simply mean that the chair was to be kept in stock storage until it was needed. Several other Herter Brothers chairs bear the same mark. An identical chair, with a Brooklyn history, is in the collection of the High Museum in Atlanta. America's fascination with Japanese art and culture was at its peak in 1880, approximately when this chair was made. The popular Japanese Pavilion at the Philadelphia Centennial Exhibition, held in 1876, had introduced many Americans to the arts of Japan. Together with English reform literature and the writings of American reformers like Charles Locke Eastlake, the Centennial launched a craze for things Japanese. Herter Brothers was in the vanguard of that craze and supplied a Japanesque bedroom suite to William T. Carter of Philadelphia the year of the Centennial.

The chair shown here is made of ebonized cherry that has the smooth look of lacquer. A floating, low-relief carved panel set in the chair's back is reminiscent of Japanese wood carving. The subject of the carving, birds in flight, was used extensively in Japanesque designs and was a favorite Herter motif as well, appearing in marquetry on a table now in the collection of the Wadsworth Atheneum. The spare design of the chair back is a clever open grid of rectangles and squares that gives the piece a delicate appearance, as do the tapered legs and widely spaced sets of spindles connecting the primary and secondary seat rails. Carving also appears on the chair's crest rail, on either side of what looks like a handle. This type of chair, sometimes called a reception chair, was meant for use in a reception room, or parlor. The convenient handhold rendered the chair perfectly adapted to an environment that necessitated frequent rearranging to suit conversation groups and variable numbers of guests. Like other Anglo-Japanesque Herter side chairs, this example is a carefully considered statement, meticulously crafted and designed to reflect the latest in fashionable taste.

References:

Doreen Bolger Burke et al., *In Pursuit of Beauty: Americans and the Aesthetic Movement* (New York: The Metropolitan Museum of Art, 1986), pp. 438–40.

David A. Hanks, "Herter Brothers: Art in Furniture," *The Journal of Decorative and Propaganda Arts* (Spring 1986), pp. 32–39.

William N. Hosley, *The Japan Idea* (Hartford: Wadsworth Atheneum, 1990), pp. 137–39.

W. N. H. and K. B.

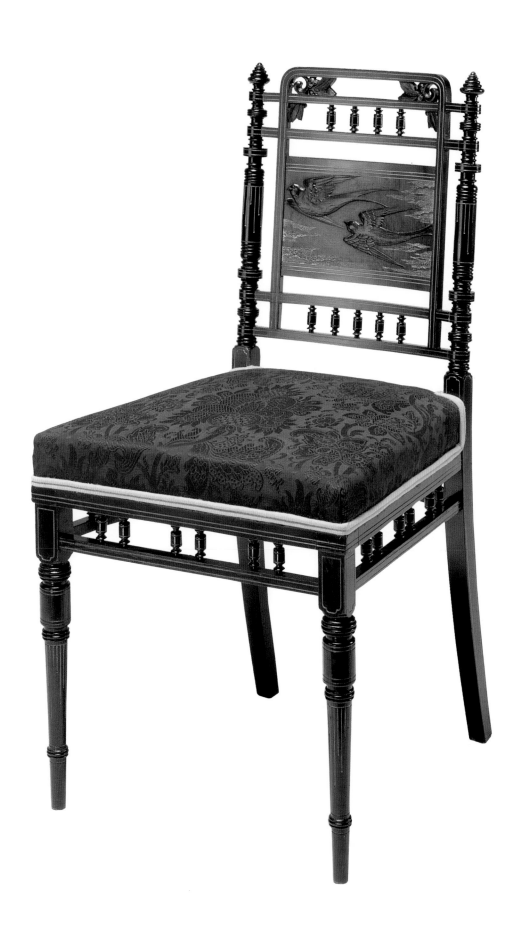

ETAGERE
Boston, ca. 1885

Bancroft and Dyer

Ebonized cherry and tulipwood; 60⅞ x 55¼ x 17½ in.
Markings: label reads "From Bancroft and Dyer's/Furniture
Warehouse/180 Tremont Street"
Anna Stearns Fund, 1991.23

The campaign to invest everyday things with a quality of artfulness gained headway after the 1876 Centennial Exhibition in Philadelphia. Between 1876 and 1890, American manufacturers of everything from carpets and plumbing fixtures to tableware and wallpaper created products imbued with a sense of "art," a quality epitomized by the theory and practice of industrial design promoted by the South Kensington School and Museum (founded in 1857) in London. British-influenced "artistic furniture" gained international favor, and for the first time Britain became a dominant force in world art. The British aesthetic emphasized rectilinear lines, traditional joined construction, and highly stylized naturalistic ornament. Dubbed the Aesthetic movement, this style in the decorative arts accommodated several design tendencies—from modern Gothic and Japanesque to Queen Anne and, in America, colonial revival. Although relatively pure expressions of these styles exist, the Aesthetic movement encouraged customization by mixing and matching design elements within a general linear format. Americans never had so many choices in the variety of form and ornament as were available during the 1880s. Choice created the illusion, if not the reality, of individualism. While Aesthetic interiors were a popular fashion, no two ever looked quite alike.

The étagère is perhaps the most emblematic form of its period. By 1880, America had become a nation of collectors. Coins and butterflies, exotic porcelains and colonial furniture were amassed, classified, and displayed, both in newly founded museums, and in the "little museums" of the home—étagères. The form, unusual a generation earlier, became an almost indispensable component of a personalized interior and was used, as were cabinets, for displaying collectibles. Primarily installed in reception rooms, interior spaces reserved for quasi-public social gatherings of women, the étagères would have been regarded by the Victorians as naked if not groaning with the weight of odd bits of china, glass, and decorative accessories. Indeed, the image of "Victorian clutter" is mostly a legacy of such interior decorating schemes.

The étagère shown is labeled by its maker, Bancroft and Dyer, one of several Boston firms that produced furniture for an affluent clientele. Although not in the same league as designers such as Herter Brothers or Kimbel and Cabus of New York, Bancroft and Dyer clearly competed in the market for stylish goods. The cabinet is richly ornamented with galleries, brackets, carved sunflowers, turned columns, and abundant space for display and storage. It is made of ebonized cherry, which has associations with Japanese lacquerwork, then at the height of popularity.

Reference:

Edward S. Cooke, Jr., "The Boston Furniture Industry in 1880," *Old-Time New England* 70, no. 257 (1980), pp. 82–98.

W. N. H. and K. B.

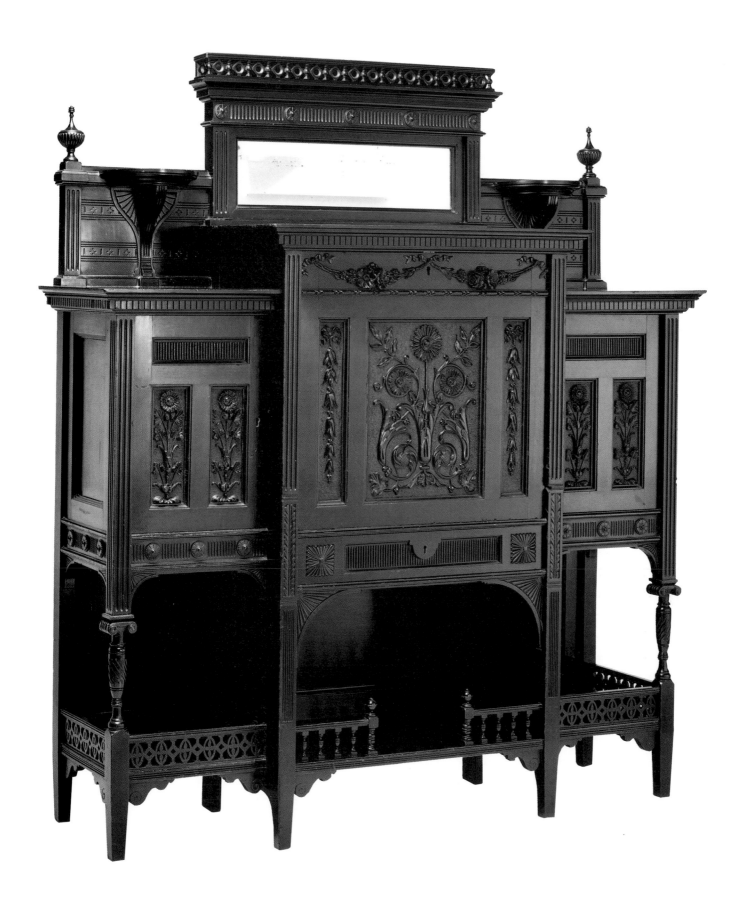

SUGAR BOX
Boston, 1680

John Coney (1655–1722)

Silver; 5⅜ x 8⅞ x 7⅛ in.
Markings: "IC" (partly obscured) stamped on inside bottom
with a cross in a heart
Gift of Eunice Higgins Straw in memory of
H. Ellis Straw, 1955.1

Sugar boxes, extremely rare objects in early American silver, were a particular specialty of the Boston silversmith John Coney. Arguably the most highly skilled of his peers, Coney is responsible for three of the nine examples known today. This sugar box is the largest of the three, but otherwise is identical in form and decoration. All extant sugar boxes were made by silversmiths in or near Boston, where there existed a unique fashion for the ornate containers.

Coney's early training remains a mystery. No records of an apprenticeship have been found, although John Sanderson and John Hull were both old enough to have been Coney's teachers, and Coney was later related to Sanderson through marriage. Coney's first known work was a caudle cup, made in 1676 when he was twenty-two and probably had just finished his apprenticeship. A talented engraver, Coney was responsible for creating the plates for printing the paper money of Massachusetts and the Harvard College seal. When he died in 1722, Coney was still silversmithing, as indicated by an extensive inventory of tools and stock.

There has been much speculation among scholars about the intended purpose of sugar boxes. Whether they were a glorified first generation of the covered sugar bowl or a fancy candy dish, it is agreed that they were meant to hold some form of sugar, then a luxury commodity available to only a small percentage of the colonial population. Little is known about the original owners of sugar boxes. One example by Coney was passed down through the female side of a Boston family, as fine pieces of silver often were. Several wealthy Boston Huguenot merchants, who made their fortunes in the lucrative rum and molasses trade with the West Indies, had both access to sugar and the means to afford such an expensive container. One, John Faneuil, owned a "turtle shell sugar box" when his estate was inventoried in 1748. The box appears in the list of the contents of Faneuil's farm in Roxbury, which was smaller, and more simply furnished than his mansion in Boston. The owner of a sugar box as-

serted a refined and privileged lifestyle by displaying rather than simply storing his sugar. The box was of course also functional, keeping the sugar clean and dry.

Every inch of the sugar box is decorated in a meticulous manner, characteristic of Coney's superior work. The lobed, chased body of the sugar box, set on cast scrolled feet, creates an undulating baroque surface that reflects light and is reminiscent of the applied busses found on court cupboards and chests made at the same time. A cast coiled serpent, executed in minute detail, forms the handle. Repoussé oak leaves form a wreath around the top of the box, which is ringed by more bulbous lobes. Wherever it was placed, the sugar box commanded attention.

This sugar box has a history of ownership by silversmiths. During the mid-nineteenth century it was acquired by the Boston silversmithing firm of Jones Ball and Poor, which placed its mark on the bottom. The mark has since been removed. Its ownership after that is not known, but in 1935, George C. and J. Herbert Gebelein, also Boston silversmiths, acquired the box. In 1955, Eunice Straw, the widow of H. Ellis Straw, a former Currier trustee who was instrumental in the museum's acquisition of several other fine pieces of colonial silver, made a gift of the sugar box to the Currier.

References:

Inventory of James Bowdoin, March 1748, Suffolk County probate records, Massachusetts State Archives, Boston Docket 8829.

"Currier Gallery Acquires an Important Silver Sugar Box by John Coney," The Currier Gallery of Art, January 12, 1956 (press release).

Hermann Frederick Clarke, *John Coney: Silversmith, 1655–1722* (New York: Da Capo Press, 1971).

David B. Warren, Katherine S. Howe, and Michael K. Brown, *Marks of Achievement* (Houston and New York: The Museum of Fine Arts, Houston, and Harry N. Abrams, 1987), pp. 64–65.

W. N. H. and K. B.

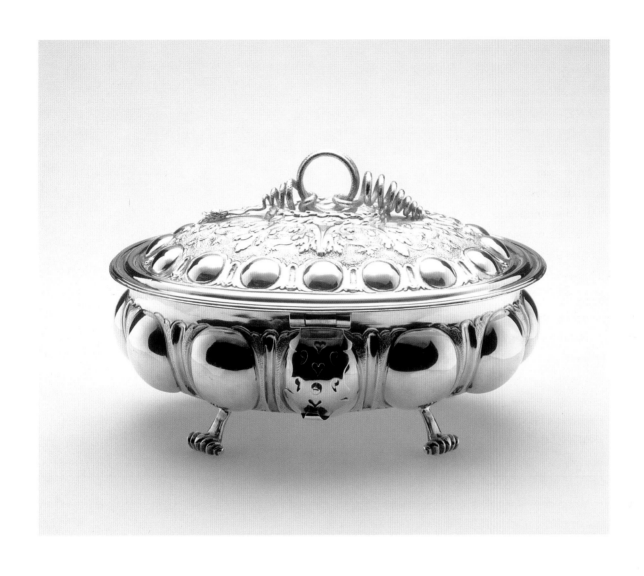

TANKARD
Boston, ca. 1700

Edward Winslow (1669–1753)

Silver; 7⅝ x 5⅞ in.

Markings: on bottom, "F/R.P" engraved and "3[?]8.3/4" stamped; "F/I+E/to/WF.C" stamped on lip; "EW/[cross in shield]" stamped in three places

Museum purchase: gift of the friends, 1964.3

This tankard is a masterpiece of early American silver. Made during a time when weight and ornamentation were the main features contributing value to silver articles, the tankard is heavy (thirty-eight ounces) and ornate. Such costly items were rare among seventeenth-century New Englanders, and there is usually a story behind the ownership. The museum purchased this tankard from a dealer who acquired it from the pioneer antiquarian and founding director of Boston's Society for the Preservation of New England Antiquities, William Sumner Appleton, who carefully preserved its history of descent in the Foster and Codman branches of his family. The earliest set of initials engraved on this tankard confirms its ownership by Captain Richard Foster (1663–1745) and his wife, Parnell (Winslow) Foster (1667–1751), cousin of the maker. The Fosters were residents of Charlestown, Massachusetts, where they were members of the First Church, which Winslow supplied with a comparable pair of tankards in 1703. Foster was a West Indies trader, the class of entrepreneurial capitalist most given to ostentatious living and investing in luxuries such as silver. The second set of engraved initials signifies the transfer of the tankard to the Fosters' son Isaac and his wife, Eleanor. Their grandson, William Foster Codman, inherited the tankard during the nineteenth century.

The tankard's maker, Edward Winslow, was one of Boston's most accomplished silversmiths. In 1683, he commenced an apprenticeship to Boston's first American-born silversmith, Jeremiah Dummer (1645–1718). Like that of Dummer and contemporary John Coney, Winslow's work exhibits features typical of Boston silver from the period. The tankard's grooved handle, tapering pendant drop inside the handle's upper end, dolphin-shaped cast silver thumbpiece, cast cherub terminating the handle, flat top, and bold geometric massing are features of the best Boston silver work. These symbols of power, birth, and death also flattered the owner's sense of control over mortality and reputation.

American silver exhibited strong regional features throughout the eighteenth century. Although only a handful of major coastal cities were able to support silversmiths skilled at making hollowware forms, apprenticeship networks and the preferences of local and regional patrons assured the development of a distinct local style. Boston was the most active center of the silversmithing industry in colonial America, and its smiths enjoyed a near monopoly on commissions from interior New England towns.

Reference:

Kathryn C. Buhler, "A Tankard by Edward Winslow," *The Currier Gallery of Art Bulletin* (July–August 1964), pp. 1–5.

W. N. H. and K. B.

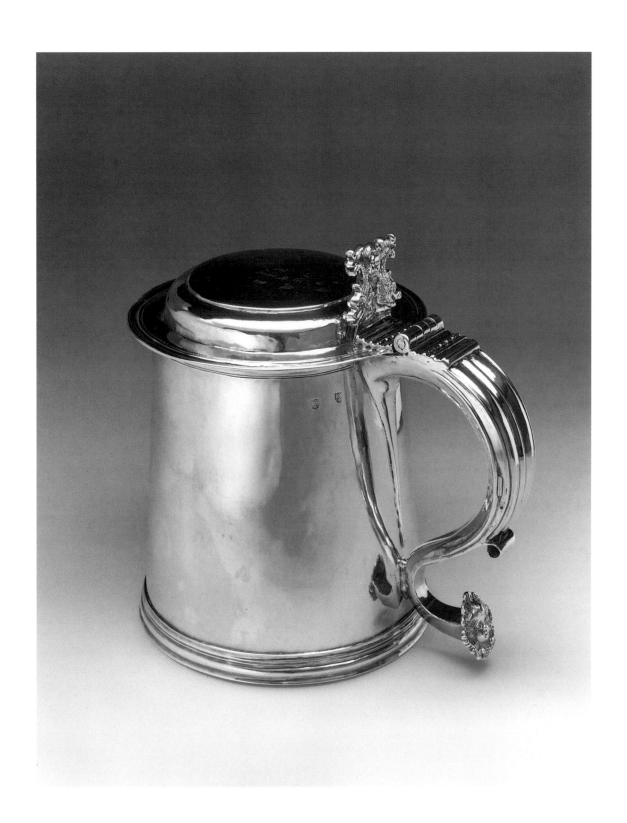

53 PATCH BOX
Boston, 1712

William Cowell (1682–1736)

Silver; 1 1/16 in., diam. base 1 3/4 in.
Markings: "Hanna/Bray 1712" engraved on bottom;
"WC" stamped on inside bottom
Currier Funds, 1948.7

The patch box is one of the earliest silver forms associated with personal adornment and beauty. Its purpose was to store little wax patches used to cover the blemishes and scars that were common in an age ravaged by smallpox. As a quirk of fashion, men and especially women adopted the patch as a fashion statement. The custom gained widest acceptance among the young and became part of the ritual of courting. The practice of patching was satirized by seventeenth- and early eighteenth-century writers, further testimony to the importance of this peculiar custom.

Patch boxes were an ostentatious luxury, and most owners were affluent and probably urbanites. Although small, the form is complicated and often engraved. This example is decorated with a delicately hatched border around a stylized sunflower.

The box bears the mark of William Cowell, one of Boston's most successful early eighteenth-century silversmiths. Cowell probably trained under Jeremiah Dummer, the first native-born American silversmith. Cowell's wife, Hannah Hurd Cowell, was the aunt of Jacob Hurd, one of Boston's most illustrious silversmiths. At the time of Cowell's death in 1736, Hurd was brought in to appraise his estate. His tools were valued at a hefty one hundred and forty-five pounds sterling, not including almost three hundred pounds worth of silver stock and finished work in use by his family. Cowell was patronized by churches in Boston and as far away as the Connecticut River valley. He was an innkeeper as well as a silversmith and a wealthy and respected member of Boston society.

The exact dates and personal history of Hannah Bray, the first owner of the box, are not known. The Brays were among the first European settlers in New England, arriving on the Mayflower in 1620. Major John Bray was a Boston selectman and an officer of the Ancient and Honorable Artillery Company, and thus a man of rank and reputation.

This patch box was exhibited at the first American exhibition of early silver, held at the Museum of Fine Arts, Boston, in 1906.

Reference:

Kathryn C. Buhler and Graham Hood, *American Silver*, vol. 1 (New Haven, Conn.: Yale University Press, 1970), pp. 83–87.

W. N. H. and K. B.

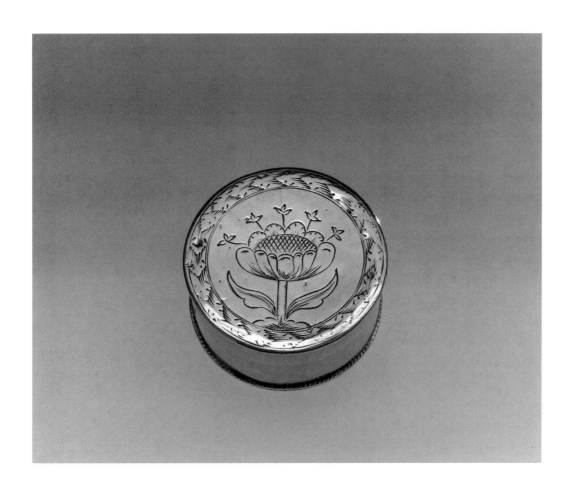

TANKARD
Boston, ca. 1729

Andrew Tyler (1692–1741)

Silver; 8⅜ x 7 in., diam. base 4⅞ in.
Markings: "1729/I✱D/to/E✱D" engraved on handle;
"A. Tyler" stamped on side
Currier Funds, 1943.20

The tankard, a staple in the colonial American silversmithing trade, was already an archaic form in England, where it had originated, by the time Boston silversmith Andrew Tyler produced this example in 1729. The story of the tankard in colonial Boston is a story of compromise, adaptation, and innovation. A declining local economy beginning in the 1720s meant that by 1729 very few people could afford to buy silver; it also meant that few immigrant craftsmen saw Boston as a place of opportunity. Until this time, the influx of foreign craftsmen and a growing economy had ensured a brisk business for anyone able to reproduce the latest English styles for fashionable Boston patrons. Those who could afford plate preferred to acquire traditional forms, such as tankards, canns, and porringers—objects that had conveyed status in previous generations, would not seem ostentatious, and would hold their value. Thus the tankard received more attention than it would have had the prosperity of the early eighteenth century continued.

Boston tankards underwent two significant stylistic renovations after the form became obsolete in England. The first was the substitution of a domed lid for a flat, brimmed cover. The second, subsequent, change was the tapering of the tankard body, the use of a double-domed lid and finial, and the addition of a molded midband on the tankard body. Within the constraints of the tankard form, silversmiths in Boston found ways to make it seem new. The changes happened gradually, and this tankard contains elements of both stylistic developments, offering a good example of a form in transition. The high domed lid with its cast urn and flame finial and the tapered body are characteristic of the final stage of tankard development; while the absence of a molded midband is more characteristic of the second, earlier phase of development, and the heartshaped terminal is associated with the first generation of tankards. In 1729, this tankard would have been viewed as moderately fashionable, incorporating some of the latest details, yet retaining tried and true elements. The unadorned, smooth surface of the tankard body, framed by the restrained curves of the contoured lid and the Gothic S-shaped handle, epitomizes the late baroque style, which sought to streamline the elaborate kind of decoration that had been fashionable a generation earlier (see cat. no. 51) in favor of a more austere aesthetic.

Andrew Tyler was an accomplished and established silversmith in 1729, approximately when this tankard was made for an unknown patron. His early training is not verifiable, but he may have been an apprentice of John Coney's. Tyler was involved in the settlement of Coney's estate, which suggests close ties between the two men. Tyler's reputation and clientele extended beyond Boston, as evidenced by the 1726 inventory of Portsmouth resident Samuel Winckley, which lists silver made by prominent Boston silversmiths, including two canns made by Tyler. Tyler's marriage in 1714 to Miriam Pepperell of Kittery, near Portsmouth, linked him to one of the most powerful and prominent families in New England and was no doubt good for business. When Tyler died in 1741 he was a wealthy man, leaving the sizable sum of thirty pounds to the Boston poorhouse.

References:

Martha Gandy Fales, *Early American Silver* (New York: E. P. Dutton and Company, 1973), pp. 16–22, 49–52, 260.

Barbara McLean Ward, "Boston Goldsmiths 1690–1730," in Ian M. G. Quimby, ed., *The Craftsman in Early America* (New York: W. W. Norton for the Henry Francis du Pont Winterthur Museum, 1984), pp. 126–57.

Barbara McLean Ward, "The Edwards Family and the Silversmithing Trade in Boston, 1692–1762," in Francis J. Puig and Michael Conforti, eds., *American Art and the European Tradition, 1620–1820* (Hanover, N.H.: University Press of New England, 1989), pp. 66–91.

Brock Jobe, *Portsmouth Furniture: Masterworks From the New Hampshire Seacoast* (Boston: Society for the Preservation of New England Antiquities, 1993), pp. 156–58.

W. N. H. and K. B.

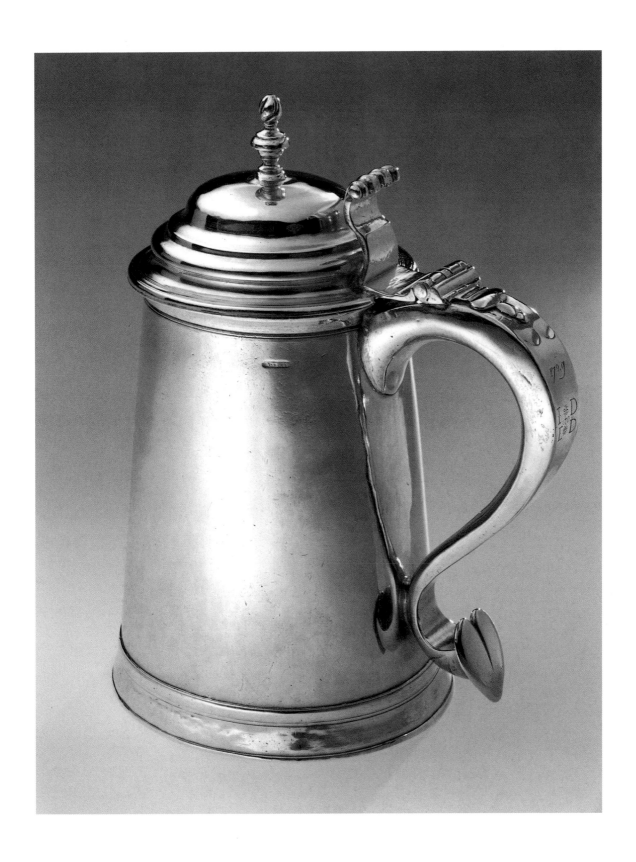

CREAM POT
Boston, ca. 1750

Paul Revere I (1702–1754)

Silver; 3⅞ x 4 in., diam. base 2½ in.
Markings: on bottom, "B A H" engraved in block letters and
"PR" stamped in rectangles twice
Currier Funds, 1948.12

The craze for tea and coffee, introduced from the Orient and the Middle East to England during the mid-seventeenth century, reached the American colonies around 1700. By mid-century, greater affordability of the exotic beverages prompted a proliferation of forms to accommodate the rituals of tea and coffee drinking. Ceramic teapots, cream pots, slop bowls, strainers, and sugar bowls were imported from England to the colonies, where eight tons of tea were consumed in 1759 in Boston. For those who could afford it, the same forms were available in silver, either imported from England or made locally. Matched silver tea sets were available by 1750, but they were extremely expensive. Far more common was the pairing of small silver cream pots, such as this one, with ceramic teapots and sugar bowls.

Paul Revere I, a French Huguenot and the father of the more famous silversmith, his namesake, was born Apollos Rivoire in Riaucaud, France. He emigrated to Boston, where there was an established Huguenot community, in 1715. After serving an apprenticeship to John Coney, Revere set up his own business, which was later inherited by his son Paul Revere, the patriot, who had been his father's apprentice. The few pieces of the elder Revere's work that have survived exhibit the meticulous craftsmanship associated with Coney's apprentices.

This trifid cream pot has often been attributed to Paul Revere I and Paul Revere II, probably because each produced almost identical versions of the form. However, only the mark of the elder Revere appears on the bottom of the piece, whereas several other pots are known to bear the mark of both men. An identical creamer, attributed to Paul Revere I, was made for his sister-in-law, Mary Hitchbourn, and is now in the collection of the Worcester Art Museum in Massachusetts. The undulating curves and broken lines characteristic of the rococo style are found here in the scalloped rim, double-scrolled handle, bulbous body, and cast cabriole feet. The rich effect of rococo is achieved without the expense of overall engraving or chasing, making this a popular form, produced by many contemporary silversmiths during the second and third quarters of the eighteenth century.

References:

"Early Boston Silver," *The Currier Gallery of Art Bulletin* (January 1949).

Kathryn C. Buhler, *American Silver from the Colonial Period Through the Early Republic in the Worcester Art Museum* (Worcester, Mass.: Worcester Art Museum, 1979), pp. 24–25.

Morrison H. Heckscher and Leslie Greene Bowman, *American Rococo, 1750–1775: Elegance in Ornament* (New York: The Metropolitan Museum of Art, 1992), pp. 89–94.

W. N. H. and K. B.

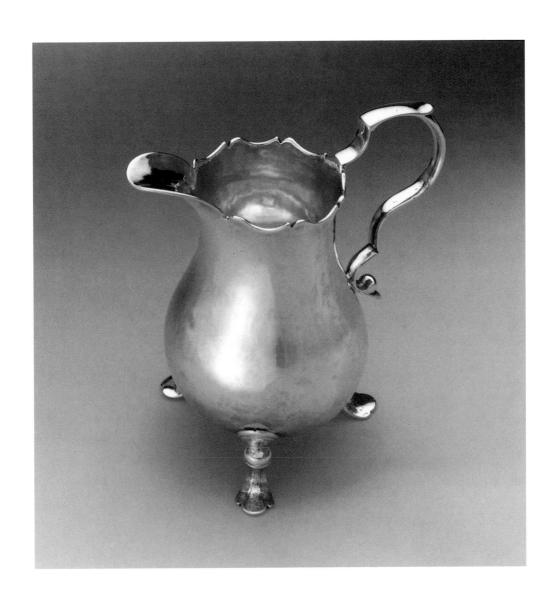

56 | CREAM POT AND SUGAR BOWL
New York, ca. 1770

William W. Gilbert (1746–1818)

Silver; Cream pot: 5⅛ in., diam. base 2⁵⁄₁₆ in.;
Sugar bowl: 5¼ in., diam. base 4½ in.
Markings: Cartouches with the monogram "LVK"
Gift of Frances H. and Laura E. Dwight, 1974.36, 1974.37 a,b

Wealthy colonists who aspired to be fashionable during the second half of the eighteenth century purchased the finest silver accoutrements for their tea tables. Before 1800, entire matched silver tea sets, while available, were not popular. Most people preferred and could only afford to supplement their ceramic forms with a few choice pieces of silver. Those who had the means sometimes ordered sets of silver sugar bowls and cream pots, like this elaborately carved set by William Gilbert.

This rococo sugar bowl and cream pot compare favorably with the work of the finest London goldsmiths, whose work could be found in every colonial port. Chased, scrolling floral decoration accentuates the robust curves of the pyriform bodies. Asymmetrical cartouches, hallmarks of rococo decoration, appear on both pieces, with the monogram "L V K." Several features identify this set's New York origin: the cream pot's Gothic S-curved handle, the sugar bowl's reel lid, and the contoured pedestals. The shape of the sugar bowl is based on an earlier, undecorated silver sugar-bowl form that was based on the simple form of a chinese porcelain cup. A similar, but more elaborately decorated set by Pieter de Riemar (1738–1814), also of New York, was made for the Van Rensselaer family around 1760. The similarities are striking enough to suggest that Gilbert may have seen the de Riemar set or perhaps received some of his training from the older silversmith.

William Gilbert first advertised as a silversmith in the mid-1770s in New York. During his lifetime he held various city offices, including alderman, and was elected state senator in 1809.

References:

V. Isabelle Miller, *Silver by New York Makers* (New York: Museum of the City of New York, 1938), p. 14.

Morrison H. Heckscher and Leslie Greene Bowman, *American Rococo, 1750–1775: Elegance in Ornament* (New York: The Metropolitan Museum of Art, 1992), pp. 81–83, 89–94.

W. N. H. and K. B.

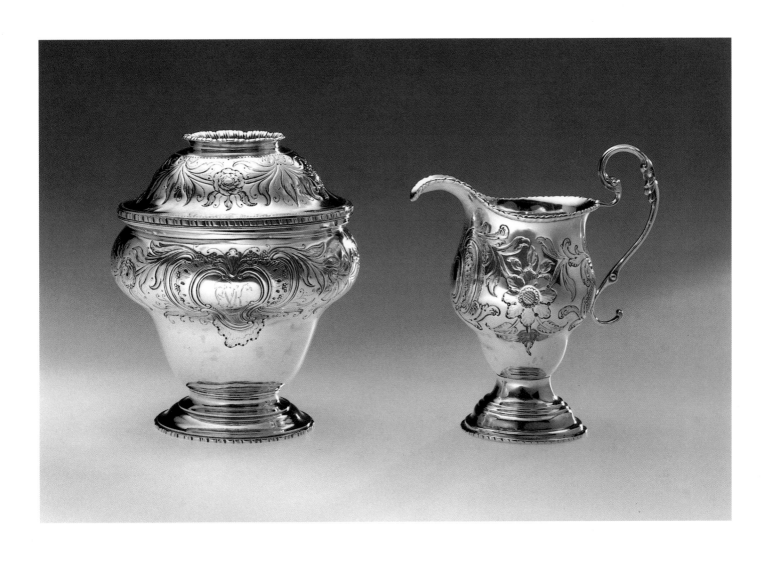

CANN
Boston, 1770–90

Paul Revere II (1735–1818)

Silver; 5¾ in., diam. base 4 in.
Markings: "WPG/to/MLB" engraved in script on front;
".REVERE" stamped in rectangle to left of handle
Currier Funds, 1943.12

The patriot Paul Revere is by far the best known of all American silversmiths. Because of his legendary status, which was firmly established during the nineteenth century with the publication of Henry Wadsworth Longfellow's popular poem "Paul Revere's Ride," more silver objects made by Revere have been preserved than by any other colonial silversmith. Two daybooks, saved by Revere's descendents, in which Revere recorded the daily activities of a diverse metalsmithing business, reveal an entrepreneurial approach to business. In addition to his work in silver and gold, including engraving, Revere performed dentist's duties and ran a foundry and copper-rolling mill.

Canns were used in both domestic and ecclesiastical settings during the eighteenth century as drinking vessels. Several Revere canns are known today. Of particular interest is a quart cann, virtually identical to the cann shown, and now in the Museum of Fine Arts, Boston, which was part of a pair of canns made for Thomas Lee of Boston in 1787. An entry in one of Revere's daybooks reveals that Lee paid over twelve pounds for materials (silver was typically seven shillings per ounce), an additional four pounds, sixteen shillings for Revere's labor, and sixteen shillings for engraving. An engraved quart cann therefore cost about eighteen pounds, the equivalent of four months of the average journeyman's wages. The Salem merchant Elias Hasket Derby also owned a pair of Revere canns, purchased in 1783, now at the Metropolitan Museum of Art in New York.

The design and decoration of this cann are typical of American rococo silver. The foliate-leaf chasing on the cast, double-scrolled handle, bulbous pear-shaped body, and contoured splayed foot are features that had been incorporated into the design of canns by 1750 and changed little until the form became obsolete around 1800. Like tankards and porringers, after 1750 canns were considered to be traditional forms; hence their popularity was scarcely affected by the latest styles. A cann was a secure investment, likely to retain its value over time, an important consideration before the advent of banking.

References:

Kathryn C. Buhler, *American Silver, 1655–1825, in the Museum of Fine Arts, Boston,* vol. 3 (Boston: Museum of Fine Arts, 1972), pp. 384–85, 407, 429.

Kathryn C. Buhler, *American Silver from the Colonial Period Through the Early Republic in the Worcester Art Museum* (Worcester, Mass.: Worcester Art Museum, 1979), p. 27.

William N. Hosley and Gerald W. R. Ward, eds., *The Great River* (Hartford: Wadsworth Atheneum, 1985), pp. 305–06.

Conversation with David Barquist, Yale University Art Gallery, July 1994.

W. N. H. and K. B.

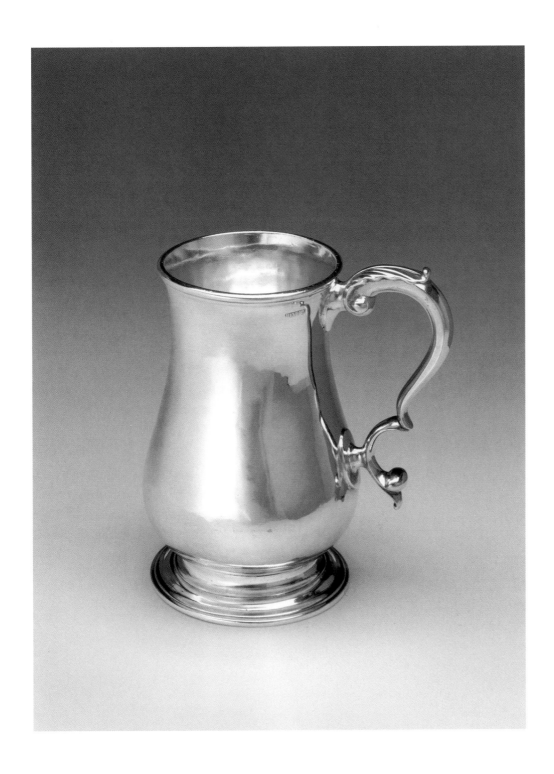

58 | PAIR OF COVERED STANDING CUPS
Boston, ca. 1790

Joseph Foster (1760–1839)

Silver; 9¾ in., diam. base 3½ in.
Markings: on foot rim, "Foster" stamped in rectangle and
"C 9 oz=17" and "B 10 oz=6" engraved; "PROPERTY/OF/
BRATTLE STREET CHURCH/BOSTON" engraved on
both cups
Anonymous gift, 1981.74.6.1–2

Early American silver is largely the story of church patronage. Outside the major urban centers, private ownership of silver rarely extended beyond occasional spoons and cream pots. Large and well-ornamented forms were rare. Churches, however, required communion and baptismal vessels, and memorial bequests from deceased parishioners provided a foundation for commissioned works. This pair of urn-shaped cups was part of a set of six made for the Brattle Street Church in Boston by Joseph Foster—a prominent Boston silversmith who trained under Benjamin Burt, a member of one of eighteenth-century Boston's most successful silversmithing dynasties—and was purchased with funds supplied by an unidentified parishioner. The Brattle Street Church, founded in 1699, is significant in the architectural history of Boston as it is the first meetinghouse built like a traditional Anglican church—with a steeple and with the pulpit and entrance opposite one another at the narrow end of the structure.

These standing cups were part of a much larger set of at least twenty-eight memorial and sacramental vessels presented to the church beginning in 1729 and are among the first neoclassical-style objects offered. The smooth, elegant urn form used for the cups is a masterful execution of one of the most popular symbols of the Federal period. Funerary urns were used as ornaments on furniture, architecture, metalwork, and gravestones. Urn-shaped ceramic tea caddies and silver communion cups are just two of the many instances in which the motif acquired a functional formality.

Reference:

Kathryn C. Buhler, *American Silver 1655–1825 in the Museum of Fine Arts, Boston*, vol. 2 (Boston: Museum of Fine Arts, 1972), pp. 505–06.

W. N. H. and K. B.

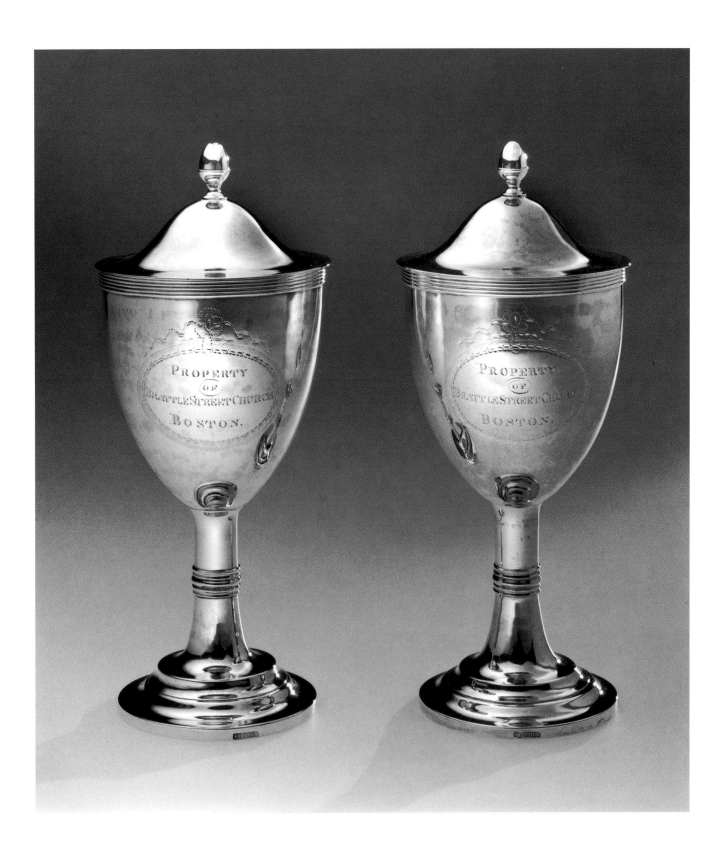

59 | SUGAR BOWL AND CREAMER
Philadelphia, 1802

John McMullin
(active 1795–1841)

Silver; sugar bowl: 10½ x 4⅜ in.; creamer: 7¹⁵⁄₁₆ x 4¾ in.
Markings: on creamer, "I.M" stamped on foot and "MH"
engraved on bowl; on bowl, "I. McMullin" stamped four times
on bottom of foot bowl (in rectangle) and "MH" engraved
on bowl
Gift of Phoebe Prime Swain in memory of her parents, Mr. and
Mrs. Alfred Coxe Prime, 1984.12.1–2

The examination of democratic ideals; the publication of the archeological discoveries of Pompeii; the arrival in America of the French Empire style, brought by craftsmen fleeing the French Revolution; and the popularity of English designs based on classical architecture all prompted an American interest in ancient Greece and Rome during the last quarter of the eighteenth century. While the new nation was taking shape, the latest fashions in decorative arts expressed patriotism and an emulation of classical forms. Silver hollowware from this period mimics the forms of Roman helmets and Greek vases. Engraved shields and wreaths frame monograms and brightwork swags, and applied beading outline architecturally influenced pierced galleries. The fluting that appears around the sides of some pieces imitates classical columns. Surface decoration is flat and secondary to the bold outlines produced by the forms themselves. Neoclassical designs were well suited to the flat sheets of silver produced by one of the latest technological developments in silversmithing—the rolling mill. Rather than raising a piece of hollowware from a billet, a process that was extremely time-consuming, the silversmith cut flat sheets to the correct size and shape and then seamed them together to produce the rough form. Time and cost were thus reduced. The seams in turn could be concealed with applied beading, which also could be mass-produced.

Mary Hutton's purchase of the covered sugar bowl and matching creamer shown here from silversmith John McMullin is recorded on an original bill of sale in Philadelphia, dated December 11, 1802. At the time, Philadelphia was the largest American city and produced some exceptional neoclassical silver pieces. McMullin charged $13.25 for the creamer and $28.25 for the "sugar dish." Six teaspoons and a pair of sugar tongs were purchased with the sugar bowl and creamer. A $2.50 charge for engraving was added. Such a large silver purchase by an unmarried woman was most likely connected with her marriage and the subsequent establishment of a new household. The urn and helmet shapes, brightwork feathers, bows and stippling, and applied beading are typical of the period and the neoclassical style.

Reference:

Mrs. Alfred Coxe Prime, ed., *Three Centuries of Historic Silver* (Philadelphia: The Pennsylvania Society of the Colonial Dames of America, 1938), pp. 62–63, 152.

W. N. H. and K. B.

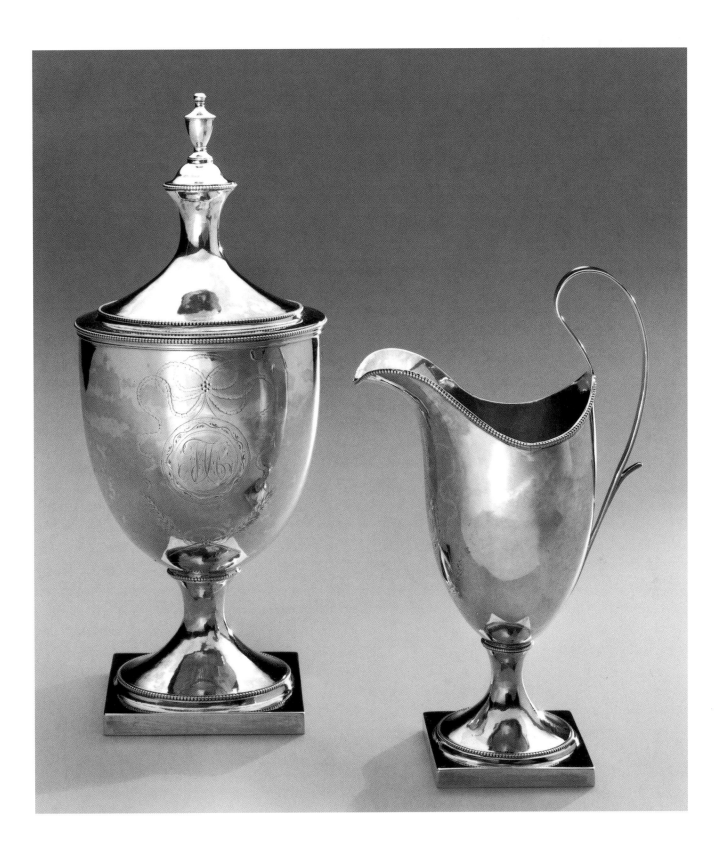

SOUP TUREEN
North Attleboro, Massachusetts, ca. 1880

Whiting Manufacturing Company (1866–1924)

Silver; 8⅝ x 12 in.
Markings: "[lion in a rectangle]/STERLING/998" stamped on bottom
Museum purchase: gift of the friends in honor of Mary Shaw Shirley, 1985.3

Leading late nineteenth-century American silver manufacturers responded quickly to ever-changing tastes and a surging demand for silver objects by increasing specialization, mechanization, and production in their factories. The discovery of the Comstock Lode, and other mining activities in Nevada and Arizona beginning in the 1860s, had plunged the price of silver to a level that made it affordable for more people than ever before. Technological advances both increased the speed of production and allowed more decoration to be applied at a lesser cost. No longer was there as much of a demand for the highly and broadly skilled traditional artisans who had dominated the field during the colonial and Federal periods, as production was divided into many specialized tasks carried out by an equally specialized and usually more moderately skilled workforce. William Dean Whiting's ability to adapt his silversmithing business to reflect the changing times made the Whiting Manufacturing Company competitive with the better-known firms of Tiffany and Gorham.

William Dean Whiting (1815–1891) was trained traditionally as a jeweler in his uncle's North Attleboro shop. After working for other jewelers for several years, he started his own business in North Attleboro in 1840. Both production and retail for his company were located in that town until 1853, when he moved the retail part of his business to New York City. In 1867, when the market for silver objects was growing, Whiting Manufacturing Company, silversmiths, was established in New York City. Production for the new company was still carried out at Whiting's North Attleboro factory, where it was easier to control supply and labor costs. Whiting produced its most artistically significant objects during the last quarter of the nineteenth century. Not much is known about the designers working for the company at this time. Known to have been designing for Whiting when the

tureen shown here was made, Charles Osborne possessed the aesthetic sensibilities and attention to detail and proportion that could have produced this design. Osborne was responsible for the firm's entry in the prestigious Bryant Vase Competition, which called on the American silver industry to produce an article for exhibition at the Philadelphia Centennial that would honor beloved poet William Cullen Bryant's eightieth birthday.

Embracing all the essential aspects of the Anglo-Japanesque design popularized by the 1876 Philadelphia Centennial and overtly apparent in the work of competitors Tiffany and Gorham, this soup tureen by Whiting is a fanciful and sophisticated expression of an aesthetic ideology. The naturalistic decoration on the tureen—a swimming turtle on one side, a flying crane on the other, and delicate peapods around the base—is especially realistic, depicting movement and exceptional detail in the fine repoussé work. Both animals are commonly represented in Japanese art. Also characteristic of Japanese design is the diagonal orientation of the tureen's major decorative elements. While much of the decoration on the body of this piece was executed by hand, a fact emphasized and advertised by the deliberate hammer marks that appear on the body, the role of the machine cannot be overlooked. A machine-molded floral band around the top of the body, the cast handles, and the fact that the body and lid of the tureen were burnished or shaped on a lathe rather than raised by hand serve as reminders that the reform ideology of the Aesthetic movement was selectively adopted by American manufacturers seeking to satisfy consumer tastes as efficiently as possible. Whiting's success stemmed from an ability to react to the market without sacrificing integrity; in other words, he achieved a balance between cost-effective production and high-quality workmanship and design, all exceptionally displayed here.

References:

Stephen K. Victor, "'From the Shop to the Manufactory' Silver and Industry, 1800–1970," in Barbara McLean Ward and Gerald W. R. Ward, eds., *Silver in American Life* (New York: The American Federation of Arts, 1979), pp. 23–32.

Doreen Bolger Burke et al., *In Pursuit of Beauty: Americans and the Aesthetic Movement* (New York: The Metropolitan Museum of Art, 1986), p. 485.

W. N. H. and K. B.

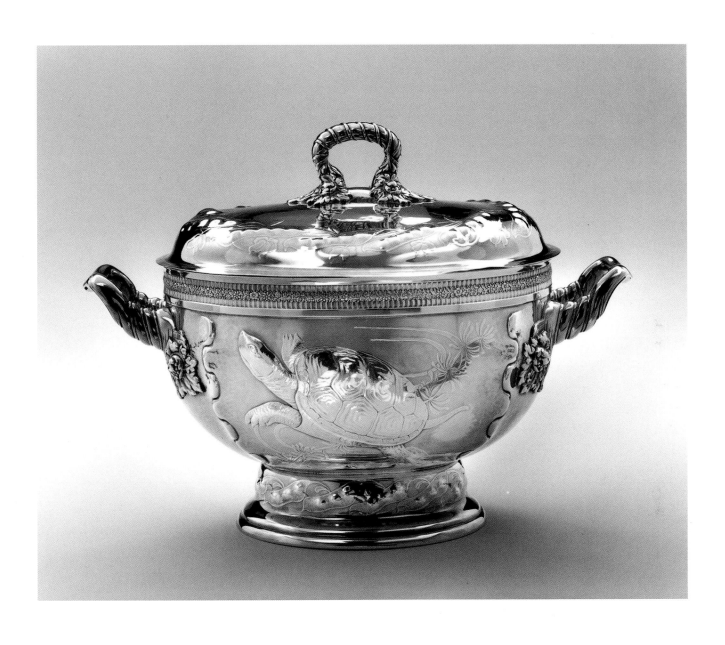

61 | QUART MUG
Charlestown, Massachusetts, 1785

Nathaniel Austin (1763–1807)

Pewter; 6¼ x 6⅜ in., diam. base 4¾ in.
Markings: "N. Austin" stamped on handle at terminal
Currier Funds, 1932.1.22

This strap-handled quart mug by Nathaniel Austin is an American original. Quart mugs were the most popular drinking vessels of the eighteenth century, used by men and women for hot and cold beverages. The majority of pewterers made these mugs, and most are very similar. Austin and a very few others, perhaps working with molds made by the same person, fashioned quart mugs with bodies that tapered more dramatically than those of other mugs and with handles that were solid instead of hollow. The result is a mug that is exceptional in construction and decoration. The popularity of the mug as a basic form ensured that pewterers usually could sell whatever they produced. Austin's desire to alter and improve a successful design, albeit slightly, gives some indication of his ingenuity. Boston's many pewterers all vied for a larger share of the same market, providing incentive for those who could differentiate themselves from the crowd.

Instead of a separately cast handle soldered to the body of the mug, Austin's mug features a strap handle cast in place or burned on the mug. This technique formed a stronger bond between the body and the handle and also eliminated one step in the fabrication of a mug, thus saving time. At the thumb rest, an extremely stylized interpretation of an acanthus leaf replaces the high-relief version found on the handles of the most elaborate silver and pewter quart mugs. Also unusual is the location and manner in which Austin applied his mark: cast on the handle terminal, it eliminated the step of placing a touchmark on the piece, since the maker's name was incised in the handle mold. The rest of the mug is very simple, lacking any decoration save the molding at the base and a simple midband. Making his name a part of the handle mold served several purposes for Austin: it prevented the mold from being used by anyone other than its maker, and it conspicuously identified Nathaniel Austin as an innovator behind an improved design.

References:

Charles F. Montgomery, *A History of American Pewter* (New York: Praeger Publishing, 1973), p. 32.

Charles F. Montgomery and Patricia E. Kane, eds., *American Art: 1750–1800, Towards Independence* (Boston: New York Graphics Society for Yale University Art Gallery and The Victoria and Albert Museum, 1976), p. 219.

W. N. H. and K. B.

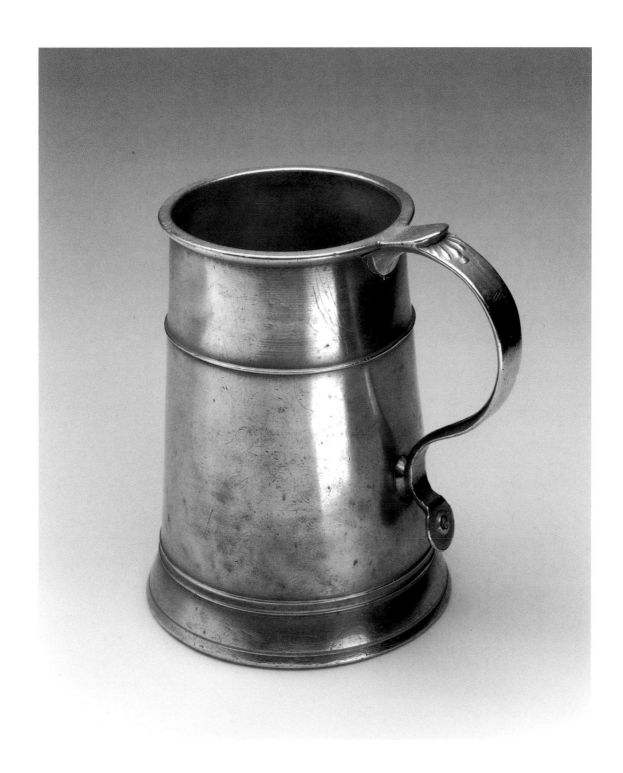

TANKARD
Philadelphia, 1785

William Will (1742–1798)

Pewter; 7 ½ x 6¾ in.
Markings: "X [surmounted by a crown]/Wm. WILL" stamped
on interior bottom; "HG" engraved on bottom
Currier Funds, 1932.1.40

The crowned "X" on the bottom of this tankard is a mark
of quality used by William Will to identify his finest work.
Will, the son of the German pewterer John Will, immigrated
with his family to New York from Neuwied, Germany, in
1752. His work is well respected, and he is known as the first
innovator in the fabrication of American pewter. John Will
and his sons did not perpetuate Germanic design in their
pewter work, choosing instead to cater to English taste.
After an apprenticeship to his brother, Henry, William
moved to Philadelphia, where he remained. There he devel-
oped a reputation for producing pewter objects of the high-
est quality. Today, more than two hundred pieces of his
work survive, encompassing a wide range of forms and
styles, testimony to a prolific and successful career.

Several features of this tankard are worth noting. A
well articulated double-domed lid replaces the straight top
found on the majority of eighteenth-century pewter tan-
kards and indicates an awareness of style. Style is also evi-
dent in the overall proportions of the tankard, which is taller
and narrower than most of its stout contemporaries. Neo-
classicism, with its emphasis on vertical lines and sculptural
simplicity, was sweeping the nation's centers of fashion,
among them, Philadelphia, where Will would have seen the
latest styles. The lid's shape was also used by Will to form
the base of a chalice, as well as the lid of his tulip-shaped
quart flagon, a more expensive option than the straight-sided
tankard seen here. An ability to successfully integrate a
shape into many designs is a William Will specialty. Many
other pewterers reused molds for more than one purpose,
but few made it look so easy. The "X" mark was used by all
the Wills, and several other American pewterers, to indicate
that the pewter they used was equal to English pewter. Qual-
ity, both in materials and craftsmanship, made Will's work
competitive with imported English pewter, a fact he empha-
sized with the "X" mark. A similar tankard is in the Garvan
Collection at the Yale University Art Gallery.

William Will was active in local politics and served as a
colonel in the Continental army during the American Revo-
lution. After the war, he was elected representative to the
Pennsylvania General Assembly. Today he is one of the
best-known American pewterers and his work is highly
sought by collectors.

References:

Charles F. Montgomery, *A History of American Pewter* (New York: Praeger Pub-
lishing, 1973), p. 124.

Charles F. Montgomery and Patricia E. Kane, eds., *American Art: 1750–1800 ,
Towards Independence* (Boston: New York Graphics Society for Yale University
Art Gallery and The Victoria and Albert Museum, 1976), pp. 221–22.

Charles V. Swain, "X Quality Marks of the Wills," *Pewter Collector's Club of
America Bulletin*, vol. 8 (March 1982), p. 171.

Bette A. and Melvyn D. Wolf, M.D., "William Will Quart Flagon; A New Dis-
covery," *Pewter Collector's Club of America Bulletin*, vol. 8 (September 1983),
pp. 280–82.

W. N. H. and K. B.

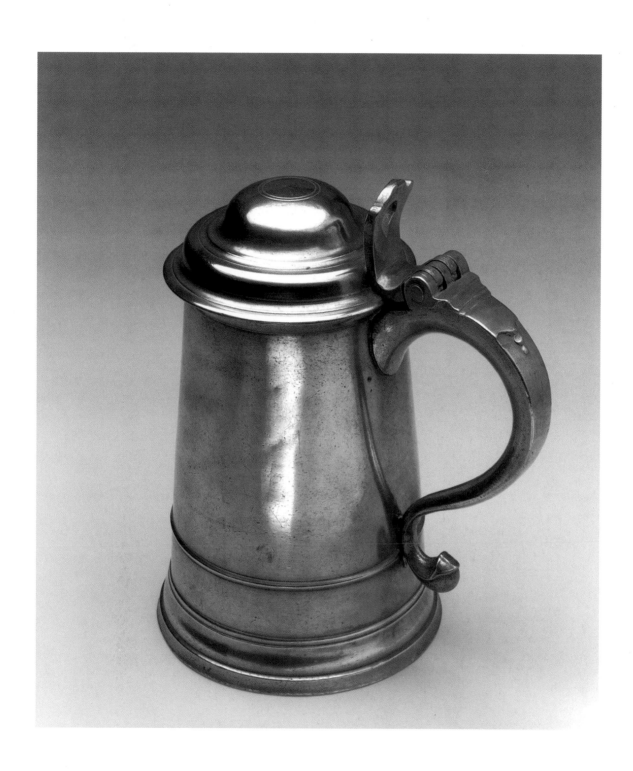

References:

Charles A. Calder, *Rhode Island Pewterers and Their Work* (Providence: E. A. Johnson and Company, 1924), p. 14.

Pewter Collector's Club of America Bulletin, vol. 8 (March 1982), p. 205.

W. N. H. and K. B.

63 | FOUR CUPS
Providence, Rhode Island, 1825

Samuel E. Hamlin, Jr.
(ca. 1801–1856)

Pewter; 3¼ in., diam. base 2⅜ in.
Markings: "A B" engraved in script on outside body of each cup;
touchmark "HAMLIN" in rectangle on outside just under lip of
each cup
Anonymous gift in honor of Mrs. Katherine Palmer, 1963.6.1–4

Sets of beakers were made for use in homes and churches during the colonial and Federal periods. While this group has been called "a set of church cups," the lack of an inscription or history associated with any church suggests that these beakers were used only for domestic service. The plain, smooth surface, marked only by the engraved monogram, and the slightly tapered shape of the beakers are consistent with the neoclassical design that was popular during the first two decades of the nineteenth century. Unlike their counterparts made of silver, most pewter beakers from this period are not engraved, probably since they usually were made for basic, everyday use in taverns and homes rather than for presentation. Everyday pewter is not what distinguishes these beakers, for their bright, shiny surface was achieved through the use of a newly discovered, lead-free alloy that contained antimony. Introduced as "Britannia" in England around 1790, this new formula resembled silver, was easy to work, and was stronger than traditional, lead-based pewter. By the early 1800s, American pewterers were developing their own Britannia formulas. The strength and malleability of Britannia allowed it to be easily shaped through casting or by using sheets rolled into the popular, thin-walled neoclassical shapes. This set probably commemorated a marriage and was a tasteful, but moderately priced, alternative to the equivalent in silver.

Samuel E. Hamlin, Jr., was trained by his pewterer father, also named Samuel. When the elder Hamlin died in 1801, his son continued the business. Like many of his counterparts, Samuel E. Hamlin was a diversified metalsmith, also working in brass and lead. His advertisements list many different types of objects, including bedpans, basins, porringers, tankards, skimmers, ladles, lead weights, and brass items made at short notice. The port of Providence ensured a steady business in the utilitarian items needed on the many ships that passed through.

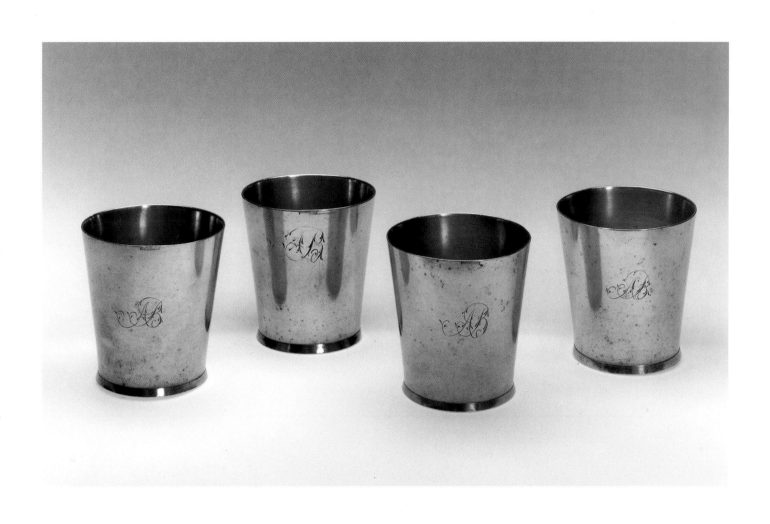

References:

Richard L. Bowen, Jr., "Some of Roswell Gleason's Early Workers," *Pewter Collector's Club of America Bulletin*, vol. 8 (September 1981), pp. 148–61.

Richard L. Bowen, Jr., "The G. Richardson Problem II," *Pewter Collector's Club of America Bulletin*, vol. 8 (March 1981), pp. 104–121.

Richard L. Bowen, Jr., "Richardson Sugar Bowls," *Pewter Collector's Club of America Bulletin*, vol. 9 (December 1988), pp. 161–65.

W. N. H. and K. B.

64 | SUGAR BOWL
Cranston, Rhode Island, 1839–41

Glennore Company
George Richardson (1782–1848)

Pewter; 5¼ x 6⅝ in.
Markings: "GLENNORE Co./eagle/G. Richardson/
Cranston, R.I." stamped on bottom
Bequest of Mrs. Peter Woodbury, 1980.62.4 a,b

From 1839 until 1841, George Richardson, one of the most innovative and skilled American pewterers, worked for the short-lived Glennore Company in Cranston, Rhode Island. The company was founded by four men from Providence for the purpose of manufacturing Britannia ware and folded three years later when a foreclosure forced operations to cease. Little else is known about the company or the extent of Richardson's involvement there.

This form has attracted much attention over the years because it represents the innovative character of the best American pewter designs. Unlike much of the popular pewterware produced in America at the time, the Richardson sugar bowl cannot be linked to an English precedent. A French pewter soup tureen exported to the United States during the nineteenth century seems to have inspired the shape, which was only produced by Richardson, and is considered to be his signature form. A dozen such bowls are known today, many of them stamped with a "No. 2" mark on the bottom, which corresponds to a "No. 2" teapot also made by Richardson, and with the same bottom shape as the sugar bowl. The high cost of molds prompted pewterers to economize and use the same molds for several different pieces.

Richardson was a versatile and experienced pewterer who started work in Boston in 1818 and worked in that area until the 1830s, when he moved to Rhode Island. Over the course of his long career, the pewterer moved or changed employment situations at least seven times, presumably in search of an ideal situation. He died in Providence, where he had been working for only a few years. As the nineteenth century progressed and pewter objects were replaced by ceramic, glass, and silver-plated goods, traditionally trained pewterers like Richardson experienced more difficulty finding enough work to support themselves.

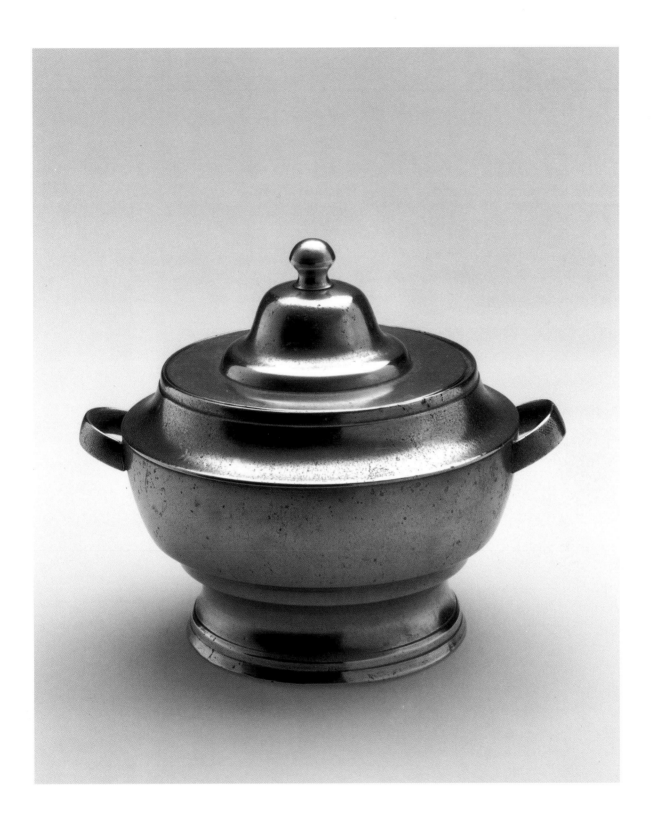

65 | PITCHER
Cranston, Rhode Island, 1839–41

Glennore Company
George Richardson (1782–1848)

Pewter; 8½ x 9¼ in.
Markings: "GLENNORE Co./[eagle]/G. Richardson/No.1/
Cranston. R.I." stamped on bottom
Bequest of Mrs. Peter Woodbury, 1980.62.5

Throughout the nineteenth century many everyday items, especially dishes and containers, were made of pewter. Affordability and availability were the main reasons for pewter's continued popularity. Glass and ceramic vessels were more expensive and less durable, and silver was simply too expensive. Large pewter pitchers, made both with and without hinged lids, were advertised as cider pitchers during the second and third quarters of the nineteenth century. Many pewterers, including Roswell Gleason, George Richardson's employer before he moved to Cranston, made pitchers such as the one shown. The designs tend to be uniform. George Richardson's pitchers, like most of his work, exhibit an exceptional degree of originality and flair. Rather than the tall, flared neck and squat, bulbous body that most pitchers from this period share, Richardson pitchers have a short, straight neck, seamed to a pear-shaped body. The elongated body and short neck give the piece an elegant and refined proportion. Traditional English ale jugs are very similar in shape and probably inspired Richardson's design. The shape was adopted by only a few American pewterers. Inside the pitcher, a whimsical heart-shaped cut-out forms the opening where the spout is attached. On the outside, solder seams joining the three pieces of the body are concealed with decorative banding, making the construction part of the design.

The "No. 1" stamped on the bottom of the pitcher presumably identifies the shape of the object. Richardson also made a pitcher with a hinged lid and a simpler handle, but otherwise identical, also stamped "No. 1." Pewterers varied their product lines by using the same basic forms, embellished with different, smaller cast elements such as lids and handles. A cast double-C scrolled handle, reminiscent of handles made for silver objects almost a century earlier, is unusually elaborate for pewter, as well as for the period, and gives the pitcher a bold silhouette. Wear associated with regular usage is indicated by repairs made to the rim near the spout and on the base. Pewterers typically found steady business in repair work because the softness of the metal combined with frequent use rendered it susceptible to breakage. Pewter's repairability is one of its virtues. Whereas dropping a ceramic or glass pitcher would destroy it, a dented or chipped pewter pitcher could easily be fixed and put back into service.

References:

Lura Woodside Watkins, "George Richardson, Pewterer," *Antiques* (April 1937), pp. 194–96.

Charles F. Montgomery, *A History of American Pewter* (New York: Praeger Publishing, 1973), p. 130.

Richard L. Bowen, Jr., "The G. Richardson Problem II," *Pewter Collector's Club of America Bulletin*, vol. 8 (March 1981), pp. 104–21.

Richard L. Bowen, Jr., "Some of Roswell Gleason's Early Workers," *Pewter Collector's Club of America Bulletin*, vol. 8 (September 1981), pp. 148–61.

Donald L. Fennimore, *The Knopf Collectors' Guides to American Antiques, Silver and Pewter* (New York: Alfred E. Knopf, 1984), pp. 282, 283.

W. N. H. and K. B.

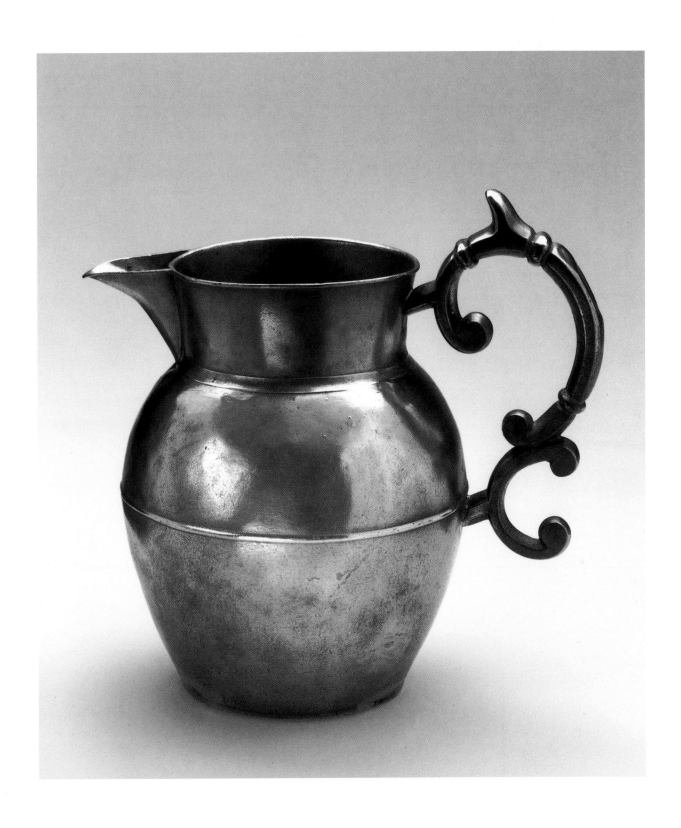

NEW HAMPSHIRE GLASS

Bottle

Stoddard, New Hampshire, ca. 1860
Possibly Joseph Foster
Dark olive-green free-blown lead glass; 6 in., width base ⅞ in.
Gift of Lew Sherburne Cutler, 1943.25

Milk Pan

Pembroke, New Hampshire, ca. 1845
Suncook Glass Works (1839–50)
Light blue-green blown lead glass; 3½ in., diam. 15 in.
Currier Funds, 1941.9

Tumbler

Pembroke, New Hampshire, ca. 1845
Suncook Glass Works (1839–50)
Attributed to Robert Parker Cotton
Light blue-green blown lead glass; 4½ in., diam. base 3⅜ in.
Currier Funds, 1933.4

Flask

Stoddard, New Hampshire, ca. 1860
Granite Glass Company (1846–72)
Amber mold-blown glass; 8⅞ in., width base 3⁹⁄₁₆ in.
Markings: "Granite Glass Co." and "Stoddard"
Gift of Mr. and Mrs. Curtis H. Caldwell, 1973.49

Flask

Keene, New Hampshire, ca. 1825
Keene Glass Works (1815–72)
Green-amber mold-blown glass; 7½ in., width base 2¹⁵⁄₁₆ in.
Markings: "Keene"
Gift of Mr. and Mrs. Curtis H. Caldwell, 1973.48

Objects are identified from left to right.

New England's glassmaking capacity was severely limited until the nineteenth century, when a number of glassworks achieved real success and distinction. The earliest efforts were spare and marred by a lack of skilled workmen and little working capital. The first attempt at glassmaking in New Hampshire was carried out between 1780 and 1782 at the little-known New-England Glass-Works in Temple. It failed, and it was some time before bottle manufacturing in Keene and Stoddard made glassmaking in New Hampshire a success story.

New Hampshire was home to several successful glassworks. The New Hampshire Glass Factory and the Keene Glass Works were both founded in Keene around 1814, as part of a wave of glass-factory start-ups that occurred when trade with England ceased during the War of 1812. These firms made window and bottle glass, respectively. The bottle-glass factory was founded by Henry Rowe Schoolcraft, former superintendent of the Vermont Glass Factory. The Keene Glass Works produced ribbed and swirled pattern-molded bottles and as many as fifty varieties of glass flasks. The most popular bore Masonic emblems or the American eagle, impressed with the name "Keene." Other flask patterns illustrated Grecian cornucopia and even an early railroad.

Stoddard is the other important source of early bottle glass in New Hampshire and one of the last firms to produce historical flasks in commemorative patterns that were first developed during the 1820s. The Granite Glass Company was the second glassmaking enterprise located in Stoddard. The first was founded by Joseph Foster, who moved from Keene to settle there in 1842 and commenced making bottles and other small domestic objects.

Established in 1839, the Suncook Glass Works specialized in the production of window glass. Characterized by brilliance and an aquamarine tint, several blown hollowware pieces have been identified and are regarded as the most important of Suncook's output. One of the finest examples of work from Suncook is the milk pan illustrated here.

Reference:

Kenneth M. Wilson, *New England Glass and Glassmaking* (New York: Thomas Y. Crowell Company, 1972).

W. N. H. and K. B.

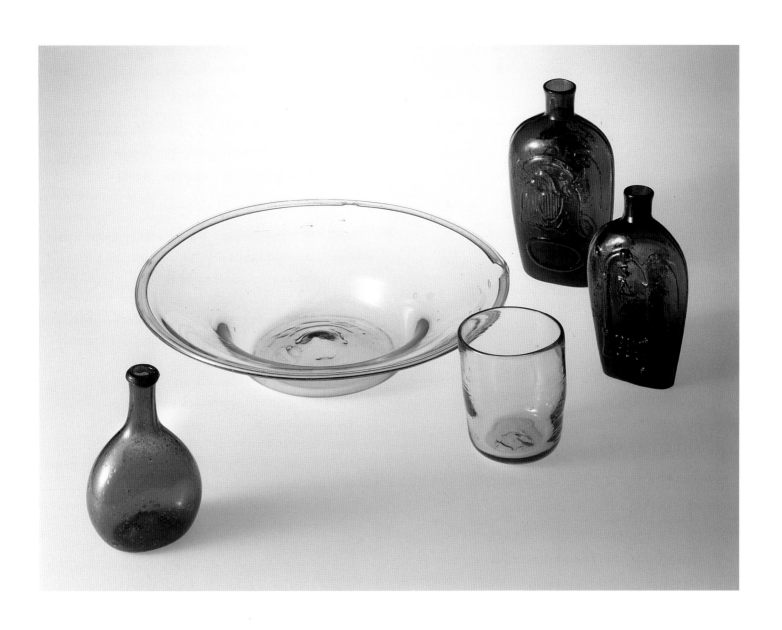

PRESSED PATTERN GLASS

Molded-glass Pitcher

Pittsburgh, Pennsylvania, ca. 1830
Attributed to Bakewell, Page & Bakewell
Blue blown-molded glass; 4⅜ in., diam. base 2½ in.
Richard J. Healy Fund, 1969.23

Footed Compote

Sandwich, Massachusetts, ca. 1840
Boston and Sandwich Glass Company (1825–88)
Yellow flint glass; 6¼ x 10⅝ x 8⅞₁₆ in.
Bequest of Richard J. Healy, 1942.7.200

Boat Salt

Sandwich, Massachusetts, ca. 1830–45
Boston and Sandwich Glass Company (1825–88)
Blue flint glass; 1⅝ x 3½ in.
Markings: "B & S Glass Co" and "LAFAYET"
Gift of Mrs. Kenneth D. Wakefield, 1974.26

Objects are identified from left to right.

One of the first indications of the American penchant for inventing labor-saving devices was the development of pressed pattern glass. On the eve of the industrial revolution, glass factories in both Pittsburgh and Sandwich, Massachusetts, applied for patents for equipment used in pressing melted glass into shaped and patterned molds. The technology of pressed-glass manufacturing earned American glass an international reputation and helped the nation achieve self-reliance in the production of domestic consumer goods. By lowering the cost of production, it also put glass within reach of the average buyer.

Pressed glass also has an important place in the history of antique collecting in America and serves as a reminder of just how much romance and aura have contributed to the popularity of antiques. Furniture studies were a quarter century old before American antiquarians turned their attention to glass. "Sandwich glass," the name originally applied to all pressed glass, first acquired antique status about 1920, an unusual achievement for a type of goods then not yet one hundred years old. The 1920s witnessed a flurry of commentary on American and "Sandwich glass," mostly aimed at and written by the growing ranks of women antiquers in search of a collecting niche to call their own. "Sandwich glass" became a popular and more affordable class of antiques at a time when several of America's most legendary collectors—with names like DuPont and Ford—were competing for furniture treasures. With the Great Depression, furniture prices collapsed and antique collecting shifted toward more reasonably priced objects. Glass scholarship accelerated, and at the height of the Depression, pressed glass was the most popular of American antique collectibles. Added to this was the allure of Sandwich, a remarkably quaint New England town at the entrance to Cape Cod, where glass scholarship and collecting had been actively promoted for seventy years. A convergence of needs was clearly met: Sandwich was king, or perhaps more accurately, queen, of the American antiques scene.

Among the first pressed-glass forms were patterned furniture knobs, created to provide an appealing substitute for turned wood and brass. Eventually the New England Glass Company in East Cambridge, Massachusetts, the Boston and Sandwich Glass Company in Sandwich, and Bakewell, Page & Bakewell in Pittsburgh dominated an industry that developed hundreds of molds, which in turn made an astonishing variety of forms, from cup plates and salts to monumental compotes and candlesticks decorated with eagles, cornucopia, and French scrollwork.

Color, form, and pattern are important aspects of value in pressed glass. The yellow compote is an impressive form composed of two separately molded parts, a lobed foot with leaf decoration, and a dish decorated with an undulating band of grapes, flower baskets, scrolls, and crosshatching.

The blue pressed boat salt is the only known piece actually marked with the initials of its Sandwich manufacturer and was probably designed as an advertising gimmick. The boat, marked "LAFAYET," is thought to have been modeled after the steamboat *Lafayette* that was in service between Boston and Plymouth, Massachusetts, during the period when the salt was made.

The blue pitcher was a popular item made by a technique in which a blob or "gather" of glass is blown, rather than pressed, into a patterned mold. Glass made by this method assumes less sharply delineated decoration, here confined to a sunburst-in-square and bands of herringbone and diapering.

Reference:

Raymond E. Barlow and Joan E. Kaiser, *The Glass Industry in Sandwich*, vol. 1, Lloyd C. Nickerson, ed. (Windham, N.H.: Barlow-Kaiser Publishing, 1993).

W. N. H. and K. B.

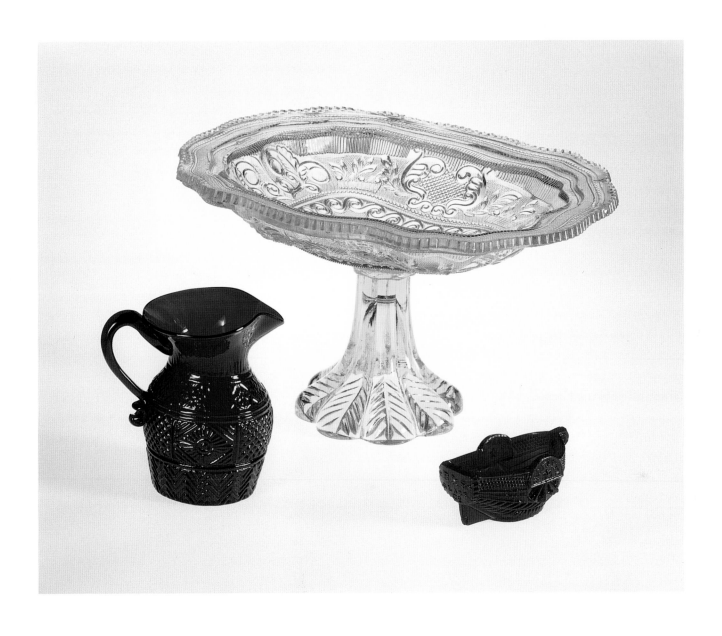

74 | PITCHER
Stoddard, New Hampshire, 1842–73

Attributed to Matt Johnson (active 1846–70)

Olive-amber free-blown glass with applied and tooled decoration; 8 in., diam. base 4¼ in.
Bequest of Richard J. Healy, 1942.7.190

During the first decades of the nineteenth century, American glassmaking firms multiplied in number, dramatically increasing production in response to an expanding demand for bottle and window glass. In southern New Jersey, where glassblowing was established during the eighteenth century, eleven factories were in operation by 1820. This region became known for several distinct blown-glass forms and decoration, including the famous lily-pad pitcher. Since many of the glassblowers had German training, it is not surprising that the manufacturing techniques and methods of decoration they employed can be traced to those used by German glassmakers. The pitcher shown here is in the so-called South Jersey tradition. This tradition was carried north through New York and into New Hampshire by former employees of southern New Jersey glassworks, who were lured north by the promise of abundant natural resources (glassblowing required vast amounts of wood for fueling the necessary furnaces) and growing markets for their products.

Free-blown forms, including the lily-pad pitcher, bowls, and decorative glass balls were traditionally made by the glassblower at the end of a shift to finish the day, or at the end of a batch of glass to finish the raw material. Often presented as gifts to friends and family, these forms were a by-product of the window- and bottle-glass factories and not the main focus of the business, although several manufacturers are known to have sold such pieces in company stores and occasionally they were marketed to other retail outlets. The type of glass used to create the primary goods produced by the glassmaker dictated the kind used for the free-blown objects. Free-blown pieces are seldom marked. In the case of the pitcher shown, bottle glass, of the type produced in Stoddard, New Hampshire, was used. It has been attributed to Matt Johnson, an itinerant glassblower who worked at several of the Keene and Stoddard glass factories and was known for his use of lily-pad decoration. This piece

and other objects featuring lily-pad decoration were formed by repeatedly applying a small drop of glass to the body of the blown pitcher and pulling it to form a lily-pad shape. As seen in this example, pitchers usually had threaded necks (formed by wrapping threads of molten glass around the neck) and crimped handles. Lily-pad decoration was popular from the 1840s through the 1870s. New England glassmakers are known for their amber- and olive-colored glass pitchers, whereas the southern New Jersey and New York glassworks produced pale blue and green examples. The double lily-pad decoration found on this pitcher, consisting of alternating and curved elements, is rare and exhibits the stylistic flair of an accomplished artisan.

References:

George S. and Helen McKearin, *American Glass* (New York: Crown Publishers, 1941), pp. 37–39, 164–74.

Lyman and Sally Lane and Joan Pappas, *A Rare Collection of Keene and Stoddard Glass* (Manchester, Vt.: Forward's Color Productions, 1970).

Kenneth M. Wilson, *New England Glass and Glass Making* (New York: Thomas Y. Crowell Company, 1972), pp. 49, 169–71.

Helen Allan, *Reflections: The Story of Redford Glass* (Plattsburgh, N.Y.: Clinton County Historical Association, 1979).

Jane Shadel Spillman, *The Knopf Collectors' Guides to American Antiques: Glass Tableware, Bowls and Vases* (New York: Alfred A. Knopf, 1982), pp. 75, 122–23.

W. N. H. and K. B.

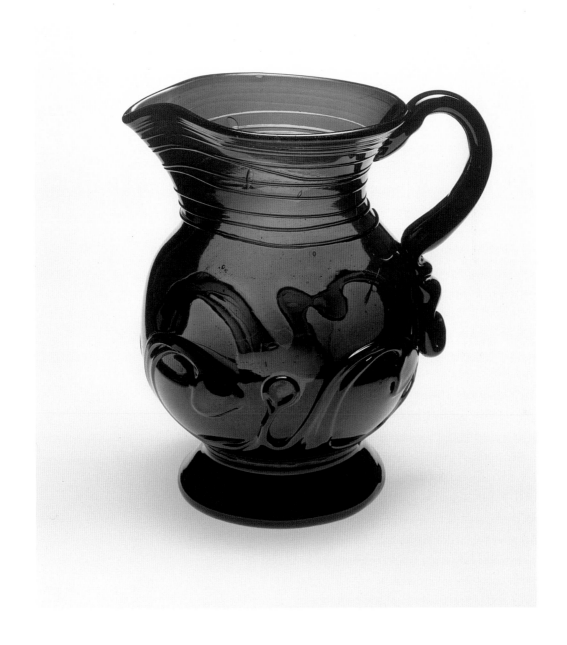

75 | COMPOTE
Cambridge, Massachusetts, 1860–80

Louis Frederick Vaupel (1824–1903)

Cut glass; 9⅜ in., diam. bowl 9 3/16 in., diam. base 5 7/16 in.
Markings: "LHWV" engraved
Bequest of Minette D. Newman, 1961.14.1

The nineteenth century was the golden age of American glass. Technological innovations and an influx of skilled artisans from England and Europe enabled firms like the New England Glass Company (which later became the New England Glass Works) in East Cambridge, Massachusetts, to produce a high-quality product on a large scale. Louis Frederick Vaupel was one of these artisans. Born into a family of glass artisans in Schildhorst, Germany, Vaupel received specialized training in several aspects of glassmaking. In 1836, after working in a factory for many years, Vaupel's father and uncle established their own glassworks. It was there that young Louis became a master engraver of glass. Political upheaval and the accompanying economic uncertainty in Germany in the 1840s led the engraver, and thousands of other Germans, to the United States in 1850. Vaupel went to work for the New England Glass Works, eventually securing a position as head designer, in charge of the engraving department. His skill and familiarity with German techniques was a great advantage to the Massachusetts company. During this period, Bohemian and Austrian glass was being imported in large quantities to the United States, where people admired the fine detailing and elaborate carved and engraved decoration. Not only could Vaupel execute this type of work, but he could also teach others.

Vaupel worked at the East Cambridge factory until 1888, when the company's owner, Edward Drummond Libbey, moved the entire operation to Ohio. The engraver, then age sixty-four, stayed in East Cambridge and continued to engrave glass on commission. During his tenure with the New England Glass Works and for years after, Vaupel engraved many beautiful pieces of glass for his family. The majority of these masterpieces were kept in the family until the late twentieth century. This compote, one of the largest pieces, was made for Vaupel's son, Louis Humboldt Washington Vaupel, and bears his initials. Vaupel's daughter, Minette, acquired the compote and left it to the Currier.

Today, Vaupel is considered the finest nineteenth-century glass engraver and his work is highly esteemed. As an example of his output, this compote represents the best decorative work done in clear glass at the time.

Reference:

Vaupel Engraved Glass, Family Collection Offering Catalog (Toledo, Oh.: Antique and Historic Glass Foundation, 1975).

W. N. H. and K. B.

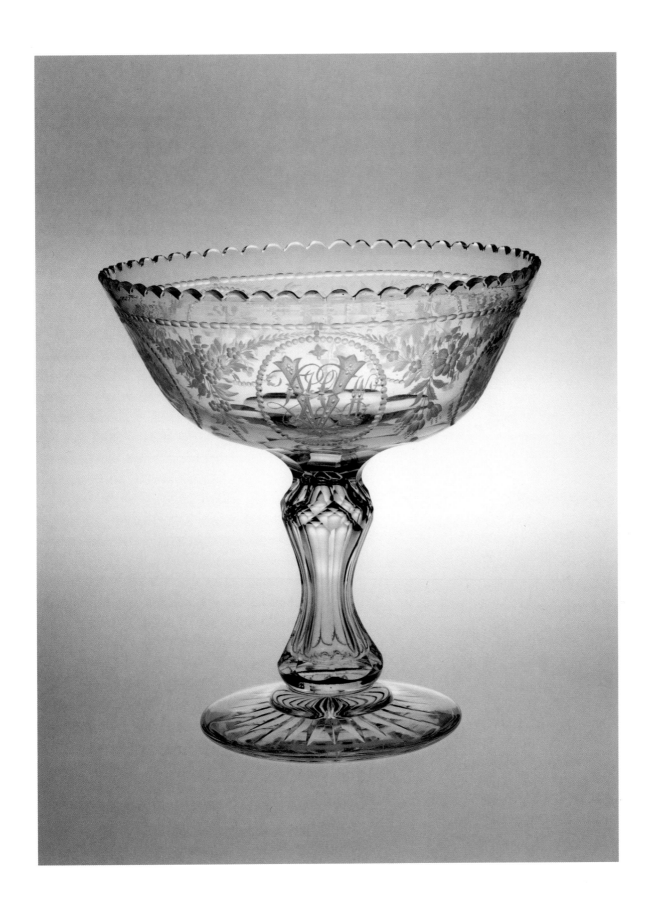

AMERICAN ART GLASS

Royal Flemish Biscuit or Cookie Jar

New Bedford, Massachusetts, ca. 1885
Mount Washington Glass Company (1871–1900)
Jewel-encrusted overlay glass; 8¼ in., diam. 6¾ in.
Markings: "MW 4415"
Gift of Priscilla and Albert C. Murray, 1974.33.200

Morgan Vase

Wheeling, West Virginia, ca. 1886
Attributed to Hobbs, Brockunier and Company (1863–90)
Blown overlay glass; 9⅞ in. (with stand), diam. vase 1⅝ in.,
diam. base 3¼ in.
Gift of Priscilla and Albert C. Murray, 1974.33.139 a,b

Pear Paperweight

East Cambridge, Massachusetts, ca. 1865
New England Glass Company (1818–80)
Blown overlay glass; 2⅝ in., diam. 3⅜ in.
Gift of Prudence Drake, 1986.14.1

Lily Vase

East Cambridge, Massachusetts, ca. 1886
New England Glass Works (1880–88)
Agate glass; 7⅛ in., diam. base 3 in.
Gift of Susan B. Aller, 1988.32

Plated "Amberina" Syrup Pitcher

East Cambridge, Massachusetts, ca. 1883–88
New England Glass Works (1880–88)
Overlay glass with electroplated mounts and stand;
5¾ (including plate), diam. 5¾ in.
Markings: "James W. Tufts/Boston/Warranted/quadruple
plated" stamped on bottom of plate
Gift of Priscilla and Albert C. Murray, 1974.33.161 a,b

Objects are identified from left to right.

After the Centennial Exhibition in Philadelphia in 1876, the manufacturers of American consumer goods awakened to the importance of artistic design. Objects from doorknobs to wallpaper and tableware underwent radical restyling. Art education flourished while industries engaged in a mad scramble to resurrect lost crafts, expand their technical and aesthetic range, and generally advance the horizon of national art. Art became a national imperative, and in no decade before or since has the value of art been more widely recognized and its uses more widely accepted. This revolution in taste was especially pronounced in the decorative arts. Following the lead of the American ceramics industry, prominent glassmakers launched a campaign to develop "art glass" in order to compete with the best European work, which was then flooding into the American market.

The most interesting and prolific American art-glass manufacturer was Frederick Shirley's Mount Washington Glass Company in New Bedford, Massachusetts. Product lines marketed with trade names like "Burmese," "Crown Milano," and "Royal Flemish" testify to the firm's technical and artistic inventiveness. The tantalizing "Burmese" and "Peach Blow," which Shirley patented in the mid-1880s, were types of shaded overlay glass, the former bleeding from yellow to pink and the latter, gray blue to a bluish pink. Mount Washington's success depended in part on the importation of skilled decorators, among them, the English-trained Alfred and Harry Smith. Britain's esteemed South Kensington School and Museum (now the Victoria and Albert Museum in London) championed the revolution in decorative art, and graduates occupied important positions in American industry.

The New England Glass Company (which later became the New England Glass Works) was founded in 1818 and by 1820 employed almost one hundred men and boys in the making of blown-mold and cut glass. At the time of the Centennial, the factory was run by William L. Libbey and remained under his management until 1888. This was the period of its most varied and prolific experimentation with art glass. The agate lily vase and "Amberina" syrup pitcher, illustrated here, are among the products associated with the firm during these years. The trade name "Amberina" was given to one of the New England Glass Company's most successful products. The first of the shaded glasswares, it was the result of a process patented by the English-trained designer Joseph Locke.

Another firm that flourished during the art-glass era was Hobbs, Brockunier and Company, founded in West Virginia by former workers from New England Glass. With products marketed under such names as "Craquelle" and "Rubina," it soon became one of the largest glass factories in the country. Its greatest fame came with the manufacture of "Peach Blow," the most popular shaded glass. The vase illustrated here was Hobbs's imitation of the "Morgan vase," a Chinese peach-colored porcelain vase that made international news in 1886 when it was purchased from the Morgan collection by the Baltimore art collector William T. Walters, for the then unheard-of price of eighteen thousand dollars.

W. N. H. and K. B.

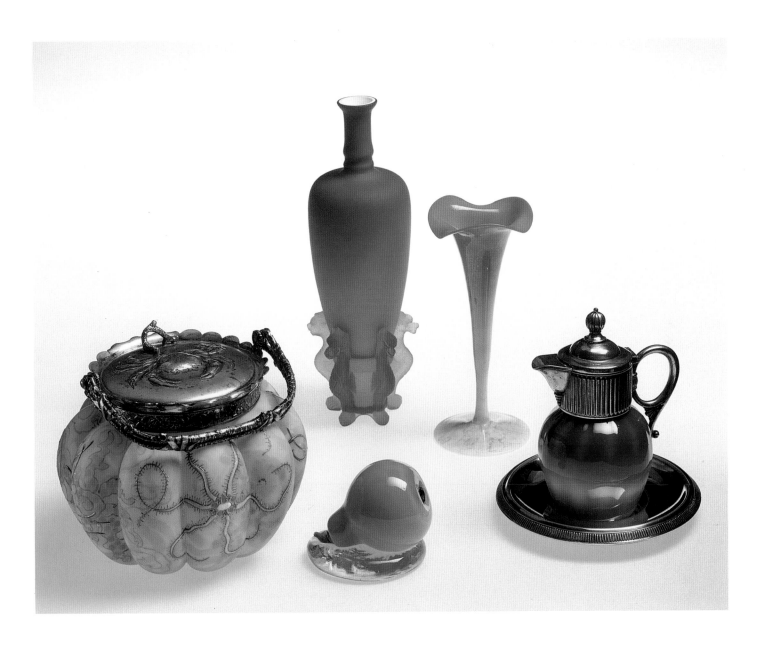

81 | JACK-IN-THE-PULPIT VASE
Brooklyn, New York, ca. 1901

Quezal Art Glass and Decorating Company (1901–25)

Glass; 16 ¼ in., diam. base 5 ⅜ in.
Markings: "Quezal 11"
Richard J. Healy Funds, 1985.32

The Quezal Art Glass and Decorating Company was founded in Brooklyn in 1901 by two former Tiffany Studios employees, Thomas Johnson, a glassblower, and Martin Bach, a batch mixer. The obvious aim of their partnership was to obtain a share of Tiffany's lucrative market in iridescent favrile glass. No effort was made to hide the fact that Quezal used Tiffany techniques and imitated Tiffany forms, as in this jack-in-the-pulpit flower-form vase, which was one of the company's first products.

During the late nineteenth century, the price of success was competitive imitation, a fact that prompted many lawsuits and numerous patents. Quezal was not the only Tiffany imitator. Others included the Union Glass Company of Massachusetts, which called its product "Kew Blas," and the Vineland Glass Manufacturing Company in New Jersey, which employed some Quezal artists. Glass made by Quezal, while leaving much to be desired in terms of originality, does not lack in quality. The walls of Quezal vases are thicker than those of Tiffany vases, but otherwise the pieces are identical. Most of the company's production was in the form of iridescent glass vases featuring striated decoration that formed a feathered pattern. The flower-form vases, of which the jack-in-the-pulpit versions are the largest and most dramatic, were not meant to serve any function other than a decorative one, as their design included both the flower and the vase. Quezal's success lasted only as long as iridescent glass was fashionable. The advent of Art Deco meant the demise of companies like Quezal, which had capitalized on a style but had not developed any products for the future.

References:

Philip D. Zimmerman, ed., *Turn of the Century Glass: The Murray Collection of Glass* (Manchester, N.H.: The Currier Gallery of Art, 1983), p. 12.

Judith and Martin Miller, eds., *Millers' Antiques Checklist: Art Nouveau* (London: Mitchell Beazley International, 1992), pp. 70–71.

W. N. H. and K. M.

TIFFANY STUDIOS
Corona, New York

Louis Comfort Tiffany
(1848–1933)

Morning Glory Vase, 1917

Glass; 6⅜ in., diam. base 2⅞ in.
Markings: "L. C. Tiffany, Favrile, 8060L"
Gift of Priscilla and Albert C. Murray, 1974.33.294

Vase, 1916

Glass; 2¾ in., diam. base 1¹⁵⁄₁₆ in.
Markings: "L.C. Tiffany, Favrile, 4305K"
Gift of Priscilla and Albert C. Murray, 1974.33.270

Red Bud Vase, 1916

Glass; 11⅞ in., diam. base 2½ in.
Markings: "L.C. Tiffany, Favrile, 3049K"
Gift of Priscilla and Albert C. Murray, 1974.33.296

Agate Vase, 1906

Agate glass; 3¾ in., diam. base 1½ in.
Markings: "103A- Coll. L. C. Tiffany Favrile"
Gift of Priscilla and Albert C. Murray, 1974.33.256

Vase, 1913

Glass; 7⅞ in., diam. base 3⅛ in.
Markings: "L. C. Tiffany, Favrile, 9452 H"
Gift of Priscilla and Albert C. Murray, 1974.33.293

Objects are identified from left to right.

Following a successful career with Associated Artists, a New York decorating firm that catered to an exclusive clientele, Louis Comfort Tiffany formed the Tiffany Glass Company in 1885 and officially began an odyssey in glass that was to lead to discovery, fame, and fortune. During this time, Tiffany designed and produced stained-glass windows for churches and mansions. The success of this venture and a desire to experiment more with forms and colors led him to establish glass furnaces in Corona, New York, on Long Island in 1892. The Tiffany Glass and Decorating Company made its debut to high acclaim at the Columbian Exposition in Chicago the next year with a Byzantine chapel display. Though it was not marketed until 1895, Tiffany's now famous "favrile" glass, a term he applied to his handwrought blown glass, was introduced in 1893. The new type of glass built upon the extensive knowledge acquired during Tiffany's search for ideal colors and textures to use in his stained glass windows. By 1900, favrile glass was well known and collected in Europe. The 1899 Paris Exposition had featured a large display of Tiffany glass, and it was there that the new style was born.

Acclaim was not enough to ensure financial success. While Tiffany had intended to offer his artistic glass creations to a broader public, the expense of production pushed the price out of reach for most Americans, though they certainly were less expensive than his stained-glass windows. The company reportedly operated at a loss.

Within the realm of favrile glass the possibilities were endless. A few examples are shown here, attesting to the versatility and diversity of Tiffany's product. One type of favrile glass used a technique borrowed from French paperweight manufacturers. Paperweight (cat. nos. 82 and 86) have a design that is tooled and shaped, then encased in subsequent layers of clear glass, or very rarely, as in catalogue number 86, encased in opal glass. Designs ranged from naturalistic morning glories (cat. no. 82) to abstract foliage (cat. no. 86) and required great skill to achieve the desired effect. Iridescent glass, produced by adding metallic salts to a batch, could be made in many different colors, but the most popular was a bright peacock blue, seen here in the small blue vase (cat. no. 83). Steuben's Frederick Carder was sued by Tiffany for infringing on the latter's patent for iridescent glass. The case was settled out of court, and Tiffany's claims were determined to be unfounded.

The two remaining vases pictured exhibit an Oriental influence, though they are otherwise dissimilar. Tiffany had from an early age been exposed to Asian art through the decorative arts imported for sale in his father's store. The

bud vase (cat. no. 84) is based on an ancient bottle form and is colored a deep Chinese red. Red glazes were particularly difficult to perfect. Agate glass, named for its striking resemblance to the stone, was created by layering opaque glass of several earthy shades, one atop the other, and then carving through the layers to reveal the colors underneath. The rare fish-carved, faceted example shown here (cat. no. 85) bears the inscription placed on objects that Tiffany kept for his own collection, which contained only the most unusual or exquisite objects.

The skill of the glassblowers and chemists employed by Tiffany should not be overlooked. Some eventually took their skills—and the company secrets—and started rival firms, such as Quezal (see cat. no. 81). And some had come to Tiffany bearing the trade secrets of other companies. One of the latter, Arthur J. Nash, the Corona furnace supervisor and head glassblower, had worked in Stourbridge, England's glass capital, before accepting Tiffany's invitation to join him. He is sometimes credited with the invention of Tiffany peacock blue and cypriote glass. There is no question, however, that it was Tiffany's vision of a more artful world that was the catalyst for the great achievements in glassblowing for which he earned so much fame.

References:

Robert Koch, *Louis C. Tiffany, Rebel in Glass* (New York: Crown Publishers, 1966), pp. 119–29.

Diane Chalmers Johnson, *American Art Nouveau* (New York: Harry N. Abrams, 1979), pp. 107–08.

Philip D. Zimmerman, ed., *Turn of the Century Glass: The Murray Collection of Glass* (Manchester, N.H.: The Currier Gallery of Art, 1983), p. 12.

Jane Shadel Spillman and Susanne K. Frantz, *Masterpieces of American Glass* (New York: Crown Publishers, 1990), pp. 50–56.

Alastair Duncan, *Louis Comfort Tiffany* (New York: Harry N. Abrams with the National Gallery of American Art, 1992), pp. 80–100.

W. N. H. and K. B.

STEUBEN DIVISION OF CORNING GLASS WORKS
Corning, New York (1918–33)

Vase, ca. 1925

Acid cut-back glass; 9⅜ in., diam. base 3½ in.
Gift of Priscilla and Albert C. Murray, 1974.33.206

Cintra Cologne Bottle, ca. 1928

Cintra glass; 8⅜ in. (including stopper), diam. base 3¾ in.
Markings: Steuben fleur-de-lis
Gift of Priscilla and Albert C. Murray, 1974.33.218 a,b

Frederick Carder (1863–1963) began his career in England, where he was a designer and decorator for the well-known firm of Stevens and Williams (1830 to present), located in the historic glassmaking center of Stourbridge. Glassmaking had been established there in the seventeenth century and continues today. After failing to secure a management position at the firm, Carder was persuaded by the T. G. Hawkes Company in Corning, New York, a cut-glass manufacturer, to set up a new glassworks, one that would provide the cutting blanks for his business. Carder accepted the offer in 1903, and the Steuben Glass Works was founded. Soon after the company's founding, Carder expanded the operations and began to produce decorated glass of the type made at his old firm.

Unlike those of the contemporary firm of Tiffany Studios, Steuben's products, while unique and innovative, were targeted for mass-production and mass appeal. Constant experimentation, a wide range of products, and a willingness to cater to popular taste ensured Steuben's success, which continues today (the company separated from Corning and now operates under the name Steuben Glass, Inc.).

Two of the many types of glass produced by Steuben are Acid cut-back and Cintra, examples of which are shown here. By the 1920s, when both pieces were made, the Hawkes family had sold the Steuben company to the Corning Glass Works, which retained Carder as head designer until 1932. Acid cut-back glass is a cameo glass, made by laminating two (or more) layers of glass together and then cutting back or etching (with acid) through one layer to produce a relief design. The technique was used at Steuben to create intricate Chinese-inspired decoration, such as the jade green and alabaster dragon design seen here. The process of acid etching was particularly suited to such complex patterns.

Cintra glass was introduced during the 1920s, when Art Deco was gaining popularity in the United States. In true Art Deco style, the cologne bottle pictured is faceted, polished, and geometric in shape. The tiny bubbles that form the design were achieved by rolling a gather over crushed particles of colored (in this case, black and white) glass to form the interior, and then when adding more glass, heating it only enough so that the exterior casing could be blown into shape. The interior formed bubbles. Afterward, the piece was cut and polished.

The two examples of Steuben glass shown here are vastly different in style, but both accurately convey the breadth of the company's production, both stylistically and artistically. While the Chinese cameo vase would attract a customer with traditional taste, the Cintra bottle is decidedly avant-garde and, like Carder, looks to the future.

Reference:

Judith and Martin Miller, eds., *Millers' Antiques Checklist: Art Nouveau* (London: Mitchell Beazley International, 1992), pp. 70–71.

W. N. H. and K. B.

cat. no. 87

Artist Index

Numbers refer to catalogue numbers.

The American Federation of Arts National Patrons

Amy Cohen Arkin
Anne H. Bass
Nancy Terner Behrman
Mr. and Mrs. Frank B. Bennett
Mr. and Mrs. Winslow W. Bennett
Mrs. Edwin A. Bergman
Mrs. George F. Berlinger
Mr. and Mrs. Leonard Block
Mr. and Mrs. Donald J. Blum
Mr. and Mrs. Duncan E. Boeckman
Mr. and Mrs. Andrew L. Camden
Mr. and Mrs. George M. Cheston
Mrs. Paul A. Cohen
Elaine Terner Cooper
Marina Couloucoundis
Catherine G. Curran
Mr. and Mrs. Hal David
Dr. and Mrs. David R. Davis
Mrs. Dominique de Menil
Sandra Deitch
Beth Rudin DeWoody
Mr. and Mrs. Charles M. Diker
Mr. and Mrs. C. Douglas Dillon
Mr. and Mrs. Herbert Doan
Mr. and Mrs. Robert B. Dootson
Mrs. Lester Eisner
Mr. and Mrs. Oscar Feldman
Mr. and Mrs. James A. Fisher
Bart Friedman and Wendy Stein
Barbara Goldsmith
Marion E. Greene
Mr. and Mrs. Gerald Grinstein
Leo S. Guthman
Mr. and Mrs. John H. Hauberg
Mrs. Wellington S. Henderson
Elaine P. Kend
Mr. and Mrs. Robert P. Kogod
Mr. and Mrs. Anthony M. Lamport
Natalie Ann Lansburgh
Carole Meletio Lee
Mrs. Robert H. Levi
Barbara Linhart
Mrs. Richard Livingston
Mr. and Mrs. Jeffrey M. Loewy
Mr. and Mrs. Lester B. Loo
Mr. and Mrs. Mark O. L. Lynton
Dennis H. Lyon
Mr. and Mrs. Richard A. Manoogian

Mr. and Mrs. John Marion
Mr. and Mrs. Melvin Mark, Jr.
Jeanne Lang Mathews
Mr. and Mrs. Alan M. May
Mrs. Eugene McDermott
Mr. and Mrs. Paul Mellon
Mr. and Mrs. Robert Menschel
Mr. and Mrs. Eugene Mercy, Jr.
Raymond Donald Nasher
George P. O'Leary
James H. Ottaway, Jr.
Patricia M. Patterson
Mr. and Mrs. Mark Perlbinder
Mr. and Mrs. Nicholas R. Petry
Mr. and Mrs. Charles I. Petschek
Mr. and Mrs. John W. Pitts
Mr. and Mrs. Harvey R. Plonsker
Mr. and Mrs. Lawrence S. Pollock, Jr.
Mr. and Mrs. Charles Price
Howard Rachofsky
Audrey S. Ratner
Edward R. Roberts
Mr. and Mrs. Jonathan P. Rosen
Mr. and Mrs. Robert Jay Rosenberg
Walter S. Rosenberry, III
Mr. and Mrs. Milton F. Rosenthal
Mr. and Mrs. Richard Rosenthal
Felice T. Ross
Mr. and Mrs. Douglas R. Scheumann
Marcia Schloss
Mr. and Mrs. Paul C. Schorr, III
Lowell M. Schulman and Dianne Wallace
Mr. and Mrs. Alan Schwartz
Mr. and Mrs. Joseph Seviroli
Mr. and Mrs. George A. Shutt
Mr. and Mrs. Gilbert Silverman
Mr. and Mrs. James G. Stevens
Mr. and Mrs. Harry F. Stimpson, Jr.
Mr. and Mrs. Robert Susnick
Mrs. Norman Tishman
Mr. and Mrs. William B. Troy
Mr. and Mrs. Michael J. Waldman
Mr. and Mrs. Robert C. Warren
Mr. and Mrs. Alan Weeden
Mr. and Mrs. Guy A. Weill
Mr. and Mrs. David Welles
Mr. and Mrs. Robert E. Wise
Mr. and Mrs. T. Evans Wyckoff